The Return of King Arthur

The Legend through Victorian Eyes

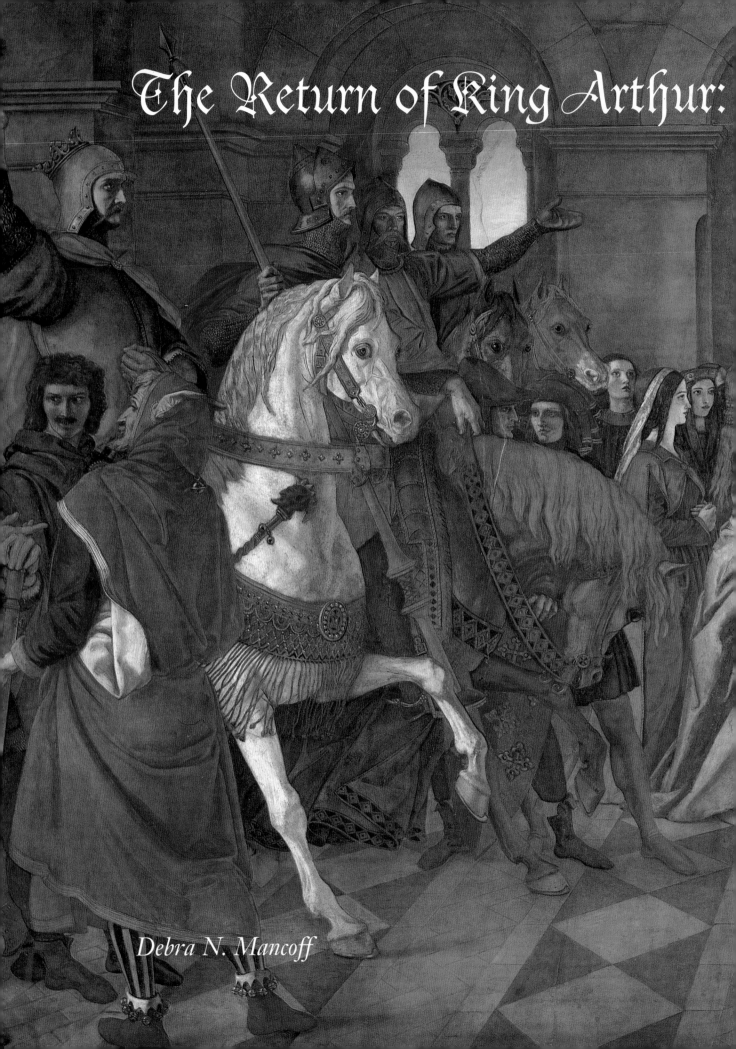

The Return of King Arthur:

Debra N. Mancoff

The Legend through Victorian Eyes

Harry N. Abrams, Inc., Publishers

To Elinor R. Mancoff and Philip Mancoff,
with fondest memories for the years between
Arthur and Albion

Project Manager: *Margaret Rennolds Chace*
Editor: *Carol Betsch*
Designer: *Darilyn Lowe Carnes*

Pages 2–3: William Dyce. *Hospitality: The Admission of Sir Tristram to the Fellowship of the Round Table* (detail). 1859–64. Fresco, 11' 2½" × 21' 9". Queen's Robing Room, Palace at Westminster, London. Reproduced by kind permission of the House of Lords

Library of Congress Cataloging-in-Publication Data
Mancoff, Debra N., 1950–
 The return of King Arthur : the legend through Victorian eyes / Debra N. Mancoff.
 p. cm.
 Includes bibliographical references (p.) and index.
 ISBN 0–8109–3782–4 (hardcover)
 1. Art, Modern—19th century—Great Britain. 2. Arthurian romances—Adaptations—History and criticism. 3. Art and literature—Great Britain—History—19th century. 4. English literature—19th century—History and criticism. 5. Arthurian romances—Adaptations—Illustrations. 6. Medievalism—Great Britain—History—19th century. 7. Knights and knighthood in literature. 8. Kings and rulers in literature. 9. Knights and knighthood in art. 10. Kings and rulers in art. I. Title.
N6767.M34 1995
700—dc20 95–6473

Published in 1995 by Harry N. Abrams, Incorporated, New York
A Times Mirror Company

Printed and bound in Japan

Table of Contents

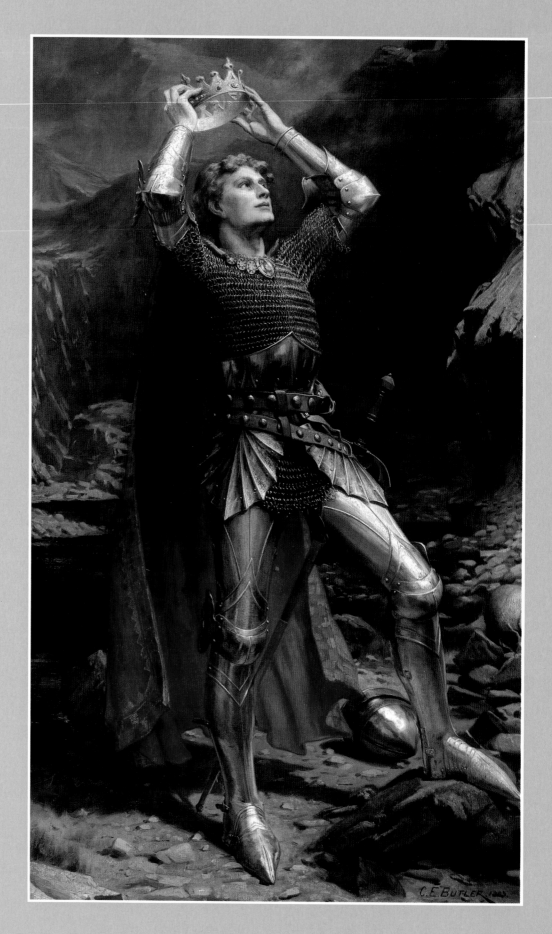

Charles Ernest
Butler. *King Arthur.*
1903. Oil on canvas,
49½ x 29″. Private
collection

Acknowledgments

Many people graced this project with their interest and encouragement from beginning to end. My gratitude goes to Beloit College and Parker G. Marden, former Vice-President for Academic Affairs, for the generous support of my continuing research. I am grateful as well for the rich resources and wonderful staff of the Newberry Library, most notably Mary Wyly, Associate Librarian, and photographer Kenneth Cain. To the many curators, collectors, gallery owners, and librarians whose expertise guided me along the way I offer my sincere thanks. The kind help of Christopher Wood of Christopher Wood Gallery, Rupert Maas of the Maas Gallery, Neil Wilson of Christie's, and Sarah Colegrave of Sotheby's proved invaluable. Among my scholarly colleagues, I owe a special debt of thanks to Susan P. Casteras, Alan Lupack, Mark Cumming, and Leonard Roberts for their interest and their advice.

Others helped me with support and services as I transformed ideas into words. I thank Christine Nelson, Reference Librarian of the Robert Morse Library at Beloit College, my student research assistants Amy E. Trendler, Mary Ashby Girard, and Heather R. Stuart, and my parents, Philip Mancoff and Elinor R. Mancoff, for always being ready to help. I thank David Heesen of Beloit College Secretarial Services for treating my manuscript with unfailing special care, Carol Betsch for her sensitive editorial suggestions, and Darilyn Carnes for her creative vision in designing the book. I am also grateful for the kind hospitality of Lady Elizabeth Arthur during my stays in London. Finally, I express my deepest gratitude to three people who helped a dream of mine come true: Gary Kuris, for initially encouraging me to get this project going; Margaret Rennolds Chace, for giving me her unflagging enthusiasm and expert advice; and David Kargl, for listening to my schemes with patience and love.

D. N. M.

The Myth of the Return

Yet some men say in many parts of England that King Arthur is not dead and men say that he shall come again . . . I will not say it shall be so, but rather I will say, here in this world he changed his life. But many men say that there is written upon his tomb this verse: Hic Iacet Arthurus Rex, quondam Rex que Futurus. *Here Lies Arthur, Once and Future King.*

Sir Thomas Malory (1469)

A hero rose out of the shadows of dark-age Britain. Born in mysterious circumstance and raised in obscurity, he proved his right to rule by drawing a sword from a stone. The armies he led were always victorious, and he governed his nation with justice and generosity. He made his court at Camelot, married a beautiful queen, and founded the most noble order of knights in chivalric history. This was Arthur, the legendary king, and his noble acts and heroic spirit were celebrated throughout the centuries.

But Arthur's destiny was marked with tragedy. His wife refused his love and turned instead to his best friend. His fellowship of knights was corrupted with rivalry and rumor. His kingdom, hard won to peace, fell to the ravages of war. And Arthur faced his fate in defeat on the battlefield of Badon, betrayed and wounded by his only son.

At the very end of this saga, however, there is a promise. Arthur, broken in body and spirit, is removed from the fatal field by gentle queens. They take him to rest on the Isle of Avalon, where they soothe his pain and heal his wounds. On some distant day, when his country calls, he will be ready and will return. His kingdom, lost, will be regained, and his shattered dream of an ideal world will be realized. This chord of hope tempers the tragedy of the legend, but it does more than that. With this promise, the Arthurian legend is shaped as an open tale, a story without an end. Once told, it begs to be told again.

While the myth of the return has ensured the survival of the legend, it has also inspired the story's evolution. With each retelling, Arthur keeps his promise. But, as each generation remakes the legend in its own image, inscribing its own aspirations on the lives of Arthur and his companions, each return brings a transformation.

Arthur made his promised return, to nineteenth-century England. Neglected since the Middle Ages, the tales of the king and his court at Camelot enjoyed an unprecedented revival in the painting and poetry, the plays and popular culture of the reign of Queen Victoria (r. 1837–1901). But the story told by the Victorian poets and painters was not the same as the one told in medieval times. The legend was not simply revived, it was reinvented, and the dreams and desires of a modern society found eloquent expression in a medieval form.

In reviving the Arthurian legend, Victorian artists and writers, and their eager audience, sought a window on the past in a desire to learn from their heroic and noble ancestors. What they forged, however, was a mirror of the present, projecting their own ideals and ambitions, dreams and fears, onto legendary characters and events. In a romanticized portrait they captured a vivid reflection of themselves. Through the poetry and painting of the Arthurian Revival, we can see how a society interpreted its own identity and informed its present view by remaking the cultural legacy of its past.

The innovative productions of the Arthurian Revival mark one of the most creative phases of the entire tradition, and the Victorian era left an indelible mark on it. No single legend could suffice to speak to the diverse Victorian public. There was an official version for the queen and the state, celebrating monarchy and heritage. A heroic version confirmed masculine power and position, playing an essential role in the construction of Victorian manhood. The legend for women taught them their place in society

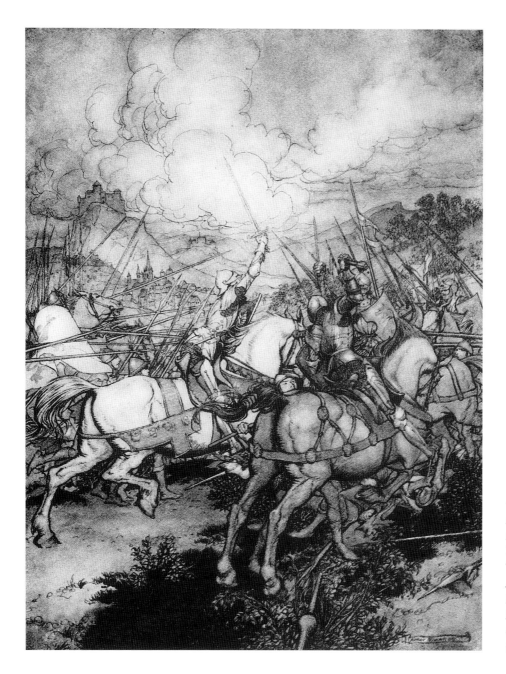

Arthur Rackham. "How Arthur Drew His Sword Excalibur for the First Time," *The Romance of King Arthur and His Knights of the Round Table*. London: Macmillan, 1917. Courtesy of The Newberry Library, Chicago

as well, defining patterns to follow and paths to avoid. Even children had their own legend, written in simple language and depicted in innocent wonder, a legend without moral stain and without a tragic ending.

The legends of Victorian England confirmed the power of the Once and Future King. He returned in glory to reign over the popular imagination, and little in the era—from the first days of the young queen's accession, through the vast expansion of Britain's colonial empire, to the tragic losses in the wars of the early twentieth century—was untouched by Arthur's image. But just as the mythic king left his stamp on Victorian England, Victorian England transformed the mythic king. Even today we cannot look back to the Arthurian world without looking through the lens of Victorian transformation. When the Victorians called Arthur out of Avalon to reign again, they changed his life, and in doing so, extended his tradition and perpetuated his memory. To look today at the Arthurian Revival in Victorian England is an act of reaffirmation: even in our contemporary world, the myth of the return fulfills its promise.

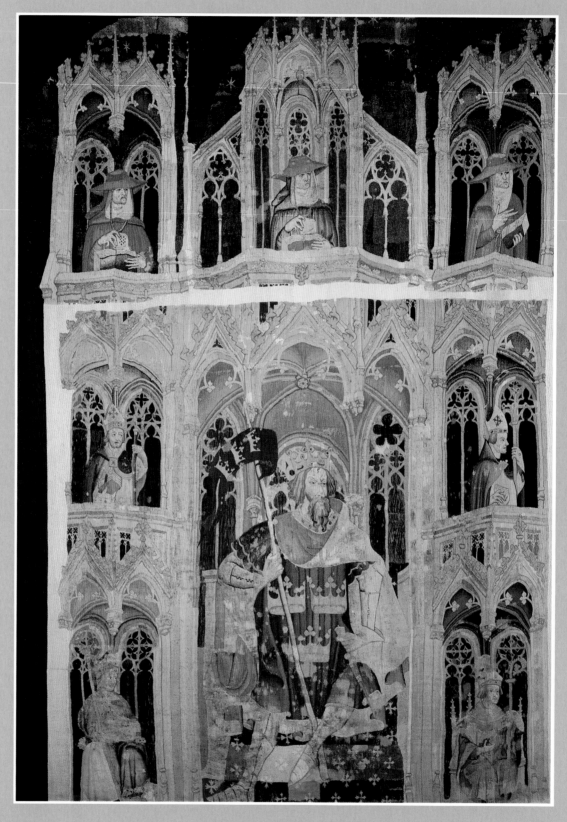

"Arthur as One of the Nine Worthies," *Cloisters Tapestry*.
c. 1385. The Metropolitan Museum of Art, The Cloisters
Collection, New York, Munsey Fund, 1932, and Gift of
John D. Rockefeller, Jr., 1947

CHAPTER 1

"The Style of Those Heroic Times"

Why take the style of those heroic times?
For nature brings not back the mastodon,
Nor we those times; and why should any man
Remodel models?

Alfred Tennyson (1842)

In 1842, when Alfred Tennyson presented his first Arthurian poem to the Victorian public, he framed it with a prologue and an epilogue he called "The Epic." The scene is a Christmas reunion of old college friends. Recalling their idealistic and younger days, they urge the most cynical among them, a poet named Everard Hall, to read from the saga of King Arthur he wrote as a student. At first Hall hesitates and then refuses, claiming that the work was nothing but a boyish fancy and that he'd burned it. He protests that the times of myth had long passed, and nothing could, or should, revive them. But one of his fellows had rescued a single poem from the fire, and once he is persuaded to read, Hall's voice rings out with the words of the "Morte d'Arthur," the first installation in Tennyson's epic *Idylls of the King*.

Arthurian poetry occupied Tennyson for his

Walter Crane. "The Arms of Arthur," *King Arthur's Knights: The Tales Re-Told for Boys and Girls*. Edinburgh and London: T. C. and E. C. Jack, 1911. Courtesy of The Newberry Library, Chicago

whole career. Although his first reflection on the life and times of the Once and Future King appeared when he was thirty-three, the twelve-part saga would only be complete near the end of his life, five decades later. In the *Idylls* Tennyson crafted a vivid portrait of the king, his court, and his companions, but he did more than tell a tale of ancient days. Tennyson gave the legend new life and the power to inspire a new audience to legendary dreams.

In the "Morte d'Arthur" Tennyson answered the challenge of his cynical character Hall. "The style of those heroic times" offered a universal and timeless code for society's aspirations. Arthur's dream of a just and peaceful order, and the sacrifices he made to achieve it, spoke directly to any heart that valued honor, loyalty, bravery, and love. Tennyson set forth the tale of Arthur's last battle and his retreat to the isle of Avalon not as an arcane fantasy but as a vibrant image of a real life well lived. Every man and woman of Tennyson's day came to see his or her own reflection in the style of those heroic times; the spirit that shaped those times, and survived the centuries, was the spirit of myth. Its vitality transcended the limitations of history.

To Tennyson and his Victorian readers Arthur's world represented a perfect moment from heroic times. But, in fact, that moment was a millennium in the making. Throughout the Middle Ages in Britain, the legend emerged, evolved, and endured. Each era left its stamp on the saga; each time Arthur returned, he was transformed. From the dark days of the Saxon invasions to the glorious dynasties of Gothic England, Arthur served as a symbolic identity for the nation. The Arthurian tradition inherited by the Victorians was a vast storehouse for

cultural values and memories, and although the saga's popularity had reached its zenith in the Middle Ages and declined in the centuries that followed, the tale of the Once and Future King lived on in the popular imagination.

Arthur was not born a king. During the Middle Ages a gradual development transformed a shadowy war chieftain who struggled boldly against Saxon invaders into an incomparable monarch who presided over a glittering court of heroic champions. The early dark-age warrior set a standard for stalwart bravery and fierce tenacity. The high medieval king defined a code of knightly chivalry, civility, virtue, and honor. Interest in the members of Arthur's mythic court waxed and waned, but fascination with the soldier turned sovereign endured in British medieval culture. As his saga unfolded, in the tales of the bards and the ballads of the troubadours, in the chronicles of the historians and the narratives of the romancers, it was embraced as the dominant secular myth of Europe and the national epic of Britain. Arthur's true role in history could not be proved, but in the medieval era, he "made a realm and ruled in literature."[1]

The earliest written reference to a warrior named Arthur is found in the *Historia Brittonum* (c. 800, The History of the Britons). In an account of the fall of post-Roman British civilization to Saxon warriors of the sixth century, Arthur is described as the victor of twelve battles and a warrior who fought on the side of the "kings of Briton." One century later, in the *Annales Cambriae* (The Annals of Wales), a Latin document written in Wales, we learn of his role in two battles: the battle of Badon, where "Arthur carried the cross of Our Lord Jesus Christ for three days and three nights" and the Britons were victors, and the "strife" of Camlann, "in which Arthur and Medraut fell. And there was plague in Britain and Ireland."[2] These brief citations, dated roughly to the years 520 and 540, connect Arthur's name with verifiable sites and sketch the first image of Arthur as a valiant Christian hero, at one time victorious, who died in defense of his faith and his nation.

In the centuries between Arthur's time and the first written record of his history, the British isles suffered invasions and civil disruption. The oral tradition of the indigenous British culture embellished the

shadowy past of the warrior-hero, increasing his victories and raising his station. Evidence of Arthur's story in the Welsh bardic tradition has been traced back to the days of the Saxon invasions. Although songs of the bard Aneirin, a contemporary of Taliesin, were not written down until the tenth century, his elegy for British kings and heroes *Y Gododdin* was composed around 600. For Aneirin, Arthur represented a model warrior, and when the bard praises the bravery of another powerful leader who "stabbed over three hundred of the finest" and "glutted the black ravens on the rampart of the stronghold," he laments that this warrior "was no Arthur."[3] As a defeated people, the surviving Britons cherished these tales of their ancestors' victories, in hope that their spirit

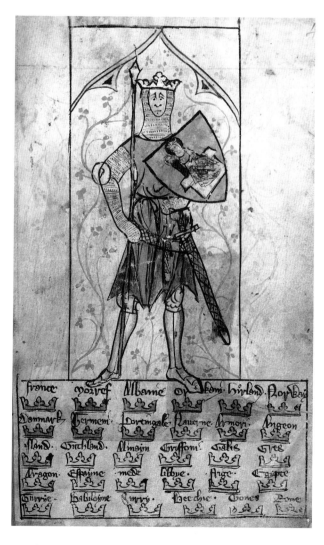

"Arthur and His Kingdoms," *The Chronicle of Peter Langtoff.* c. 1307. By permission of The British Library, London

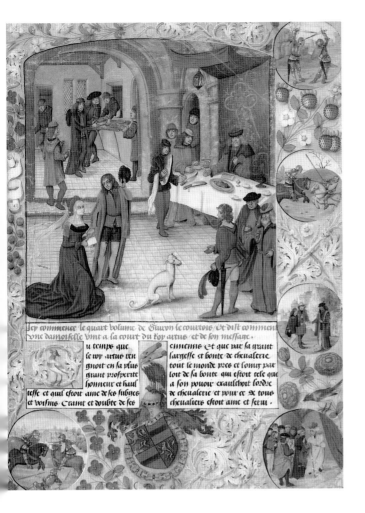

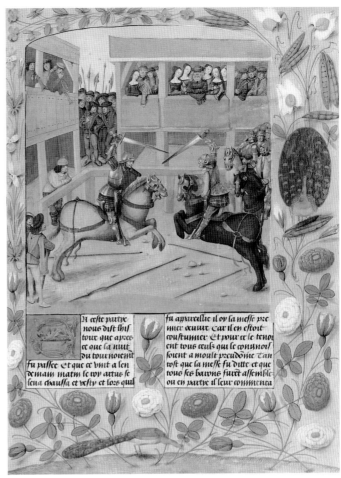

u tempe que
le roy artus ten
gnoit en sa plus
grant profperite
honneur et haul
teffe et qui eftoit aime de fes fubiece
et voifins Craint et doubte de fes

largeffe et bonte de cheualerie
tout le monde pres et fonig par
loit de fa bonte qui eftoit tele que
a fon pouoir exaulchoit lordre
de cheualerie et pour ce fe tous
cheualiers eftoit aime et ferui.

It cefte partie
nous dift thi
tour que apres
ce que la nuit
du tout noient
fu paffee et que ce vint a len
demain matin le roy artus fe
leua chauffa et vefti et lors qui

fu appareille il oy fa meffe pre
mier ouunt Car il en eftoit
couftumier Et pour ce le tenoi
ent tous ceulx qui le connoif
foient a moult preudome Tan
toft que la meffe fu ditte et que
tous fes barons furent affemble
ou en partie il leur commenca

would return and bring the restoration of their nation.

The Welsh bardic tradition perpetuated the memory of Arthur's heroic achievements and elevated his stature from battle leader to king. His biography and his royal genealogy, however, were products of later English chronicles. In 1138, an Oxford cleric called Geoffrey of Monmouth completed the *Historia Regum Britanniae* (History of the Kings of Britain), a compilation of the island's history from early colonial settlement by Brutus and his band of exiled Trojans to the fall of the Britons to the Saxon invaders. Presented as fact, a straightforward narrative of succeeding reigns and significant events, Geoffrey's book was a masterwork of fiction. He wove together the mythic tales of past centuries and lost cultures with ideas from his own rich imagination. More than one-fifth of the *Historia* concerns Arthur's reign. Geoffrey gives the king a legitimate claim to the throne

above left:
"Arrival of a Damsel at King Arthur's Court," *Guiron le Courtois*. MS. Douce, 383, fol. 17r, c. 1475–1500. The Bodleian Library, Oxford

above right:
"A Tournament in Arthur's Presence," *Guiron le Courtois*. MS. Douce, 383, fol. 16r, c. 1475–1500. The Bodleian Library, Oxford

The Ruins of Glastonbury Abbey. 1993. Drawing by
Richard T. Mueller

opposite:
"An Episode from the Arthurian Legend," *Galehaut
Tapestry.* c. 1500. Wool, 11′2″ x 7′4″. The Saint Louis Art
Museum, Museum Purchase

through his father, Uther Pendragon, and endows
him with an arsenal of supernatural weapons and an
army of unsurpassed champions. Arthur's exploits
take him to the continent and throughout the known
world. Merlin, a shadowy figure in earlier tales, takes
a prominent role, voicing prophecy, performing
magic, and giving Arthur wise counsel. Geoffrey's
book enjoyed phenomenal popularity in its day, and
copies of the *Historia* were translated and circulated
to France, Spain, Italy, Poland, and even distant
Byzantium.

In the medieval world British national identity
and Arthur's legend fused into a singular and power-
ful symbol. His saga, and the increasing number of
tales set at his court, came to be known throughout
Europe as the "Matière de Bretagne" (Matter of
Britain). His history gained credibility as specific sites
on the British isles were associated with legendary
events. Foremost among these was Glastonbury, an
abbey town in Somerset that claimed to be the
ancient "Avalon," Arthur's haven of healing and rest.
One of the earliest Christian settlements in Britain,

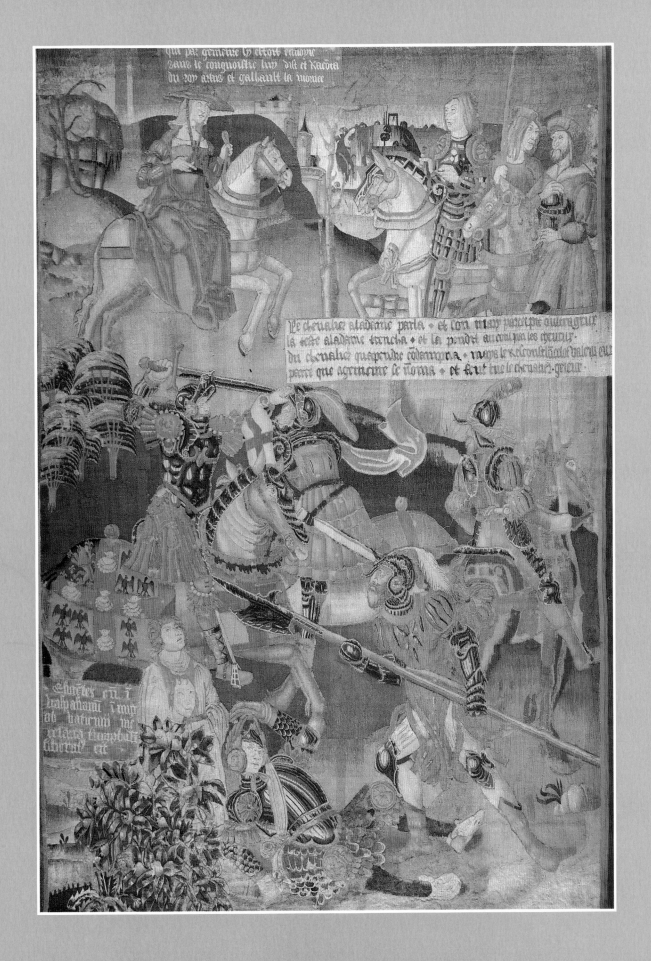

the foundation of the abbey predated the Saxon invasions. Glastonbury's connections with the legend prompted debate in the twelfth century until 1190, when the monks of the abbey produced sensational evidence to back up their claim. Digging in the abbey graveyard, at a specific location told to King Henry II by a Welsh bard, they exhumed two skeletons, a tall, big-boned man with a fractured skull and a small woman with a single lock of golden hair that conveniently crumbled when touched. In the grave shaft, set on top of the hollow log coffin, was an inscribed lead cross, proclaiming "Hic Iacet Sepultus Inclitus Rex Arthurus in Insula Avalonia" (Here lies buried the renowned King Arthur in the Isle of Avalon). Although scholars now dismiss the find as a "publicity stunt," to the monks and their followers it seemed irrefutable evidence of the existence of the legendary king.[4]

In England, the Matter of Britain was political. In France, it became romantic. Written for court circles, Breton lais (or songs) recounted adventures of love and chivalry for royal audiences. Many of the patrons of new romances were women, including Eleanor of Aquitaine and her daughter Marie de Champaigne. As the legend evolved, the emphasis switched from the battlefield to the court of love. Arthur's own achievements receded into the background as the tales of the ideal knights were crafted. The lives and loves of formerly minor characters—Tristram, Lancelot, Galahad, even Guinevere—took on new details and substance, mirroring the lives and desires of the new female audience. The new romances taught the rules of courtly love and chivalry through vivid example, urging life to imitate art. Many of the now-traditional themes and characters entered the Matter of Britain through the work of French romancers, most notably Chrétien de Troyes. As a retainer in Marie de Champaigne's court, Chrétien crafted new Arthurian stories, including *Erec et Enide* (1176), *Cligés* (1180), *Lancelot and Yvain* (1190), and *Percival* (1190). Infused with the spirit of intimacy and refinement, these works were meant for private reading rather than public recitation. The scenes of jousting and feasting, and the trials of love and loyalty set new standards for the glittering world of the Gothic aristocracy.

To bring this world to life, courtly patrons commissioned artists to portray the legend. In the thirteenth, fourteenth, and fifteenth centuries Arthurian tales emerged as the favored secular iconography in the visual arts. Magnificent illustrated manuscripts, embellished with full-page miniatures, enhanced the pleasure of reading a romance. The world portrayed was both real and ideal: the events, fashions, and manners depicted in the manuscripts reflected contemporary court life, but the richness and beauty of these images could not be matched anywhere in the known world. As seen in a painting from the fifteenth-century manuscript *Guiron le Courtois*, written by Hélie de Boron and illustrated by an anonymous Flemish painter, handsome courtiers escort delicate damsels to the king's table, where Arthur listens to their requests as he feasts in high style. Jousts look more like ballet than battle; graceful knights on rearing horses raise their weapons, to the delight of the elegant ladies who fill the stands.

In the decorative arts Arthurian imagery blurred the line between life and legend. Arthurian tales were painted on window glass, stitched into bedclothes and draperies, and woven into tapestries. The magnificent pictorial hangings that warmed the cold chambers of stone castles transformed those rooms into fantasy landscapes where knights met challenges on the road to adventure. Even a woman's dressing table provided a setting for Arthurian romance. Combs, mirrors, and jewel boxes, with ivory or enameled settings, celebrated the chivalric bond between knights and their ladies. Lancelot's treacherous journey across the sword bridge to save Guinevere, and Gawain's night in the perilous bed in the Castle of Marvels, both based on Chrétien's romances, were carved in ivory to form the sides of a jewel casket. Every time a woman reached for her jewels, or combed her hair, or admired her own fair face, she could think about the sacrifices these knights had made for their ladies. For men of these courts, the fantasy took on a real dimension in "Round Table" jousts held throughout Europe. Taking the names and identities of Arthur's knights, champions would display their prowess in field sports, bringing the pages of manuscripts to life. The earliest known Round Table tournament took place in Cyprus in 1223. In 1446 René d'Anjou hosted a tourney in a special "Arthurian" castle made for the event. And it is

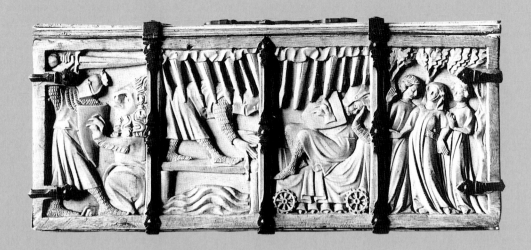

"The Adventures of Gawain and Lancelot." Ivory casket, 14th century. The Metropolitan Museum of Art, New York, Gift of J. Pierpont Morgan, 1917

below:
The Round Table at Winchester Castle. 1994. Drawing by Richard T. Mueller

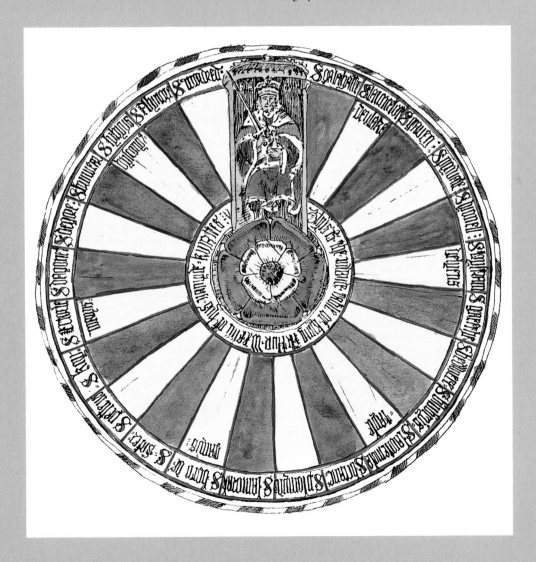

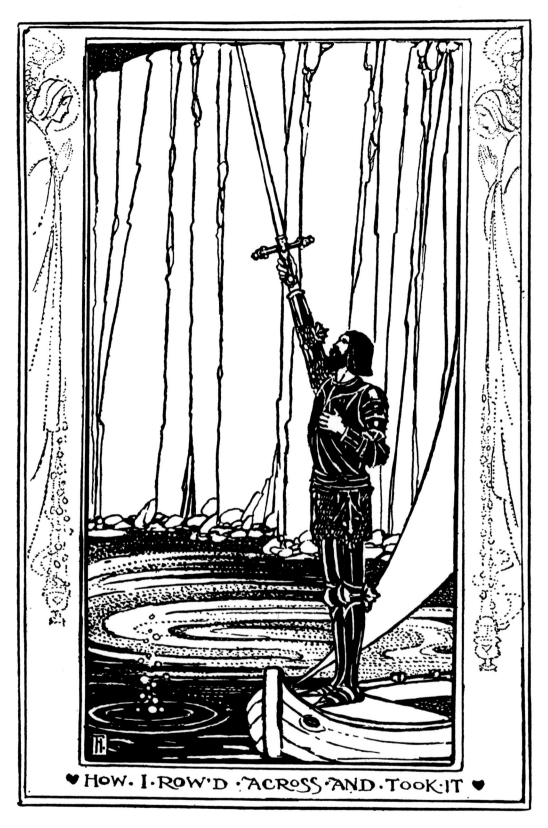

♥ HOW. I. ROW'D. ACROSS. AND. TOOK. IT ♥

Florence Harrison. "How I Row'd Across and Took It,"
Tennyson's "Guinevere" and Other Poems. London: Blackie
and Son, 1912. Courtesy of The Newberry Library,
Chicago

believed that the Round Table now hanging in the Great Hall at Winchester Castle is a relic of a similar pageant, most likely dating to the reign of Edward III.

By the mid-fifteenth century, the sheer number of legends associated with the Arthurian tradition after almost nine hundred years of evolution was staggering. In many tales, the king had receded to the background. Knights stopped briefly at his court to join the fellowship, take up a challenge, and quickly depart on adventures that took them far from Camelot. Any sense of narrative was lost in this vast collection of chivalric stories and motley characters. The term "Arthurian legend" served as a catchall for any saga or romance that began or ended in or passed through the realm of the Once and Future King.

The now-familiar tale, based on the life and death of Arthur, was crafted from these diverse sources by Sir Thomas Malory, a British knight of obscure origins, who spent over ten years incarcerated in the Tower of London for crimes that included deer poaching, cattle rustling, vandalism, extortion, and rape. Malory's own myth presents him writing his saga in jail, but his *Morte Darthur*, or The Death of Arthur, was written after his release, in the years 1469 to 1470, shortly before his death. Malory acted as an editor and an interpreter, rather than a continuator. By honing down the vast catalogue of legends to fit within the life span of his hero, he forced the sprawling saga into a plausible narrative sequence, beginning with Arthur's mysterious birth and ending with the events that directly resulted from his death.

The story opens in a war-torn land. King Uther Pendragon, while fighting the armies of rebellious feudal lords, burns with desire for Igraine, the wife of his enemy, Duke Gorlois of Cornwall. With the aid of his magician-counselor Merlin, Uther appears to Igraine in the form of her husband, and they conceive a child, Arthur, while Gorlois is killed in battle. Later, Uther too meets his death on the field, but in a last mighty thrust, he embeds his sword of sovereignty in a stone. Merlin then demands the child from Igraine and places him in the home of the knight Ector, where he is raised as a squire to Kay, the eldest son of the family. Arthur's true origins are revealed in his youth, when he draws the sword from the stone and assumes his position as the rightful ruler of Britain.

With Merlin as his adviser, Arthur proves a wise and honorable warrior. Merlin takes him to the Lady of the Lake, who gives him his own sword, Excalibur, demanding that he use it in the cause of justice and that he return it when his work is completed. A valorous leader, Arthur brings the warring factions to peace and calls the greatest knights of the world to serve in the fellowship of the Round Table. They come from as far as France—Lancelot du Lac, son of King Ban—and as close as Cornwall—Gawain, son of his own half sister. Arthur marries a beautiful princess, Guinevere, but the marriage is for political alliance, rather than for love. For years the court at Camelot reigns in peace, and Arthur's knights—Tristram, Bedivere, Geraint, Lancelot, Gawain, and Gareth—carry out the king's laws in the course of their own adventures. But they become increasingly distracted by petty grievances and personal desires, which erode the unity of the court. Lancelot suffers for the love of Guinevere, and his actions generate rumor and dissension in the fellowship. Guinevere proves to be barren, unable to give Arthur an heir to ensure the nation's future. Merlin is removed from the court, victim of his own unwise passions. The knights disband to follow the quest for the Holy Grail, and all fail but one, Galahad, the youngest and the purest. Mordred, Arthur's own illegitimate son, conceived unwittingly with his half sister Morgause, yearns for his father's wife and kingdom, and beginning a cycle of treachery that would end Arthur's rule, he entraps Lancelot and Guinevere in a romantic tryst.

Confronted with Mordred's charges against his wife and his closest friend, Arthur takes public action on his private tragedies. He tries and condemns Guinevere for treason. Lancelot saves her, but then is forced to battle the troops of his sovereign. While Arthur is abroad, Mordred attempts to take the kingdom and to rape the queen, but Guinevere retreats to the safety of a nunnery. Arthur returns from his war with Lancelot to find his order in ruins, and he faces his son for his last battle. Arthur slays Mordred, but not before the youth delivers a fatal blow, and Arthur is left wounded on the field with his last, loyal companion, Bedivere. Arthur then instructs the knight to return Excalibur to the Lady of the Lake and to carry him to the seashore. There they are met by three

stately queens who place the suffering king in a boat and sail to the isle of Avalon. The end of Arthur's life is as obscure as its beginning; it is uncertain whether his journey ends in death or in healing slumber. Bedivere is left alone to mourn the fellowship, while Lancelot and Guinevere end their days apart, in penitent exile.

Malory's story marked the apex of the medieval tradition but also signaled its termination. His clearly crafted narrative turned the open-ended saga into a cycle that closed with the departure of the king. Although Malory's chronological ordering of events set the legend in a plausible time, like the life of a man, it ended the inventive and flexible continuity that had characterized the life of the legend during its medieval evolution. Nevertheless, Malory's *Morte Darthur* served as the standard form of the legend for subsequent generations, and it was the first version to be printed, in 1485 by William Caxton of London.

Ironically, even as the publication of Malory's book was confining Arthur's reign to the realm of literature, British monarchs began to use his venerable reputation to validate their own right to rule. In 1485, Henry of Richmond, claiming descent from Arthur through the ancient Welsh king Cadwallader, defeated Richard III in the battle of Bosworth field. His victory banner, emblazoned with a red pendragon, recalled Merlin's prophecies in Geoffrey of Monmouth's *Historia Regum Britanniae*. As King Henry VII, founder of the Tudor dynasty, he named his first son Arthur. When the boy died, the king invested his hopes in his second son, Henry, and pointed with pride to his birthplace, Mona, a site mentioned in Merlin's predictions.

Henry VIII succeeded to the throne in 1509 and continued his father's interest in Arthurian iconography. At the Field of the Cloth of Gold in 1520, he faced his French rival, Francis I, with pennants and trappings that depicted Arthur as a world conqueror. He had the "Round Table" in Winchester Hall repainted in Tudor green and gold. The twenty-four segments representing the knights of the fellowship corresponded with the twenty-four members of the Order of the Garter in Henry's reign. And Henry's daughter Elizabeth I inspired the figure of Gloriana in Edmund Spenser's *Faerie Queene*

(1589–98). Arthur, demoted to "prince" from king, was portrayed as her ideal consort.

Like Arthur, Elizabeth left her kingdom no suitable heir. But when the throne passed from the Tudors to the Stuarts, James I chose to maintain the mythic connection. He, too, claimed descent from Arthur, and in the *Masque at Lord Hay's Marriage* (1606–7), Thomas Campion declared that Henry was the Once and Future King incarnate.

> *Merlin, the great king Arthur being slaine*
> *Foretold that he should come to life againe;*
> *And long time after wield Great Brittane's State,*
> *More powerful ten-fold and more fortunate.*
> *Prophet, 'tis true, and well we find the same,*
> *Save only thou didst mistake the name.*
>
> (ll. 22–27)

James's son Henry took Arthur as his personal symbol. In *Prince Henry's Barriers* (1610), Ben Jonson predicted that Henry's reign would surpass Arthur's in every way: "How brighter far than when our Arthur liv'd / Are all the glories of this place revived."[5] But Henry died long before his father, and his brother Charles I, taking the throne in 1625, preferred to define his own aspiration with classical rather than medieval references. Charles's reign ended in revolution in 1649, and with the establishment of Cromwell's Commonwealth, reference to Arthur's monarchy fell into disfavor.

Although the break in the kingship tradition lasted only until 1660, Arthurian reference lost its value as monarchical iconography. A general decline of interest in the legend had, in fact, begun during Charles's reign. Malory's *Morte Darthur* saw its last printing in an edition published in 1634; it would not appear in print again for two centuries. The close connection of the legend with the deposed Stuart monarchy made poets wary of the subject during the Commonwealth. John Milton, who in his youth had professed a desire to rewrite the legend for his own generation, dismissed it all as "fantastic." In his *British History* (1655), he discouraged reliance on Geoffrey's *Historia*, claiming that it could be used as a source only "when all others are silent."[6]

The Restoration of 1660 saw a modest revival of Arthurian interest, but the attitude toward the leg-

end had changed. Like Milton, the youthful John Dryden had dreamed of writing an Arthurian epic. The return of the Stuarts to the throne offered him the opportunity he sought, but the result was an opera rather than an epic, a popular entertainment filled with lively music, elaborate dances, and a distracting subplot about flirtatious arcadian shepherds. Dryden's progress on the work was so slow that his patron, Charles II, died before it was completed. First produced for James II in 1685, *King Arthur, or The British Worthy* had to be revised in 1688 when the Stuart house was again deposed. Dryden pleased his new patrons, William and Mary, by presenting Arthur's triumph as the unification of the Saxons and the Britons. Even Arthur's legendary prowess was diminished; the course of battles turned on spells cast by Merlin and his fairy companion Philodel, rather than Arthur's brilliant military strategy.

In the early eighteenth century, the mythic king found his place in folk tales and nursery rhymes instead of battle sagas and epic poetry. Henry Fielding's burlesque *The Tragedy of Tragedies, or The Life and Death of Tom Thumb the Great* (1731) cast Arthur as the straight man in a court of grotesques and buffoons. The tiny hero of the title, renowned for his victories over the local giants, is the protagonist in a web of intrigue and unrequited love. Arthur, the timid, henpecked husband of a drunk named Dollallolla, falls in love with the captive queen of the giants, Glumdalce. She only has eyes for Tom, who, in turn, wants to marry Arthur's daughter, the princess Huncamunca. A series of murders eliminates all the cast principals except Arthur, who delivers a pompous soliloquy and commits suicide out of sheer frustration. Jonathan Swift claimed he laughed only twice in his life; once was at a performance of *Tom Thumb*.[7] In the declining tradition Arthur was stripped of his retinue, his queen, his champions, and his kingdom. Now, he had even lost his dignity.

But, at the exact moment when the legend seemed doomed to oblivion, a new cultural trend came to its rescue. In the eighteenth century, when the legends of medieval times seemed to conflict with the rational spirit of the age, England rediscovered its past. Interest in history and archaeology was on the rise all over Europe. These studies were the tools of the Age of Enlightenment, when men and women believed they could exercise control over their own destinies through knowledge, philosophy, and science. On the continent, scholars sought to reconstruct the classical past, excavating the ancient sites of Pompeii, Herculaneum, Paestum, and the Acropolis. England's

Florence Harrison. "Morte d'Arthur," *Tennyson's "Guinevere" and Other Poems*. London: Blackie and Son, 1912. Courtesy of The Newberry Library, Chicago

classical heritage was slight and fragmentary, but its medieval legacy was rich, and when scholars turned their attention to reconstructing England's past, it was the Middle Ages that caught their imagination.

The Gothic Revival—a century-long celebration of medieval culture in popular British taste—seems an unlikely trend in a time that defined itself as practical, rational, and modern. Kenneth Clark, in his respected study *The Gothic Revival: An Essay in the History of Taste* (1928), attributed this anachronism to the attraction of opposites: "When life is fierce and uncertain the imagination craves for classical repose. But as society becomes tranquil, the imagination is starved of action and the immensely secure society of the eighteenth century indulged in daydreams of incredible violence."[8] The confrontation with emerging technology may have been another factor. The future of an industrialized era promised wealth, power, and leisure, but it held the terror of the unknown. The distant past seemed simpler, untouched by the unknown dangers of progress, and it was a closed era, therefore it was stable. Escape to the past, even in a flight of imagination, offered a retreat into secure and certain times. But reaction to rationalism and fear of the future are only partial explanations for the Gothic Revival. In the eighteenth century, England began an unprecedented ascent in global domination that would continue unimpeded for more than two hundred years. Through influence in continental politics, vast colonial territories, and gunboat diplomacy and trade, England emerged as the first modern superpower. The interest in the Middle Ages marked a quest for identity, the confirmation of a glorious present through association with a glorious past.

By the mid-eighteenth century, a fashion for medievalism affected all the arts. "Gothick" novels, tales of romantic terror set in the past and laced with the supernatural, became best-sellers. Landed gentry took new pride in long-neglected portraits of ancestors, and they poured their wealth into renovation of the family estate. Relics from the past—armor, weapons, manuscripts, tombs—grew in value and interest, attracting equal attention from collectors and scholars. More than any other art form, architecture embraced the Gothic, transforming the rational realm of building design into a field of fantasy.

Kenneth Clark claims that "Gothic architecture crept in through a literary analogy."[9] It is true that the celebration of "ancient" architecture appeared first in poetry. As early as 1726, David Mallet evoked the terrifying attraction of the site "where ruin dreary dwells, / Brooding o'er sightless Sculls and crumbling bones."[10] In his "Ode on a Distant Prospect of Eton College" (1742) Thomas Grey associated the memories of childhood with an architectural monument. But at the same time, architects with Gothic inclinations drew inspiration from their heritage and their history, and from the simple reality that the Gothic style had survived with unparalleled tenacity throughout the provinces of Great Britain.

In fact, in some areas of Britain, there was no hiatus between the late Gothic style and its reincarnation in the Gothic Revival. Despite the efforts of "classical" architects such as Inigo Jones, Sir Christopher Wren, and Sir John Vanbrugh, England never fully rejected medieval tradition. Medieval motifs were used in rural church design well into the eighteenth century. Building in the Gothic mode also survived in collegiate architecture, seen in Wren's Tom Tower at Christ Church, Oxford (1681), and Nicholas Hawksmoor's Twin Towers at All Souls, Oxford (1715). But the Gothic Revival inspired designs that existed outside of traditional forms, valued for their decrepitude rather than their link with any heritage. Counterparts to Mallet's "rev'rend pile," they appealed solely to the romantic imagination.

The English country garden, part of the vast complex of estate lands that surrounded a traditional country house, offered the first setting for romantic building. Throughout the eighteenth century, grounds were landscaped, often completely resculpted to present more "natural" and wilder vistas than originally provided by nature. Garden follies, little pavilions in a variety of styles, were scattered throughout the redesigned grounds as points of rest and entertainment for garden visitors. By the third decade of the eighteenth century, sham ruins, crumbling towers, and hermit's huts—often occupied by a hired hermit—appeared among the classical temples and Chinese pagodas in the landscape. In 1732, William Kent built a rustic retreat called the Hermitage on the grounds of Richmond Castle for Queen Caroline. Three years later he added "Merlin's Cave," a

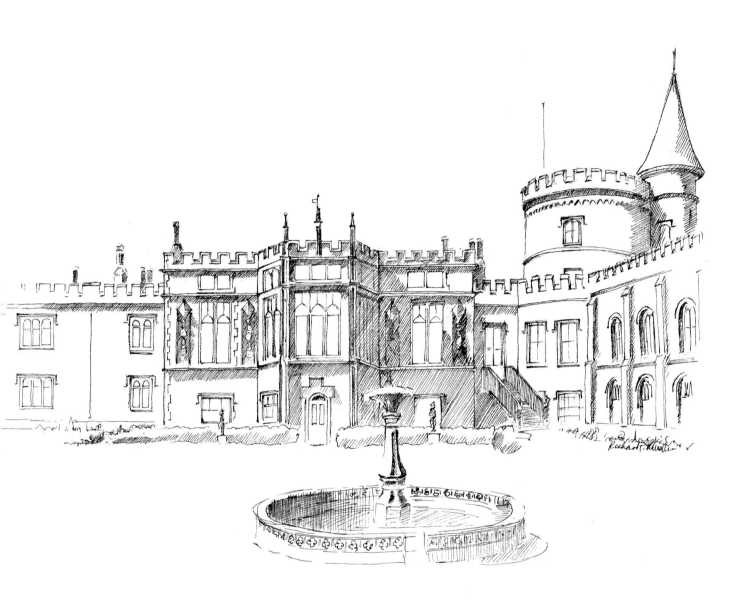

Strawberry Hill. 1993. Drawing by Richard T. Mueller

thatched, pseudo-Gothic cottage housing a modest library and six lifesize wax images of figures from Britain's literary and historical past, including Merlin and Queen Elizabeth I. The amateur architect Sanderson Miller built a thatched cottage at his own estate Radway Grange in 1744. His next design was a sham castle, complete with a ruined tower and drawbridge. It was so admired by his friends, he received commissions to build other crumbling castles, including one at Hagley Hall in 1747.

But brief afternoon visits to imitation castles were not enough for Gothic enthusiasts. In 1747, Horace Walpole, the novelist and antiquarian, decided to live in a building that matched his fantasies. He purchased Strawberry Hill, a Jacobean manor house in Twickenham, not far from London, and with the aid of a team of architects, he transformed its appearance to suit his imaginative requirements. With the addition of towers and turrets, crenellations and battlements, the original form of Strawberry Hill disappeared behind a costume of Gothic form. Plasterwork beams and tracery, twisted staircases, and newly crafted stained and leaded glass embellished the interior. To Walpole, it was a true "Gothic" edifice, looming over the tranquil countryside, casting its rugged profile against the sky. He enjoyed the irrational twists and turns of the new plan, the darkened corners where mysteries lurked, the paneled library where he could transport himself into the past without leaving his armchair. Walpole even used Strawberry Hill, under another name, as the setting for his "Gothick" novel *The Castle of Otranto* (1762). Other fantasy castles followed. Some, like Arbury Hall (1753), were transformations, but new works on a colossal scale, such as James Wyatt's Fonthill Abbey (1800) and Anthony Salvin's Peckforton Castle (1844–50), were built as well. Living in the gloom and damp of a castle—old or new—was uncomfortable at best, but for Gothic enthusiasts the romantic association was worth the inconvenience.

While Gothic enthusiasts sought escape in a medieval world crafted from fantasy, antiquarian scholars sought to reconstruct that world's reality. The wealth of material culture that survived the ages as ruins and relics now drew the attention of historians and archaeologists. In accordance with

Enlightenment belief, scholars worked to recover, catalogue, and document the artifacts of the nation's past. The results of their inquiries were published as large-scale, handsomely illustrated encyclopedias, appealing to a diverse public. Scholars and enthusiasts shared an interest in the legacy of the medieval world, and the popularity of these catalogues made the alien relics of that world intelligible, accessible, and familiar.

For the first time in British cultural history, national architecture was studied in a serious and methodical manner. Works ranging from "how to" books, such as Batty Langley's *Gothic Architecture Improved by Rules and Proportions* (1742), to sightseeing guides, such as Francis Grose's *Antiquities of England and Wales* (1773–87), and chronological surveys, such as James Bentham and Brown Willis's *History of Gothic and Saxon Architecture in England* (1798), shed new light on old architecture. Similarly, weapons, coins, tombs, and costumes were studied, in works such as Francis Grose's *Treatise on Armor and Weapons* (1786), Richard Gough's *Sepulchral Monuments of Great Britain* (1786–99), and Joseph Strutt's *Complete View of the Dress and Habits of the People of England* (1796–97). Artists used these catalogues to inform their paintings of the past, achieving a new level of archaeological correctness in their historical works. The public began to "see" the past, and see in it a new vitality.

In literature, the anthology was the counterpart to the catalogue. In the last half of the eighteenth century, literary scholars began to collect and compile the fragments of poems, ballads, and romances known since the medieval era. At the same time, literary critics strove to develop new standards for the appreciation of "ancient" national literature. Thomas Warton's *Observations on the Faerie Queen* (1754) pioneered the suggestion that the aesthetic of medieval poetry was equal to that of classical, only it was different. Richard Hurd, inspired by Warton to write *Letters on Chivalry and Romance* (1762), extended the search for new critical criteria and even suggested that, in a national sense, the heroic vision of the Middle Ages was greater than that of classical Greece or Rome. Hurd, in turn, inspired Thomas Percy to publish *Reliques of Ancient English Poetry* (1765), combining literary history and criticism with collected

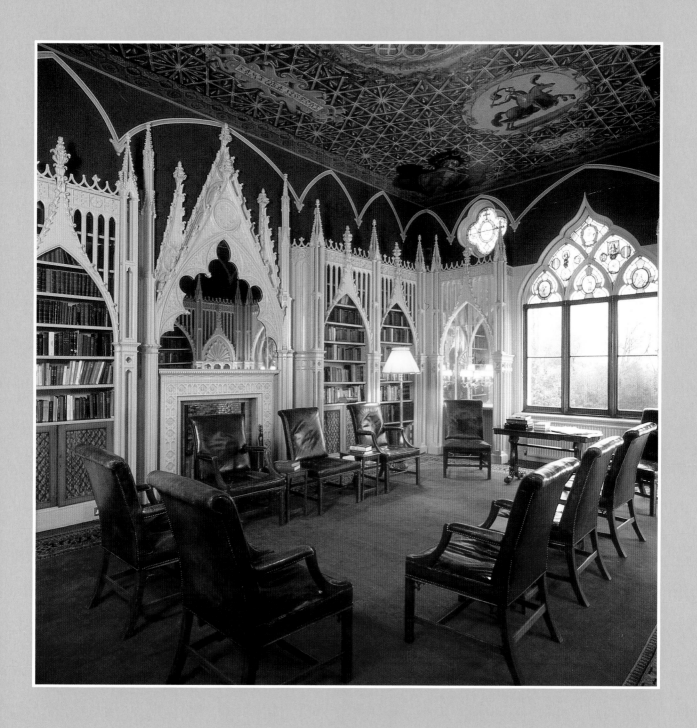

Strawberry Hill, Library. Courtesy of St. Mary's University
College, Strawberry Hill. Photograph by Michael Dunn

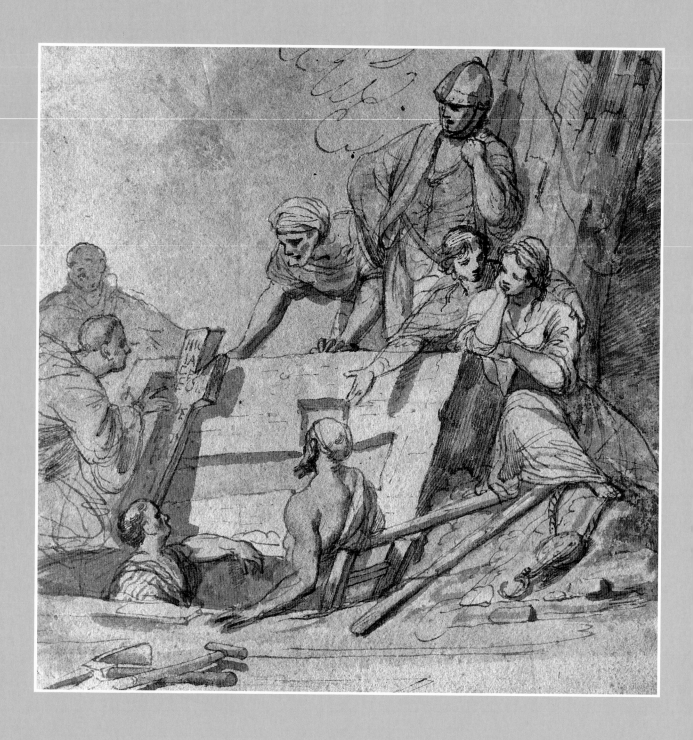

John Hamilton Mortimer. *The Discovery of Prince Arthur's Tomb by the Inscription on the Leaden Cross.* c. 1767. Pen and ink with watercolor, 7¾ x 7¾". National Galleries of Scotland, Edinburgh

examples, a perfect parallel to the illustrated compendia of material culture in both its mode of presentation and its range of appeal.

The legends of King Arthur were slow to return to public attention. Although people could read about them in the essays by Warton, Hurd, and Percy, no complete, popular publication of the saga was readily available. Malory's *Morte Darthur* had been out of print since 1634, but by the turn of the century, it was evident that a new edition would be well received. In 1807, an eager public welcomed the news that Walter Scott, known by his dual reputation as antiquarian and romance writer, planned to edit a new version of Malory's classic. His project never materialized. Robert Southey, the poet, began to prepare a manuscript for the publisher Longmans, but his project, too, was shelved. Even though these two efforts failed, new editions of the Arthurian saga appeared in 1816. These were simple, inexpensive, and poorly edited works, but the public demand made them a popular success.[11] Perhaps their popularity inspired Southey, now poet laureate, to revive his plans, for in 1817, Longmans published his manuscript, based on the Caxton publication of 1485, in two deluxe—and expensive—quarto volumes. *The Byrth, Lyf, and Actes of King Arthur* offered the fullest account of the medieval legend to date. The king's saga, if not the king himself, had returned to Britain.

But what of the king's promise of return? In the late 1760s, John Hamilton Mortimer painted a telling subject. That work, *The Discovery of Prince Arthur's Tomb by the Inscription on the Leaden Cross*, cannot be located, but the image exists in several preparatory drawings and an engraving. It illustrates the discovery of the king's tomb at the abbey of Glastonbury. Two workmen, still standing in the open grave pit, rest after their labors, while a monk traces the worn inscription with his finger. A diverse crowd of onlookers listens intently for the translation of the ancient epitaph. The focus of their fascination is the leaden cross, not the mythic king. For Mortimer's generation the relics of the past were more enticing than the prospect of the return. The Gothic Revival cultivated a climate in which the Arthurian legend could be recovered, but recovery was not revival. Like an age-old artifact, the words of the legend were excavated, cleansed of the dust of the centuries, and placed on display for an admiring audience. Enthusiasm and scholarship created a public who could recognize and appreciate the "style of those heroic times." But, to them, Arthur appeared as an ancient relic, an emissary from the distant past, unchanged through time. The promise of return required a transformation of the king, and that challenge would be met by future generations.

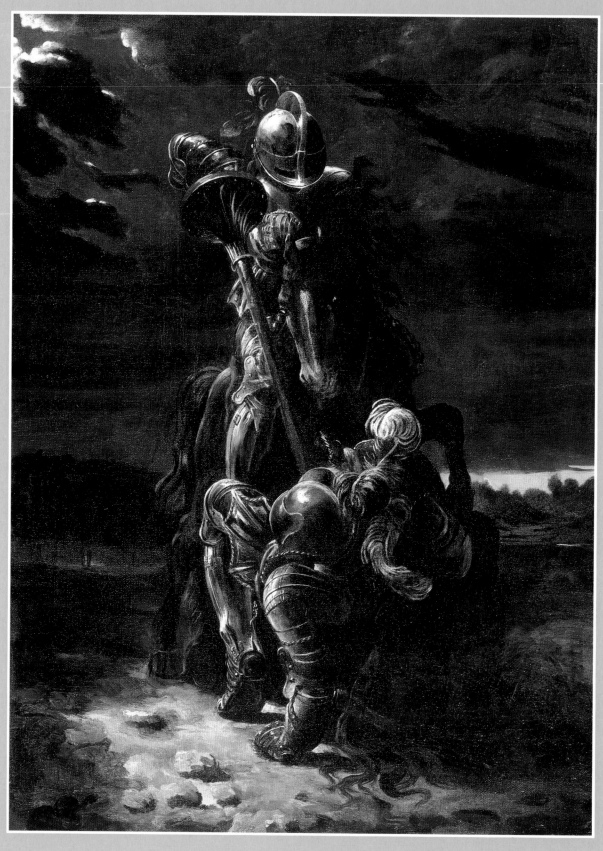

Daniel Maclise. *The Combat of Two Knights*. Undated. Oil on canvas, 24¾ x 19¼″. Private collection. Courtesy of Christie's Images, London

For Queen and Country

Our father's swords are on the wall,
Their blades with rust o'erspread;
And oft these sloth-dimmed brands recall
The memory of the dead.
For spirits linger round the spot,
And mourn for ages flown,
When brightly flashed those weapons forth,
For the altar and the throne.

Daniel Maclise (1835)

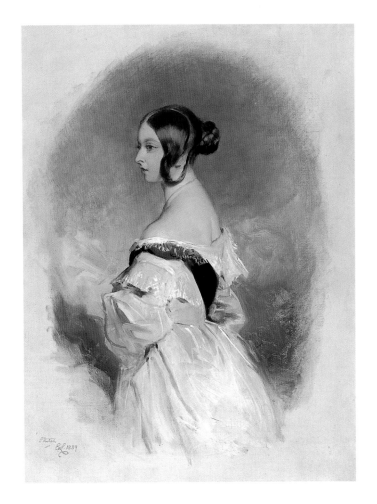

Edwin Landseer. *Queen Victoria*. 1839. Oil on canvas, 16 x 12″. The Royal Collection, © 1994 Her Majesty Queen Elizabeth II

From the dawn of the Arthurian tradition, Arthur was summoned from Avalon in times of national need—until the nineteenth century. Then, the Victorians roused Arthur to celebrate victory rather than to divert defeat. The Victorian era, in contrast to times past, enjoyed peace, stability, and expansion. In the European theater against Napoleon, Britain's military might proved invincible. In colonial territory, Britain's domain was unsurpassed. In the global economy, Britain's markets reigned supreme. And, in the enduring strength of the monarchy in a century of change and revolution, the population maintained a sense of continuity unequaled in the Western world. When the Victorians summoned Arthur out of Avalon, they were not in need of his service. On the contrary, they believed that their time would at long last offer Arthur the realm he deserved.

And the men of Britain were ready and eager for noble service. Inspired by the new popularity of romance literature, brought back to currency during the Gothic Revival, British gentlemen saw themselves as the modern counterparts of medieval knights. Embracing a code of ethics based on hierarchy and obedience, privilege and responsibility, generosity and fair play, modern men created their own order of chivalry. In fact, the revived code of behavior was as different from the original standard as Fleet Street was from the tilting field. Like the Gothic Revival castle, built brand-new for modern use, the medieval knight was recast in a modern image, better suited to its purpose than the original would have been. Contemporary gentlemen saw themselves reflected in the shining armor of their ancestors and were pleased by what they saw. Through identification and imagination, they transcended the prosaic present. They, like their nation, deserved such a leader as Arthur.

Modern Britain was too strong and too secure to require the inspiration of an ancient king to ensure future triumphs. But, as a symbol of chivalry and monarchy, the Once and Future King found a special mission in the present. For Britain was ruled by a

woman, and her protection and support, in reality and in metaphor, was the nation's foremost concern. In 1837, when Queen Victoria ascended to the throne, she was little more than a girl. Just nineteen years old, tiny in stature and delicate in appearance, she seemed more the heroine of a medieval romance than the leader of the most powerful nation in the world. In the men of modern Britain she found her protectors, and in the Once and Future King she found her symbolic consort. Through poetry and painting, in public works and political propaganda, Arthur's image encoded a national ideal. Desired to serve queen and country, Arthur stirred in Avalon and returned to the nation.

During the Gothic Revival, a gentleman who wished to live in a medieval castle could, with a bit of money, a clever architect, and a leap of the imagination, make his dream a reality. But if that modern gentleman wanted to transform himself, he faced a harder task. Although he could veneer his home with medieval trappings and continue to live with his accustomed comforts, he could not don the armor of his ancestors and conduct his daily business. That transformation had to be substantive rather than superficial. Nevertheless, the challenge was undertaken, and men looked to the heroes of chivalry as models of manly behavior. And, as modern men strove to be like ancient knights, a curious turnabout occurred. It was the image of the knight that saw the greater change. He was reinvented as a modern gentleman.

The promotion of chivalry as an ideal for manhood began, perhaps unintentionally, with the recovery of romance literature in the eighteenth century. In *Letters on Chivalry and Romance* (1762) Richard

Henry Justice Ford. Title page, *The Book of Romance*. London: Longmans, Green, 1902. Courtesy of The Newberry Library, Chicago

Hurd sought to give the public the interpretive means to appreciate the poems and legends of arcane times. In this he succeeded, but he also provided his readers with an image of the knight as a supreme romantic hero. Through explanation and example, Hurd portrayed an ideal form of manhood, embodied in the chivalric knight and inspired by the institution of chivalry. That this ideal was the creation of literary fiction rather than historical fact was of little consequence to Hurd or his readers. The image of a man whose high sense of honor led him to defend the powerless, face the tyrannical, and fight for the glory of his faith and his nation was far too persuasive.

Hurd had intended his *Letters*, a collection of twelve essays on the appreciation of medieval literature, as background reading for the romance enthusiast. But his method burnished his material and gave the dusty old tales an irresistible aura of heroic attraction. For example, he traced the origins of knightly behavior to the "love and exercise of arms" that distinguished the men of the tribal communities of ancient Germany and Britain. But these warriors possessed more than martial skill. They obeyed a code of honor that restrained their ferocity and tempered their treatment of enemies and inferiors alike. By the Gothic era, the warriors had become knights, inspired by "the passion for arms, the spirit of enterprize, the honour of knighthood . . . in short,—everything that raises our ideas of the prowess, gallantry, and magnificence of these sons of Mars." Hurd saw a parallel between the Greek hero and the chivalric knight, but he found the latter more admirable in his "passion for adventure" and his "utmost generosity, hospitality and courtesy." He even asserted that had Homer "seen in the west

the manners of the feudal ages," he too would have acknowledged their superiority to those of his own times. Hurd denied any desire to return to the age of chivalry, claiming that "Gothic manners" never "did subsist but once, and are never likely to subsist again."[1] But his image of the man who practiced those manners was enthralling, and readers turned to Hurd for his inspiring evocation of manly virtue rather than his pedantic literary instruction.

The next generation of scholars continued Hurd's practice of promoting the literature by praising its heroes. George Ellis, for example, gathered and researched medieval prose romances and published the three-volume anthology *Specimens of Early English Metrical Romances* in 1805. Ellis was an impeccable scholar, and his collection offered the most extensive survey of the literature to date. But Ellis's focus was on the hero of each tale, and whether the romance spoke of Arthur's battles or Richard Coeur de Lion's crusades, the protagonist in his shining armor cast the rest of the saga in shadow.

Unlike Hurd, who felt compelled to persuade his audience to read authentic sources, Ellis provided modern versions of medieval literature. In clear, contemporary language, he told stories, filling in narrative gaps and explaining antiquated references. When he discussed a supernatural occurrence, such as the ebb and flow of Gawain's strength with the rise and the set of the sun, he related it in such a matter-of-fact tone that even the fantastic seemed possible.

The strength of Gawaine, though always surpassing that of common men, was subject to considerable oscillations depending on the progress of the sun. From nine in the morning till noon, his muscular powers were doubled; from thence till three o'clock, they relapse into their ordinary state; from three till the time of evensong they were again doubled; after which the preternatural accession of strength again subsided till day break.[2]

As Ellis told it, Gawain's clockwork prowess seemed as natural as any man's work schedule. Through language and logic, Ellis established a parallel between his reader and his hero. These same qualities brought a wider audience to romance literature. The popularity of Ellis's *Specimens* reached the young and old, the scholar and the enthusiast. Ellis expanded the audience for medieval romances, and, like Hurd, he connected the study of chivalric knighthood with a modern idea of perfected manhood.

The interest and admiration sparked by the scholarly studies of chivalry turned into inspired identification through the poems and novels of Walter Scott. More than any other writer of the times, Scott convinced his readers that only the centuries separated the ancient knight from the modern gentleman. Scott was a masterful storyteller, but more than that, he crafted a medieval world that felt both authentic and familiar. His readers believed they could enter that world with ease. But the real key to Scott's popular success was in his characterizations. Vividly drawn and romantically appealing, his characters spoke in plain language and felt genuine emotions. They were idealized envoys from the golden age of chivalry, but to Scott's readers they seemed as real as contemporaries.

Scott's reputation as an antiquarian persuaded his readers to accept his historical fiction as history. His own interest in the Middle Ages began in boyhood, but when he encountered the scholarly treatment of medieval ballads in Percy's *Reliques of Ancient English Poetry* he found a way to combine his enthusiasm with serious endeavor. "It may be imagined," he wrote, "but it cannot be described, with what delight I saw pieces of the same kind which had amused my childhood, and still continued in secret Delilahs of my imagination, considered as a subject of sober research."[3] Scott contributed to the study of the literature he so loved, editing the romance *Sir Tristrem* for publication in 1804 and planning a similar treatment of Malory's *Morte Darthur*. In 1814, full recognition for his expertise on the subject came when he was invited to contribute the essay on chivalry to the fifth edition of the *Encyclopedia Britannica*. As his popularity as a poet and novelist grew, he set his scholarly projects aside, but his position as an authority never diminished. His medieval novels—*The Abbot* (1820), *The Monastery* (1820), *Quentin Durward* (1823), and most notably *Ivanhoe* (1819)—combined the results of serious study and gifted imagination. And his readers accepted his invention of the Middle Ages as if it were the truth.

The best loved and most persuasive of these

novels was *Ivanhoe*. Appealing to the widest audience, it received critical acclaim and was so popular that three editions appeared within the first two years of its publication. The narrative was entrancing; high adventure combined with romance kept the reader turning pages. The ethics of *Ivanhoe* were simple and satisfying. Good knights challenged evil knights, and the good knights triumphed. The strong protected the weak and, in every case, transgressions were punished. In the world of *Ivanhoe*, it was chivalry that ensured peace, stability, justice, and even romance. Through rich and vital storytelling, Scott convinced his readers that the chivalric ideal existed in a distant reality. And if it existed once, perhaps it could exist again.

Wilfred of Ivanhoe, the hero of the tale, bridged the chasm between medieval idealism and nineteenth-century reality. He was young, handsome, strong, and earnest. His dedication to his chivalric code was unwavering and his motives were pure altruism. Ivanhoe defeats corrupt adversaries, he defends the defenseless, he secures the lands of his thane Cerdic, and, in the end, wins the hand of the beautiful Lady Rowena, the daughter of his sovereign lord. Ivanhoe was the perfect hero, but his modesty and wide-eyed ingenuity made him seem like the boy next door. And Ivanhoe, in his strength, stalwartness, and success, called to modern youth to follow his lead, to adopt the inspiring force that led him to glory. Through chivalry, all was possible. Ivanhoe praised his code as "the nurse of pure and high affection, the stay of the oppressed, the redresser of grievances, the curb of the tyrant," and he firmly believed that "nobility were but an empty name without her, and liberty finds the best protection in her lance and sword."[4] The fantasies of young male readers turned toward imitation. They longed to be like Ivanhoe.

An eccentric writer of Scott's generation provided the instruction needed to transform the ways of chivalry into modern practice. When Kenelm Henry Digby published his first version of *The Broadstone of Honour, or Rules for the Gentlemen of England* in 1822, he was a little-known graduate of Cambridge University from a good family. His adolescent fantasies were fueled by Scott's poetry, and once at university, he began to act upon his dream of reviving chivalry. He resolved to be a modern knight and held

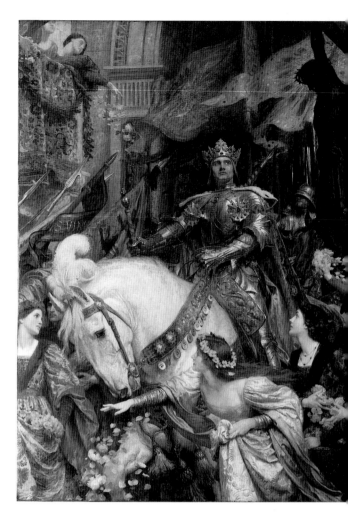

Frank Dicksee. *The Two Crowns*. Oil on canvas, 90⅞ x 72½″. The Tate Gallery, London

vigils in King's College Chapel as a testament of his devotion. He staged a solemn tournament, with "ponies for steeds and hop-poles for spears." After his graduation in 1819, he traveled the continent, looking for the sites of medieval battles and the shrines of the early church. His contemporary Edward Fitzgerald remembered his imposing appearance: "a grand, swarthy fellow, who might have stept out of the canvas of some knightly portrait in his Father's house—perhaps the living image of one sleeping under some cross-legg'd Effigies in the Church."[5] Digby believed himself the modern equivalent of a chivalric knight, and in his book he intended to teach his contemporaries how to implement the ancient code of honor in the present world.

Digby roused his readers, fellow English gentlemen, with a reminder of their identity.

You are born a gentleman. This is a high privilege, but are you aware of its obligations? It has pleased God to place you in a post of honour; but are you conscious that it is one which demands high and peculiar qualities? Such, however, is the fact. The rank which you have to support requires not so much an inheritance or the acquisition of wealth and property, as of elevated virtue and spotless fame.[6]

He argued that the destiny of the nation was in their hands for protection and perpetuation. They could choose to shirk their responsibilities or to emulate their ancient ancestors, acting as knights incarnate in a troubled world. Throughout his book, Digby calls up the names of the highest exemplars of chivalry—Arthur, Lancelot, Charlemagne, Richard Coeur de Lion, Ivanhoe—mixing the historical with the legendary. For Digby, and his eager readers, chivalry was no longer a subject for study and fantasy. It was a way to live in the contemporary world. In exciting terms he dares his readers to take up the challenge and build their lives on the models of valor and virtue from the pages of the chronicles and the romances. He offered *The Broadstone of Honour* as a guide for manly living, urging his readers to practice a new kind of chivalry, to be strong but gentle, firm but kind, forceful but charitable, noble but modest. He even listed the professions that gentlemen should follow. *The Broadstone of Honour*, with its high-minded message and its dense and proselytizing prose, is hardly read today, but for Digby's generation—and for two more to follow—it was a runaway best-seller. A second edition came out in 1823, and a new four-volume expanded version was published from 1826 to 1829. Other editions followed, and well into the Victorian era Digby's "how to" guide on knightly living convinced readers that chivalry was alive, well, and flowering in Britain.

When Kenelm Digby aimed his clarion call to chivalry at the sons of the privileged classes, he found a responsive audience. The new generation of landed gentry was eager to take up the challenge. Their parents, and even their grandparents, lived in Gothic

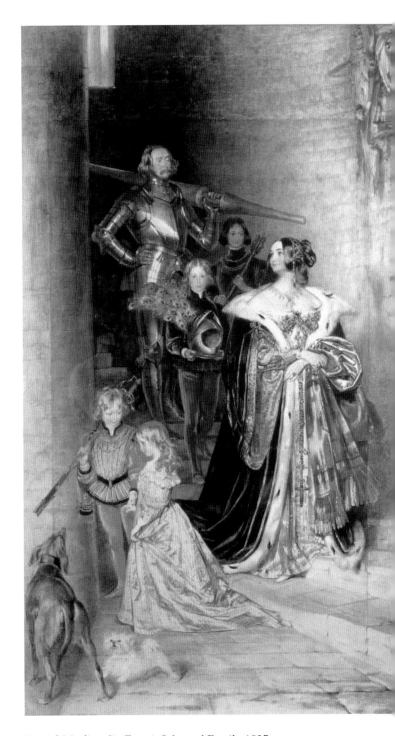

Daniel Maclise. *Sir Francis Sykes and Family*. 1837. Watercolor, 44½ x 25¼". Collection of Sir John Sykes, Bt.

Revival castles and cottages. Their ancestors' shrines reposed in their county churches and cemeteries. Their inheritance often included relics of the past: old paintings, manuscripts, tarnished swords, and armor. But their response took form in noble entertainments rather than in the revival of noblesse oblige.

Chivalric play had historical roots in Britain. Round Table tournaments amused courtiers during the late Middle Ages and well into the Renaissance. The tradition of the "King's Champion," in which an armed man interrupted the coronation banquet to challenge anyone who dared deny the right of succession of the new monarch, survived from Norman times through the sovereignty of George IV.[7] Now "medieval balls," portraits in costume, and an increased interest in ancient "collectibles" allowed the new upper classes once again to play at chivalry. In the 1820s and 1830s chivalry was all the rage. Upper-class gentlemen no longer merely dreamed of shining armor; they donned it for their own amusement. And the fashion spread to the continent. At the "Ivanhoe Ball," held in Brussels in 1823, invitations specified that guests appear as characters from the novel or in appropriate twelfth-century dress. Needless to say, many of these guests were British.

The popularity of armor collecting reached its zenith in this period. Ancient weapons and suits of plate or mail, more prized than ever, served as icons for the growing cult of chivalry. Private collections went on public display. As early as 1817, two large exhibitions vied for attention in London. Thomas Gwennap's collection graced the Gothic Hall on the Pall Mall, while a rival ensemble, belonging to William Bullock, shone in the Egyptian Hall in Piccadilly. In 1828, Samuel Rush Meyrick, the owner of one of Britain's most admired collections, put his expertise to work, designing a new installation for the royal holdings at the Tower of London. Commercial galleries followed the fashion during the next decade, and in 1838, Samuel Luke Pratt assembled a display of armor and weapons, set in a "truly Gothic apartment," featuring "six grim figures, in full armor," seated at a rustic table, "apparently in debate." Throughout its run in Lower Grosvenor Street, this exhibition enjoyed steady attendance by the general public.[8]

Fancy-dress balls gave the modern English gentleman a chance to play at chivalry for an evening. Portraits in armor preserved that conceit for posterity. In a painting commissioned from Daniel Maclise in 1837, Sir Francis Sykes and his family appear in full medieval costume. Sykes, descending the circular staircase of a rugged stone castle, is armed for battle. Ready to protect his family, he bears a mighty lance across his shoulder. His sons are knights in training. The older boys carry their father's helmet and sheaf of arrows, while the youngest boy, hoisting a sword, gestures in courtesy toward his sister. Lady Henrietta combines the fashions of both worlds; her fur-lined mantle parts to reveal a daring décolletage and a modern tight-laced bodice. For Sir Francis Sykes and his family, chivalry is more than a romantic ideal; it is the core of their identity as British nobility.

The summer of 1839 brought the promise of a public chivalric spectacle that would surpass those of memory and history. Archibald Montgomery, thirteenth earl of Eglinton, announced his intention to hold a tournament on his estate in Ayrshire. He rapidly put his plan into action, setting the date for 29 August and inviting like-minded men to take up arms and face the challenge. A "Queen of Beauty" was crowned, and a retinue of "fair maidens" was picked to inspire the contestants. The grounds of Eglinton Park, previously the site of summer races, were transformed by Samuel Luke Pratt into a vast tiltyard, and stands were erected to accommodate two thousand spectators. The whole population of Ayrshire was urged to don fourteenth-century costume and attend the games.

The London press followed the promotion of the Eglinton Tournament with eager—and mischievous—anticipation. Weekly practices in the manly art of combat, ostensibly held to sharpen the tilters' skills but expected to raise interest in the tournament, became a favorite topic for satire. After watching one group of knightly gentlemen demonstrate their prowess against padded mannequins, the reporter for the *London Times* wrote, "If these 'men at arms' are not a little more *au fait* when the 'Tournament' is to take place, they will be miserably defective in their imitation of the knights of 'olden times' . . . There were no serious accidents yesterday, and the whole business went off as such things usually do, somewhat dull and altogether silly."[9] Cartoonists also had their

fun depicting the modern-day knights astride hobby horses, partaking in "Eglintoun Tomfooleryment." As the day approached, many of the gentlemen withdrew their names from the lists; tilting proved much harder than it looked. The earl ignored the ridicule. Even the paltry turnout of thirteen men-at-arms could not dampen his spirits.

On the morning of 29 August, the knights, the ladies, and their armies of attendants readied themselves for the grand procession. The stands were packed with crowds from the far corners of the island, and even from the continent, who had poured into the county for a week. Mobs blocked the parade route, and it took over three hours for the participants to march the mile from the castle into the stands. But there was one factor that was never considered in the earl's meticulous plans. All morning a steady drizzle fell, and by the time the games were set to begin, the countryside was engulfed in a torrential Highland storm. The Queen of Beauty and her retinue ran for cover, as did some of the manly combatants. The stands creaked and shook and threatened collapse, and the crowds beat a hasty exit. Some knights were undaunted and attempted to carry the games forward, but the heroic spectacle turned into a sorry farce. One visitor recalled the scene.

> Clad in complete steel, with casque and nodding plume on his head, . . . the Marquis [of Londonderry], as far as looks went might have posed to an artist as a veritable reincarnation of a preaux chevalier, or a knight of olden times. But horresco referens! The rain beat so heavily upon him that his knightly nature could not endure it, and, to shield himself and his finery from the pitiless downpour, he hoisted a large umbrella over his head, and brought the fifteenth and the twentieth centuries into inharmonious juxta position.[10]

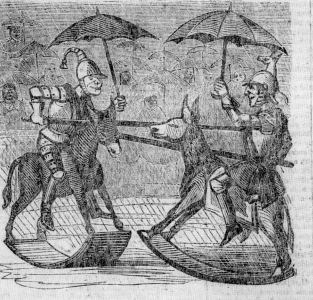

Aristocratic Sense, Or, the Eglintoun Tomfooleryment.

A tilting-match between the Earl of Eglintoun, Knight of the Cap and Bells, and the Marquis of Waterford, Knight of the Fives-Court and Knockers, mounted upon rocking-asses.

Eglintoun.—This is a reg'lar Scotch summer day, my lord marquis, rather a damper upon our fun, I guess. It's unfortunate, seeing that we *hereditary legislators* are only to be endured in society by our love for tinsel and mummery, which the world say are the only things we can comprehend; we ought to have such things complete, I trow.

Waterford.—I'm quite down through it, my lord; whether it be nonsense or mischief, I do like it in perfection,—anything *above* that is out of my line; as to *legislation*, and all that sort of d——d stuff, I leave that to the dummies and old women; we aristocrats were made for pleasures, and not for vulgar business and booby examples of morality.

"Aristocratic Sense; Or, the Eglintoun Tomfooleryment," *Cleave's Penny Gazette.* 14 September 1839. By permission of The British Library, London

Only a thin crowd assembled to watch the games rescheduled for the following day. The earl retreated in embarrassment and did not attempt a repeat performance of his grand plan to bring chivalry back to England. The Eglinton Tournament proved Richard Hurd correct in observing that "Gothic manners" existed only once and could never exist again. But out of the posture of chivalry came a new ethical practice, and within a single decade the arcane terms of the ancient institution were at long last translated into a modern vernacular.

Even before the Eglinton Tournament, the events of 1837 gave chivalric idealism its much-needed anchor in reality. In that year the mantle of state slipped onto the graceful, sloping shoulders of a childlike woman, barely out of adolescence. Young, dainty, pretty, and alone, Victoria moved from an obscure position in the line of succession to the center of a new cult of chivalry. Pushed by fate into a place of power that had daunted men twice and three times her age, Victoria appeared to her public as the

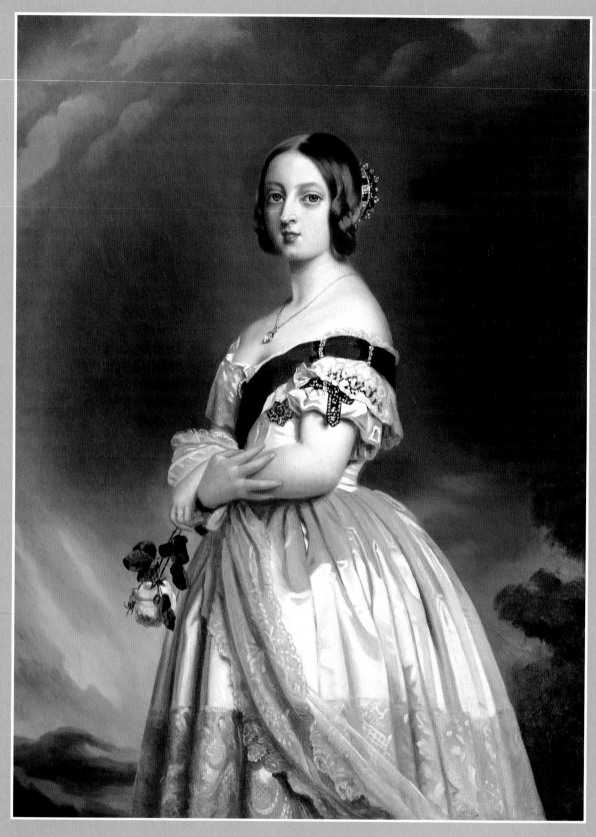

Franz Xaver Winterhalter. *The Young Queen Victoria*. Oil on
canvas, 23 x 17½". Courtesy of the FORBES Magazine
Collection, New York

perfect romantic heroine. Nature and circumstance cast her in that role, and the course of her early reign transformed the pretenses of the gentleman knight into the practical code for modern manhood.

The British welcomed their new sovereign with genuine warmth and affection but also with a sense of relief. The Hanover kings who had preceded her were distrusted and intensely disliked by their subjects. Through poor statesmanship, illness, and corrupt behavior, they had undermined the spirit of the country and placed the monarchy in jeopardy. George III (r. 1760–1820) lost the American colonies in 1776

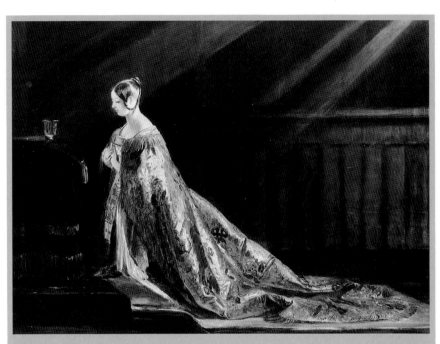

C. R. Leslie. *Queen Victoria Receiving the Sacrament.* 1837. By courtesy of the Board of Trustees of the Victoria and Albert Museum

and his sanity in 1811. During the last tormented years of his life, his eldest son ruled as regent. George IV (r. 1820–30) came to the throne with a reputation. He was known as a self-indulgent playboy, better suited to pursue sensual pleasure than rule a powerful nation. He drank, gambled, stuffed himself with rich foods, and built a hedonistic fantasy palace at Brighton. He openly kept a mistress, and shortly after his accession in 1820, arraigned his wife for adultery, a false charge that incited a public scandal. The poet Percy Bysshe Shelley painted a bleak picture of the late Hanover years.

> *An old, mad, blind, despised and dying King,*
> *Princes, the dregs of their dull race, who flow*
> *Through public scorn—mud from a muddy*
> * spring—*
> *Rulers who neither see nor feel nor know*
> *But leech-like to their fainting country cling.*[11]

During the reign of George IV, his brothers had made hasty marriages, but only one, the duke of Kent, had produced a child. When George died without a legal heir in 1830, his brother William IV (r. 1830–37), formerly the duke of Clarence, succeeded him. After an undistinguished career in the navy, William, the "Sailor King," came to the throne at an advanced age. Compared with his glutton brother, he seemed respectable, but he was a clumsy ruler who earned little respect from his government or his subjects. The duke of Wellington, a popular war hero and the prime minister of Great Britain, called the Hanover kings "the damn'dest millstones about the neck of any Government that can be imagined."[12] Few in the nation disagreed with him.

In the early hours of the morning of 20 June 1837, William IV died in his bed in Windsor Castle. The lord chamberlain and the royal physician were dispatched to Kensington Palace in London, to convey the grave news to the duke of Kent's widow, whose daughter, Alexandrina Victoria, was the next in the line of succession. Only nineteen years old, Princess Victoria was the new queen. She had been sleeping in her mother's bedchamber, a habit maintained from childhood, but when she received emissaries from Windsor in the palace sitting room, she received them alone. Within eight days, the coronation was held in Westminster Abbey. According to one observer, she entered the vast church as "gay as a lark . . . like a girl on her birthday."[13] But her

diminutive figure, swathed in the Parliament Robes of crimson velvet, trimmed with ermine and embellished with golden lace and tasseled cords, gave the crowds pause. Just as the massive robes of state enclosed her childlike body, her own slight form enclosed the fate of the nation. The little queen—girlish, fatherless, unmarried—stirred compassion as well as loyalty in the hearts of her subjects. As small as she was, she was ready to serve, but she seemed in need of protection. The gentleman knights of England now had their fair lady, and the new reign channeled romantic energy into practical service.

The chivalric spirit that fueled the warm reception for the new monarch ignited a firestorm in Parliament. A new party convened in the House of Commons; its founders were the youngest—and most radical—members of the Tories. They forged a program based on Neofeudalism, linking the rich and the poor in a benevolent socioeconomic dependency while impeding the middle-class rise to hegemony. Their symbol was the medieval knight and their slogan, "noblesse oblige" (nobility obligates). They called themselves Young England, and their vision of the nation's future creatively reenvisioned the nation's past.

The agenda of the Young England party was neither radical nor new. As early as 1832, the princi-

Contents page, *The Broadstone of Honour (in Four Parts)*. Volume 2. London: Bernard Quaritch, 1877. Courtesy of The Newberry Library, Chicago

ples of Neofeudalism were proclaimed in the pages of the Tory journal *Fraser's Magazine*. In regular features, Thomas Carlyle described a medieval system of equality and benevolence and Daniel Maclise illustrated the wealth and stability of "Merrie England" in poems and pictures. In the editorials, the journal's founder, William Maginn, challenged his readers to revive the old concept of noblesse oblige—the feudal belief that privileged status implies social obligation—and apply it to the welfare of the poor and underprivileged. The dire state of the nation's lower classes troubled Maginn, and he warned of a dark future built on urban slums, child labor, and appalling factory conditions. He proposed a new paternalism, in which the strong would protect the weak from the greedy abuse of urban industrialization and foreign importation. Maginn urged the Tories to take up his program. "Toryism ought to be a *protective* system . . . It ought to protect the agricultural labourer from the farmer, the factory child from the mill tyrant, the Spitalfields weaver from the competition of the men of Lyons; it ought to enlarge circulation; lessen in every way the surplus-labor which presses down the market; and never rest till general employment and fair wages were universal."[14] Nationalism, equity, and protection

were central to the *Fraser's* plan, and the ringing tones of Maginn's editorials appealed to the same audience that read Walter Scott and Kenelm Digby. But the journal's stance was neither pretense nor fiction. Rooted in real solutions and practical applications, it offered a plan for a new and better society.

The policy of the Young England party combined the *Fraser's* protective program with the chivalric idealism of *Ivanhoe*. In 1842, Lord John Manners rallied a small group of young high-minded members of Parliament to break from the Tory party and dedicate themselves to "a return to order, discipline and obedience, the preservation of established institutions, and a deeper reverence for ancient ways."[15] The founders of Young England came from privileged backgrounds; the one exception was Benjamin Disraeli, whose novels *Coningsby, or the New Generation* (1845), *Sybil, or The Two Nations* (1846), and *Tancred, or The New Crusade* (1847) recount the enthusiastic spirit of the party and its time. Young England launched Disraeli's political career, but it was Lord John Manners who articulated the party program. He sought to inspire the ancient families of England to take up their old responsibilities. Writing in his poem "England's Trust" in 1841, "Let wealth and learning, laws and commerce die, / But leave us still our old Nobility," he redefined the aristocracy as a resource, long untapped and neglected.[16] His formulation was simple: a program of welfare based on protectionism. And his model was the feudal system and its intricate chain of social obligation.

> *Let us show the people, i.e., the lower orders, by adding to their comforts and pleasures in the only legitimate way a legislature can do so,—viz., by voting money to build public baths, to keep up, or rather restore, public games, to form public walks, that we are their real friends. Let us give them back the Church Holydays, open the Churches and Cathedrals to them, and let our men of power in their individual capacities assume a more personal and consequently a more kind intercourse with those below them. In a word let society take a more feudal aspect than it presents now.*[17]

Armed with their noble names and lofty ideals, Young England's "knights" rode forth like their ancient

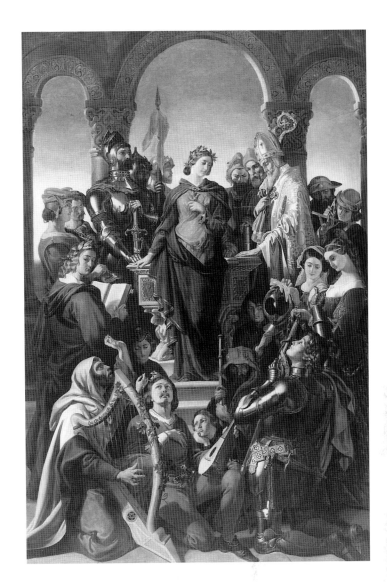

Daniel Maclise. *The Spirit of Chivalry*. 1845. Oil on canvas, 50 x 30½". Sheffield City Art Galleries

ancestors, righting modern wrongs with medieval methods. But contemporary politics defeated them. In 1846, Tory opposition over the repeal of the Corn Laws to alleviate the Irish famine drove Manners and Disraeli back into the mainstream of party politics and ended Young England's dream of a new and better nation.

The rapid rise and fall of the Young England party tarnished the Victorian knight's shining image, but the government rescued the symbol through appropriation. Twelve years earlier, the old Houses of Parliament burned to the ground and the new palace

at Westminster was nearing its final phase of construction. In 1845, the Lords Chamber was complete and ready for interior decoration. The Fine Arts Commission, a standing committee of members of both Houses and arts professionals, decided to embellish the walls with allegorical frescoes illustrating the principles that linked the government to the monarchy. They issued a statement describing their plan.

> *Six arched compartments in the House of Lords shall be* DECORATED *with* FRESCO-PAINTING; *that the subjects of these Fresco-paintings shall be personifications of Religion, Justice and the Spirit of Chivalry.*[18]

To the minds of the Fine Arts Commissioners, chivalry was a nonpartisan force, the same as justice and religion. In the modern sense, chivalry defined the service due to the monarch, and it was a national duty, not a class privilege. By including the subject in the fresco program, the government disengaged the symbol from its radical Tory connections. And by placing it in the Lords Chamber, where both Houses assembled to welcome the monarch in the annual opening parliamentary ceremonies, all who served in the government were reminded of their honorable—and venerable—obligation.

By choosing Daniel Maclise to paint the *Spirit of Chivalry* in the House of Lords, the government furthered its strategy of reappropriation. Maclise, long connected to *Fraser's Magazine*, enjoyed the friendship and patronage of most powerful radical Tories and their allies, including Sir Francis Sykes and Benjamin Disraeli. His reputation was built on paintings of "Merrie England" or traditional subjects, such as *The Chivalric Vow of the Ladies and the Peacock* (1835) and *Merry Christmas in Baron's Hall* (1838), and chivalric scenes and portraits, such as *Sir Francis Sykes and His Family* (1837) and *The Combat of Two Knights* (1841). Maclise competed with other artists for this prestigious commission, but he was clearly the government's favorite. He was the popular favorite as well. When his competition sketch appeared on public display in 1845, the critics raved. The *Athenaeum* proclaimed it the favorite of the show, and *The Art-Union* praised it as "a strain of purest poetry," asserting that it was "unquestionably

one of the most remarkable efforts of genius that has been produced in our time." Charles Dickens saw in it a complete vision of manly honor and virtue.

> *Is it the love of Woman, in its true and deep devotion, that inspires you? See it here! Is it Glory that the world has learned to call the pomp and circumstance of arms? Behold it at the summit of its exaltation, with its mailed hands resting on the altar where the Spirit ministers. The Poet's laurel crown, which they who sit on thrones can neither twine nor whither—is that the aim of thy ambition? It is there.*[19]

Maclise's original sketch is lost, but his first design is known through a finished oil sketch and a woodcut published in the *Illustrated London News*.[20] A demure woman, in modest robes and a Saxon cloak, personifies the spirit of Chivalry. Crowned with laurel and holding a lily to her breast, she reminds her followers that the pure heart is the path to victory. She places her right hand on the altar behind her, and those in her company join in the oath. To her right are stalwart knights, proven veterans of her order. To her left are members of the clergy and the government, beneficiaries of her service. Gathered on the steps to praise her are the historian, the troubadour, the bard, the poet, and the painter. At her feet, a novice knight kneels, ready to dedicate his life to her commands.

In 1848, when Maclise translated his sketch into a grand fresco in the Lords Chamber, a few of the details had to be altered to fit with the classical aspect of other works in the room's ensemble. The figure of Chivalry traded her medieval dress for a classical gown and her lily for another wreath of laurel. The elimination of several figures strengthened the composition and gave the personification greater emphasis. A Renaissance arcade with Corinthian columns replaced the Gothic colonnade behind the altar. But Maclise would not entirely relinquish his medievalized sentiment for classical detail. He twined ivy and passionflower around those classical columns and added the inscription "A Dieu et au Dame" to the novice's sword belt. In faith and in love for the Lord and the Lady, the government declared its terms of service. Chivalry was now the most noble law of the land.

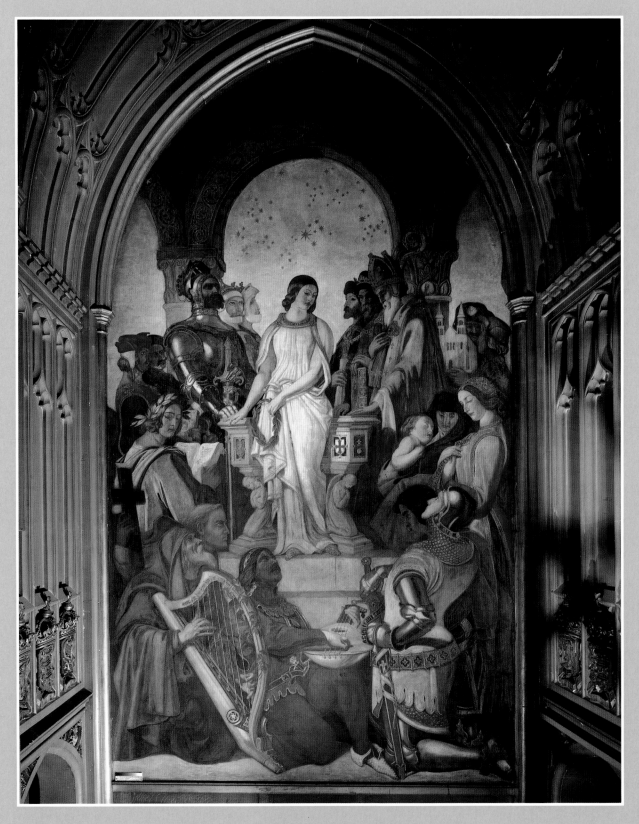

Daniel Maclise. *The Spirit of Chivalry.* 1848. Fresco,
16′ 4½″ x 9′ 4½″. Lords Chamber, Palace at Westminster,
London. Reproduced by kind permission of the House of
Lords

John Partridge. *Prince Albert*. 1841. Oil on canvas, 56½ x 44½″. The Royal Collection, © 1994 Her Majesty Queen Elizabeth II

below:
Franz Xaver Winterhalter. *Queen Victoria with Prince Arthur*. 1850. Oil on canvas, 23½ x 29⅝″ (oval). The Royal Collection, © 1994 Her Majesty Queen Elizabeth II

opposite:
Edwin Landseer. *Windsor Castle in Modern Times*. 1843. Oil on canvas, 44½ x 56⅝″. The Royal Collection, © 1994 Her Majesty Queen Elizabeth II

While the members of Parliament pledged fidelity to their sovereign at the altar of chivalry, Queen Victoria made her vows to another time-honored institution: domesticity. Victoria's marriage, and the production of a sturdy line of heirs, was the first order of her reign. The scandal of uncertain succession that brought her to the throne was, at all costs, to be avoided. Victoria approached her new duty with pleasure. In the first year of her sovereignty, she and her advisers considered and interviewed candidates from all the noble families of Europe. The pickings were slim, and Victoria's first choice, a tall, good-looking cousin from her mother's side of the family, seemed the most sensible and the obvious prospect. According to the historian Roger

Fulford, "It can be safely said that the other young bachelor Princes of Europe—the handsome but shifty Orleans princes, the slow-witted and deformed products of the House of Orange, or the other ponderous and boisterous princes of Germany—looked a dismally shabby lot beside the shining presence of Prince Albert of Saxe-Coburg-Gotha."[21]

Victoria married her handsome prince on 10 February 1840. Their first daughter, Victoria, the Princess Royal, was born before the year was out. Eight more healthy births followed: Edward, Prince of Wales (1841), Alice (1843), Alfred (1844), Helena (1846), Louise (1848), Arthur (1850), Leopold (1853), and Beatrice (1857). Motherhood suited the young queen, and when she was painted, she preferred being

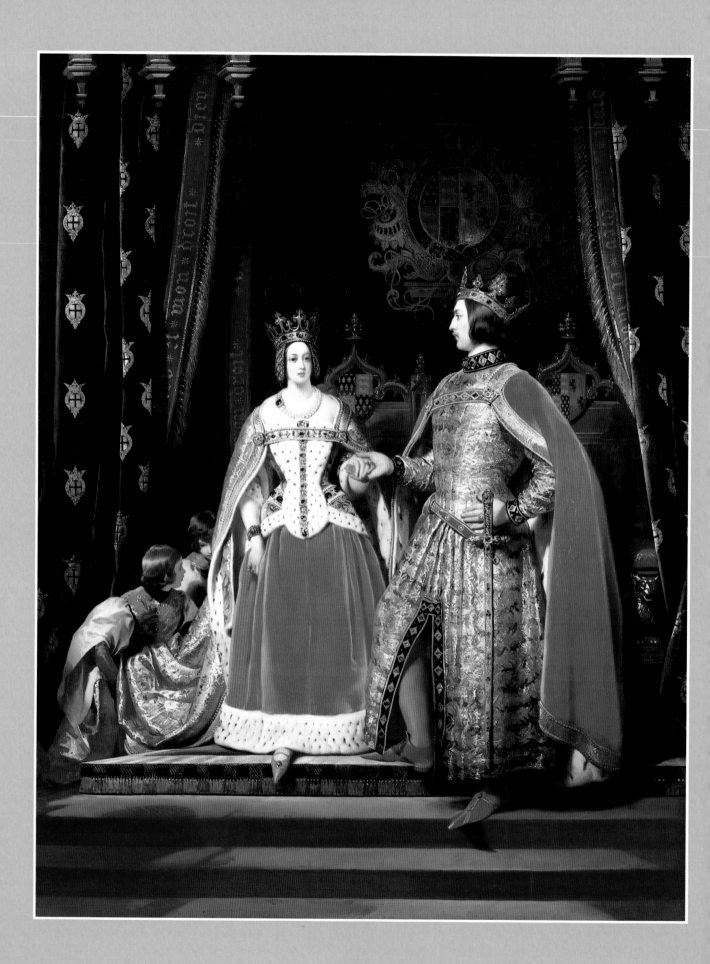

above:
Robert Thorburn. *Prince Albert at Age Twenty-four.*
1843. The Royal Collection, © 1994 Her Majesty
Queen Elizabeth II

opposite:
Edwin Landseer. *Queen Victoria and Prince Albert at the
Bal Costumé of 12 May 1842.* 1842. Oil on canvas, 56⅛
x 44″. The Royal Collection, © 1994 Her Majesty
Queen Elizabeth II

shown with her children. Typically, she appeared as a
royal madonna, holding her youngest child. In other
pictures, Victoria asserted that she was a good sub-
missive wife, no different from any other in the
nation. In Edwin Landseer's *Windsor Castle in Modern
Times*, Albert reigns as lord of the household. Just in
from hunting, he relaxes on a loveseat in a private
chamber in the royal home. Victoria stands at his
side. Coyly bowing her head, she gazes at her hus-
band in adoration. She hands him a nosegay, as if in
tribute to his manly performance at the shoot. The
Princess Royal and the family dogs play amid the
day's catch, spread on the rug at the prince's feet. In
works such as these Victoria defined her own role for
her public. Good wife, good mother, she presented
herself as the exemplar of domestic peace and joy.

Victoria's public image reflected the reality of
her existence, but that of her husband strayed far
from the truth. Despite the warm welcome he
received from his wife's subjects at the time of their
wedding, Albert failed to win public approval. During
their engagement, the queen warned him away from
politics, writing: "The English are very jealous of any
foreigner interfering in the government of this coun-
try, and have already in some of the papers (which are
friendly to me and you) expressed a hope that you
would not interfere." Excluded from politics, the
peerage, and even denied a reasonable allowance,
after only three months of marriage Albert lamented
that he was "only the husband, not the master in the
house."[22]

Although the xenophobic British public
believed Albert's presence would reintroduce the
Germanic tone of the Hanover dynasty into the
court, they had other reasons to be suspicious of the
prince from Saxe-Coburg-Gotha. Albert shunned the
sports and pleasures favored by the English aristoc-
racy. Despite Landseer's depiction of him as a great
hunter, he found leisure shooting distasteful. He had
never been in the military. Albert was an intellectual;
he preferred reading and high-minded discussion to
sport. He was an accomplished musician and artist,
and a gifted connoisseur. Before his engagement, he
had studied art history at the University of Bonn.
Quiet, intense, and sensitive, Albert was not the man
the populace desired as the consort for their queen.
The monarchy attempted to adjust Albert's public

William Dyce. *Hospitality: The Admission of Sir Tristram to the Fellowship of the Round Table*. 1859–64. Fresco, 11′ 2½″ x 21′ 9″. Queen's Robing Room, Palace at Westminster, London. Reproduced by kind permission of the House of Lords

image. In the spring of 1842, Albert attended a costume ball as Edward III. It was the queen's choice to see him as founder of the Order of the Garter and the commander of the victories in the Hundred Years' War. She designed his costume—and her own as Queen Philippa—and commissioned Landseer to commemorate their impersonation in a painting. Albert even sat for a portrait in armor. Although he contracted Robert Thorburn to paint the miniature in 1843, he only did so at the repeated request of the queen.[23] At first glance, it seems a typical chivalric conceit portrait of the 1830s: a straightforward, half-length presentation of the prince in plate armor. But there is no background narrative, no explanatory iconography to link the chivalric sitter with chivalric action. Instead, the message is simply that the sitter is worthy of his costume. To Victoria, Albert was a knight in shining armor, and this little painting remained her favorite long after the prince's tragic death in 1861. But to the public, Albert was neither knight nor consort, and certainly not the man they would have chosen for their queen.

If Victoria's real husband did not please her subjects, a symbolic marriage gave her the ideal con-

sort they desired. And Albert had a hand in the matchmaking. During the 1840s, Albert commanded one sphere of influence: he served as the president of the Fine Arts Commission. The interior decoration of the new Houses of Parliament came under his full jurisdiction. When he accepted the appointment in 1841, members of the commission believed that his role would be titular, but Albert undertook it with enthusiasm and energy, participating in every decision, large or small. As president of the commission, Albert carved out his own niche in the government, and he became widely respected as the unofficial minister of the arts in the nation.

In 1847, Albert settled an iconographic problem in the new palace at Westminster which had been an issue of contention from the earliest stages of the decorative program. The east wing, housing the Lords Chamber, the Royal Gallery, and the monarch's Robing Room, functioned as a theater of government ritual. Through its chambers and corridors, the reigning monarch processed in robes of state to greet an assembly of Peers and Commons at the annual opening session of Parliament. The decoration of the Lords Chamber and the corridors posed little problem; scenes of British history and allegories of governmental service offered appropriate subjects. But the monarch's robing room, small as it was, required special consideration. As the only room in the palace designated exclusively for royal use, it had to be grand and richly embellished. But it was also the site of a metamorphosis, where the reigning monarch shed his or her individual identity, donned ceremonial robes, and became a living symbol of majesty. It was in this guise—as monarchy rather than monarch—that the king or queen entered the Lords Chamber, affirming the power of the government to preside over issues of state. The chamber where this transformation took place held an exalted significance. It required a decorative scheme that reminded the monarch of his or her privilege and responsibility and wedded the nation's present and future with its glorious past.

Albert's idea can be traced to a casual conversation with an artist working at Osborne House, the royal retreat on the Isle of Wight. It was his habit to watch artists as they worked, asking questions, offering suggestions, and discussing issues of theory and practice. The artist William Dyce knew Albert well; he had been favored with royal patronage and enjoyed the respect and admiration of the prince. While Dyce was painting a grandiose naval allegory in the main stairwell, he and the prince reflected on the idea that other countries made excellent use of their national epics in art, but Britain neglected myth for history. At ease with Albert, Dyce moved into sensitive territory. He observed that "the stories of King Arthur . . . would supply to English Painters subjects of legendary history, which for their great interest, their antiquity, and national chivalrous character, would surpass those of the 'Nibelungenlied,' of which so much has been made by the Germans."[24] Dyce's comments about the Germans did not offend Albert; in fact, it stirred in him a desire to see his adopted country succeed, and even surpass, the achievements of the country of his birth.

Within a week's time, Albert appeared before the Fine Arts Commission and proposed that the Arthurian legend be used as the subject for the Robing Room decoration. He also recommended that Dyce be entrusted with the design and execution of the program, a choice that surprised the painter, for he believed Maclise was better suited to the challenge.[25] Absent from the British artistic repertoire for more than three centuries, the Arthurian legend would now be revived in the most important commission in the nation. After his initial hesitancy, Dyce immersed himself in the project. He read every available version of the legend, and after months of negotiations with the commission, he produced his plan. Rather than tell a story, Dyce proposed that "the Companions of the Round table [appear] as personifications of certain moral qualities . . . which make up the ancient idea of Chivalric greatness."[26] In five allegorical frescoes, Dyce constructed an ideal of monarchy, as seen in the acts of devotion, mercy, generosity, courtesy, and hospitality of Arthur and his knights. For the reigning queen, however, the image of the greatest ruler of Britain provided more than inspiring example. At home the queen was simply Victoria, a happy bride and mother, married to the husband of her choice. But in Parliament, she was monarchy, and in her Robing Room she joined with her ideal consort. She became the bride of Arthur.

Julia Margaret Cameron. "King Arthur," *Illustrations to Tennyson's "Idylls of the King," and Other Poems*. London: Henry S. King, 1875. Gernsheim Collection, Harry Ransom Humanities Research Center, The University of Texas at Austin

"Ideal Manhood Closed in Real Man"

There came a bark that, blowing forward bore
King Arthur, like a modern gentleman
Of stateliest port; and all the people cried,
"Arthur is come again."

Alfred Tennyson (1842)

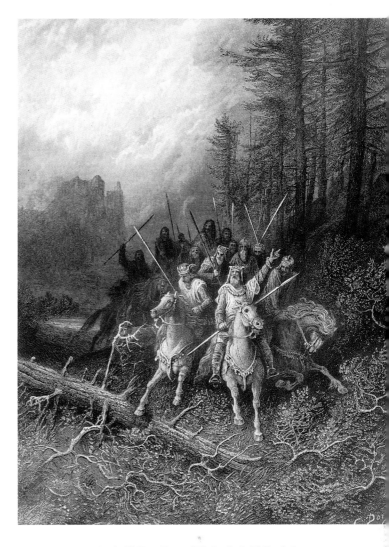

Gustave Doré. "And All Day Long We Rode," *Idylls of the King*. London: Edward Moxon, 1868. Courtesy of The Newberry Library, Chicago

Jf the medieval knights of the Round Table met the Victorian King Arthur they would take him for their sovereign in a single glance. His powerful form and noble bearing would recall Arthur's bravery in battle and his prowess on the field. He would have his magnificent armor, proud steed, and matchless weapons, and when he flashed his brand Excalibur, they would remember how he came to the throne and how he was born to rule. The winged dragons rearing on his shield and on his helm would present all the evidence they needed to confirm that the myth of return was fulfilled. Here, restored to strength and glory, was their Once and Future King.

Recognizing their legendary commander, they would ride with him and do his bidding. But, as they did, an element of strangeness would trouble their memory of their king. Had Arthur been so stern with them in past encounters? Had he always been so unforgiving of a misadventure or a romantic dalliance? Hadn't Arthur himself indulged in the pleasures of the senses? In the old days he reveled in the tales of love and conflict they brought back to court after a high adventure. Now, he judged every action according to a code, a moral code set and proven by the standard of his own behavior. Once Arthur had urged them to go off on quests, in search of honor and fame. Now he chastised them for pride and self-promotion.

Other differences would be evident. They would feel Arthur's presence more powerfully than they remembered. His voice now rang louder, it was more resonant, and it was heard more often. Their king had held court and waited to hear of their adventures. This king remained active throughout his rule and dominated his court in ways that were odd and unfamiliar. It would not take long for the medieval knights to question the identity of this man whose physique and trappings belonged to their king, but whose words and deeds were alien to the world they lived in. His medieval appearance was only a shell that housed a man of a very different time.

In "The Coming of Arthur" (1869) Alfred Tennyson told his readers how Arthur acquired his

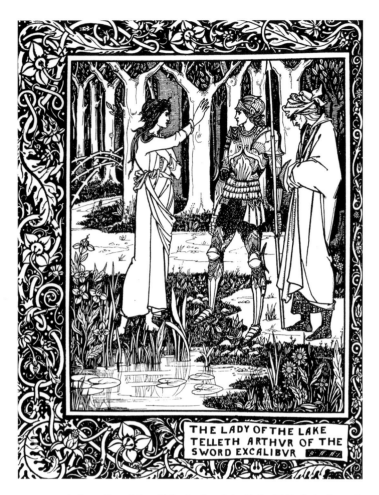

Aubrey Beardsley. "The Lady of the Lake Telleth Arthur of the Sword Excalibur," *Le Morte D'Arthur*. London: J. M. Dent, 1893–94. Courtesy of The Newberry Library, Chicago

sword Excalibur. On Merlin's advice he traveled to the shore of the mystic lake, and there it rose out of the waters "With Jewels on the rim, elfin Urim, on the hilt, / Bewildering heart and eye—the blade so bright" (ll. 298–99). He took it as his own from the hand of the Lady of the Lake, but in doing so he agreed to her pact of use and return. The terms of his obligation were inscribed on the blade: "On one side, / Graven in the oldest tongue of all this world, / 'Take me,' but turn the blade and ye shall see, / And written in the speech ye speak yourself, / 'Cast me away!'" (ll. 300–303). In rewriting the legend for his generation, Tennyson complied with this command. His source sprang from the language of his nation's origins, but his own creation spoke the prevailing vernacular, and when he gave his portrait of Arthur to his readers and to posterity he praised the king in the terms of a Victorian gentleman.

When the young poet Alfred Tennyson announced his plans to write an Arthuriad for his generation, his friends were skeptical. In the early 1830s, Tennyson was a recent graduate from Cambridge. In the course of his education, he had won prizes for his poetry and enjoyed some fame for his early publications. He circulated verses of a poetic fragment, "Sir Launcelot and Queen Guinevere," among colleagues at the university in 1830, and three years later, he wrote the first draft of "Morte d'Arthur." His plans were grand. He intended to recraft the whole legend for the modern world, a project he expected to take twenty years.[1] In fact, it took his lifetime.

The literary world also found the twenty-four-year-old poet's audacity astounding. Few of the era's great writers approached the venerable topic, and those who did, including Thomas Warton, Sir Walter Scott, Robert Southey, and William Wordsworth, interpreted only a portion of the legend or revived it as a relic of ancient literature. Since the time of Malory, no poet had succeeded in giving the legend life in contemporary language or relevance in contemporary life. Little wonder that Tennyson's plans were regarded lightly. Greater and more experienced writers had failed to revitalize the legend. How could a young and untested poet achieve the goal they could not attain?

But Tennyson did succeed. He wrote and refined his first Arthurian poems over the decade. In 1842, they were published as part of a two-volume collection, *Poems*. Some of them, including "The Palace of Art," "Sir Launcelot and Queen Guinevere," and "The Lady of Shalott," had appeared in print in earlier versions. But two poems, "Sir Galahad" and "Morte d'Arthur," made their public debut. "Sir Galahad," with its rhythmic alternating rhyme scheme and its bold and eager hero who attributed his great strength to his pure heart, was popular with the young and old alike. But the noble blank verse of "Morte d'Arthur," the saga of the king's fatal wounding and retreat, suggested that Tennyson had the potential to realize his dream.

Years passed before Tennyson returned to his ambitious project, and when he did, no one doubted his powers to bring the legend back to life. During that time he had earned wide respect and an honored reputation and, in 1850, the crown appointed him poet laureate for the nation. He demonstrated poetic scope and power, reflective in "Locksley Hall" (1842), lyric in "The Princess: A Medley" (1847), elegiac in "In Memoriam," and contemporary in "The Charge of the Light Brigade" (1854). But his yearnings were for the epic, and after a series of journeys to Arthurian sites—Glastonbury, Camelford, Tintagel—he began to write in earnest.

In 1859, four poems, "Enid," "Vivien," "Elaine," and "Guinevere," were published under the title *Idylls of the King*. Four more, "The Coming of Arthur," "The Holy Grail," "Pelleas and Ettarre," and "The Passing of Arthur," were added in 1869. "The Last Tournament" followed in 1871 and, in 1872, he published "Gareth and Lynette." In the same year he wrote a version of "Balin and Balan," but did not add the work to the *Idylls* until 1885. In 1886, Tennyson split the poem "Enid" into "The Marriage of Geraint" and "Geraint and Enid." He arranged his twelve Arthurian poems to describe a life cycle that corresponded with the cycle of seasons, the early tales of hope and promise set in spring, the stories of sensuality and passion in summer, the sagas of decay and decline in autumn, and the completion in barren winter. He framed the poems with a "Dedication" to Prince Albert, written in commemoration of his death in 1861, and the epilogue "To the Queen," written in 1872, underscoring the work's national significance. As late as 1891, the year before his death, Tennyson worked to change lines and refine the structure. Twenty years had stretched into sixty, but his contemporaries realized the magnitude of his achievement.

The poet Aubrey De Vere memorialized the laureate.

Julia Margaret Cameron. Portrait of Alfred Tennyson, "The Dirty Monk," *Illustrations to Tennyson's "Idylls of the King," and Other Poems*. London: Henry S. King, 1875. Gernsheim Collection, Harry Ransom Humanities Research Center, The University of Texas at Austin

> *Great Arthur's legend he alone dared tell;*
> *Milton and Dryden feared to tread that ground;*
> *For him alone o'er Camelot's fairy bound*
> *The "horns of Elf-land" blew their magic spell.*[2]

Had Tennyson lived to read De Vere's lines about his life's work, he would have been more dismayed than flattered. Although he saw Camelot as a mystical

place, a city "built / To music, therefore never built at all, / And therefore built for ever" ("Gareth and Lynette," ll. 272–74), its sovereign was a man with real weight and purpose. To convey this idea, Tennyson needed to convince his public of Arthur's mortal credibility, and he did so in 1842 with the publication of "Morte d'Arthur." With its framing poem, "The Epic," Tennyson's "Morte d'Arthur" sent a triple message to his audience. First, the prologue introduces the main poem as in the style of "heroic times," a single remnant of a twelve-part saga destroyed by its disillusioned writer. With this, Tennyson implies his own intention, to replace the lost work. Then, in the main poem, he reviews Arthur's history, from his rise to kingship through his fall from power, reminding his readers of the elements of the story and closing the cycle in compliance with tradition. Finally, in the epilogue, he brings Arthur back, greeted by cheering crowds. "And all the people cried, / 'Arthur is come again: he cannot die'" (ll. 346–47). But the king's appearance is startling, fully transformed. Now "like a modern gentleman / Of stateliest port" (ll. 345–46), Arthur signals his readiness to resume his rule. With these few lines Tennyson did what others had failed to do since the end of the medieval era. He reopened the cycle and called Arthur forward, taking him from the limbo of once and future, and positioning him fully in the present.

In remaking Arthur to conform to the times, Tennyson followed the venerable tradition. At the same time, the nature of this transformation reflected the vision and interest of Tennyson's culture. Two powerful forces influenced his work: the construction of ideal manhood and the practice of hero worship. The new image of Arthur drew more from these ideas than from the old saga; as habits of interpretation and reception, they linked the poet's creation with an understanding audience, ready to recognize, receive, and reverence their king.

Victorian society believed in the progression and perfection of human behavior. The direction of a life depended not on fate but on will, tempered by strong conscience and good intention. Any man could strive to be a good man, but he needed a standard of virtues to nurture and a code of ethics to obey. When the Victorians spoke of "manhood," they implied this

disciplined progression and perfection. To be a man, in the fullest sense of the word, was an honorable, even elevated, condition. An all-pervasive theme in Victorian culture, ideals of national manhood were forged in every realm of artistic and intellectual endeavor. In history, narratives of great men's lives illustrated the acts and attitudes that changed the course of events. In science, the theory of evolution did more than trace an organic chain of descent; it positioned man in a biological and progressive hierarchy. But even within the human race differences were drawn. The belief that the European was a higher form of man than the African or Asian shaped foreign policy, while differentiations between stations of birth informed attitudes at home. In the arts, no subject commanded more respect than the depiction of a noble man in high-minded action. Based in the era's intersecting needs to define national character and celebrate national heroes, the whole of the cultural discourse centered around a single question: "What makes a man?" Definition and example constructed an idea of manhood, a standard against which a Victorian man could measure himself.

The best of men were heroes, great men of the past and present, of fact and fiction, who, endowed with the manly qualities of energy, tenacity, intelligence, and discipline, rose above their peers, to serve, to lead, and to inspire. Victorian society celebrated its heroes and even worshiped them. Thomas Carlyle, only one of the many advocates for the practice, called hero worship "a most valuable tendency . . . the main impetus by which society moves, the main force by which it hangs together." He claimed that it was "instinctual, a source of strength in frail human nature," and he praised it as "the primary creed of an honorable society," a creed that would prove to be "the ultimate and final creed of Mankind."[3] For Carlyle's and Tennyson's public—and especially for their upper-middle- and upper-class male readers— hero worship was a potent force, inextricable from the inquiry into the nature of manhood. The man who could recognize and respect a hero could identify and cultivate the heroic in his own nature. To admire a hero was to learn from his example, stimulating one's own desire to emulate the highest standard of belief and action. And, to the Victorian mind, recognition of the hero was inseparable from identifi-

cation with the hero; it was the key to the construction of an ideal code of national manhood.

In presenting Arthur as a "modern gentleman," Tennyson gave his readers a hero they recognized; by constructing Arthur's character according to modern standards, he created a man with whom they could identify. Tennyson told his son that he kept to a singular vision of the Once and Future King which had come to him as a boy, on his first reading of Malory.[4] But, he knew that his king represented more than mere revival. In "To the Queen," the epilogue of the final version of the *Idylls*, Tennyson acknowledged the difference between his Arthur and "that gray king whose name, a ghost, / Streams like a cloud, man-shaped, from mountain peak, / And cleaves to cairn and cromlech still" (ll. 39–41). He also denied replication of the king as portrayed in "Geoffrey's book, or him of Malleor's, one / Touch'd by the adulterous finger of a time / That hover'd between war and wantoness" (ll. 42–44). His king lived a life without shame or sin. He governed his life by his conscience and put private pleasure aside for public good. The Victorian Arthur was the product of a perfectly regulated moral discipline and a fully evolved ethical standard. He was, in the poet's own words, "Ideal manhood closed in real man" (l. 38), and his life offered a pattern of action for modern men to follow.

In the *Idylls* Arthur lived in legendary times and undertook fantastic adventures. Knight, warrior, and king, Arthur enacted the romantic roles associated with the legend's tradition. But, like any other man, he had a job to do, a household to support, and a marriage to maintain. Here, the Victorian readers found Arthur's life as real their own. Governed by character and conscience, Arthur's heroic behavior in the more routine roles of life set a pattern for manhood that transcended time and circumstance. In the directed energy of his youth, his selfless public service, and his devotion to wife and family, Arthur's new audience found a timely answer to the question "What makes a man?" Arthur emerged as more than knight, warrior, and king; he appeared as breadwinner, public servant, husband, and father. These were the points of shared identity and most often illustrated by the painters who interpreted the legend. In the portrayal of an extraordinary man in ordinary circumstances—the passage to manhood, the work ethic,

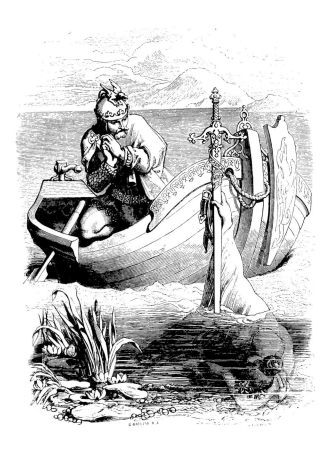

Daniel Maclise. "Arthur Obtains Excalibur," *Tennyson's Poems*. London: Edward Moxon, 1857. Courtesy of The Newberry Library, Chicago

the man's responsibility in the marriage and the household—Tennyson demonstrated the "ideal manhood" in the "real man," revitalizing the medieval king with a modern sensibility. In art, as much as in poetry, Arthur was the paradigmatic Victorian gentleman.

To the Victorian public, the events of Arthur's youth were summarized in a single subject: the Taking of Excalibur. Although Tennyson gives it only passing attention in the "Morte d'Arthur" of 1842 (a fuller account would be included in the *Idylls* in "The Passing of Arthur," published in 1869), his version cast the iconic form for the image. Tennyson presents the tale at the end of the cycle, as a memory of the "old days" told by Arthur to Bedivere before the king's departure to Avalon. Now at the end of his life, Arthur recalls where it all began, on a summer noon. He saw an arm rising from the lake, "Cloaked in white Samite, mystic, wonderful." The arm brandished a sword, and Arthur, recognizing his destiny in

that blade, took a boat, rowed to the center of the lake, and took what was offered, gaining his weapon and sealing his fate (ll. 80–86).

Daniel Maclise was the first artist to take up this theme. His work illustrated the "Morte d'Arthur" in a small, luxury edition of Tennyson's poems published by Edward Moxon in 1857. Two drawings were commissioned from Maclise to frame the poem, replacing "The Epic," which now served as a prologue. At liberty to select his subjects, Maclise chose the two landmarks of Arthur's life: how he obtained Excalibur and how he was taken to be healed in Avalon. Both images represent passage. In the first Arthur goes from youth to adult, in the second, from life to immortality. With one image conceived as practical and the other as romantic, Maclise captured the dual appeal of the Arthurian legend. The mystery of Arthur's retreat from the world sparked the imagination, but his transformation from boyish freedom to manly responsibility demonstrated an essential stage in the construction of manhood.

The composition succeeds in its masterful economy. Maclise positions the young king in his boat. Approaching the brandished sword, Arthur drops his oars and clasps his hands in reverence. He sees the Lady of the Lake beneath the water's surface, waiting for him to grasp his destiny. His awe, expressed in his hesitancy, suggests that he is fully aware of the obligations attendant to the magnificent magical weapon, and the eloquence of his powerful physique reveals his emotional tension. He leans toward the sword, but at the same time he recoils. This palpable, physical ambivalence speaks of the challenge before him. To take the sword is to take up its manly responsibilities. But, as Arthur's gaze follows the line of the blade and rests upon the Lady of the Lake churning below the waves, the transfer of power from one to the other occurs. No text is needed to confirm the act and its consequences. Arthur will take the sword and its obligations. With one gesture, Arthur becomes a man.

Maclise's image of Arthur obtaining his manhood along with Excalibur proved as influential as Tennyson's poem. In *How King Arthur by the Meanes of Merlin Gate His Sword of Excalibur of the Lady of the Lake* (1862), James Archer used an arcane title and

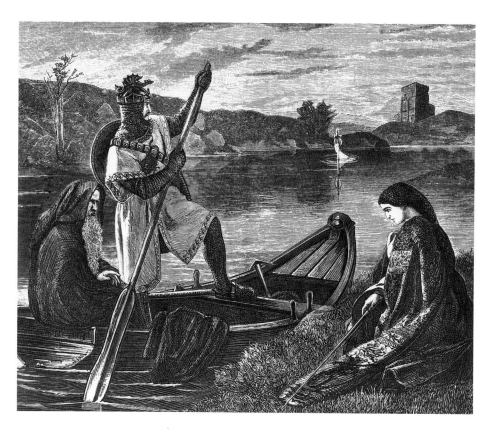

James Archer. *How King Arthur by the Meanes of Merlin Gate His Sword Excalibur of the Lady of the Lake*. 1862. Engraving after the painting by F. Kemplen. *Art Journal* 33 (April 1871). Courtesy of The Newberry Library, Chicago

opposite:
Joseph Noël Paton. *Sir Galahad*. 1879. Oil on canvas, 17 x 11½". Private collection. Courtesy of Christie's Images, London

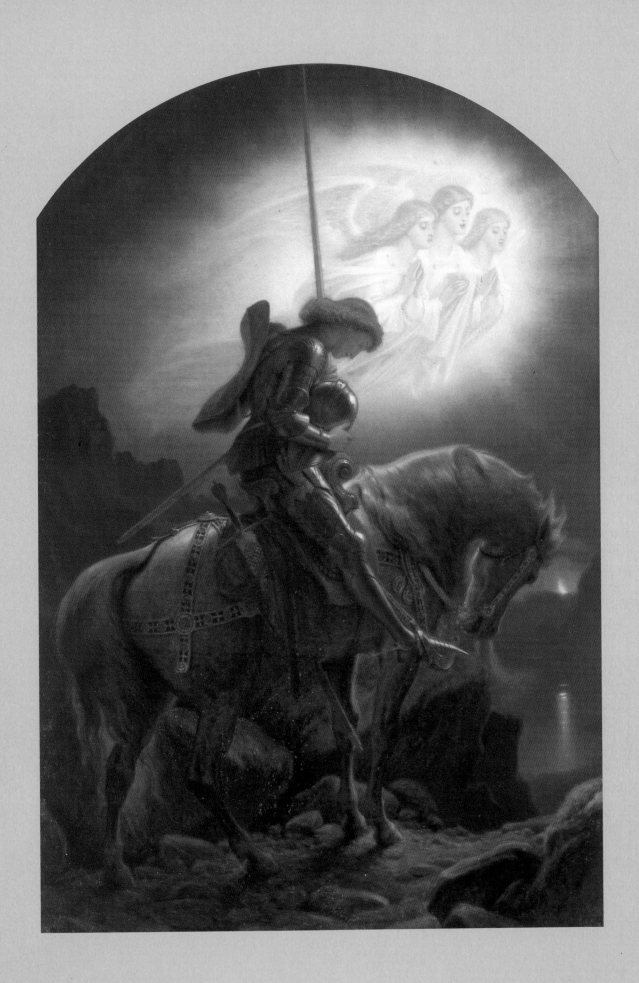

claimed a medieval text for his source, but the details of his imagery link his idea to Maclise and ultimately to Tennyson. Archer sees Arthur as a powerful man rather than as a youth gaining awareness of his potential. The firm stance and torque of his body are monumental; here is an athletic, classical hero disguised in medieval costume. The fierce profile, the muscular tension, even the drooping mustache suggest maturity, and like Maclise, Archer leaves no doubt that Arthur's passage from childhood to manhood is complete. But, unlike Maclise, Archer allows no moment of hesitancy. The single-minded tenacity of Archer's king is forged in the spirit of Tennyson's, whose altruistic vision had the passionate focus of a divine mission. In Victorian England, passage to manhood was defined by the ability of a boy to recognize the purpose of his life and direct all his energies toward achieving it. Arthur, taking up Excalibur, shows the youth of Britain the way.

It may seem curious that the young Arthur is always depicted in the physical form of a man. Towering in height, massive in breadth, bearded with a rugged, weathered visage, there is never a trace of callow youth in his appearance. Portrayals of other young knights, as seen in Joseph Noël Paton's *Sir Galahad*, allow for boyish beauty. Inspired by Tennyson's poem "Sir Galahad" of 1842, Paton gave the pure knight a slender body and a pretty face. He looks androgynous in his adolescence. This was neither accident nor artistic choice. Galahad, embodying the purity and the promise of youth, also encoded an arrested development. He would obtain the Grail, but he would never know a woman. He would never head a household and he would never lead other men. In short, to the Victorian mind, Galahad would never be a man. He was condemned to perpetual boyhood. In stark contrast, Arthur's manly form and mature countenance assured his audience that he—like them—would follow a natural cycle of life. His body was a symbol for manhood; strength, power, maturity were the hallmarks of his iconography.

With Excalibur in hand, Arthur entered the world of manly responsibility, defined by work and marriage. These provided the shape and security of Victorian society. Conducted in the public sphere, work cast and measured a man's character. More than simply a means to fill time or earn a wage, a man's work gave him a useful role in the community. Without work, a life was wasted. In the sermon "God's Will the End of Life," Cardinal Newman asked, "Why were we sent into the world? . . . To live for ourselves, to live for the lust of the moment . . . without any aim beyond this visible scene?" And his answer proclaimed life's purpose: "Every one who breathes, high and low, educated and ignorant, young and old, man and woman, has a mission, has a work."[5] In Carlyle's view, "a man that can succeed in working . . . is always a man."[6] The literary historian Walter Houghton commented that "except for 'God,' the most popular word in the Victorian vocabulary must have been 'work.'"[7] A man knew his job and did it well, wholeheartedly, and he never spared self in the face of duty. Among the best of men, work was not an activity, it was a virtue.

If work defined the public sphere, marriage distinguished the private domain. Home and family were central to the Victorian moral order, and the core of a good home was a good marriage. Home and family anchored a man, tempered his passions, and renewed his spirit. More than a place for a night's rest, home provided a haven from the daily grind, and marriage supplied the love and support needed to face the rigors of the working world. John Ruskin envisioned the perfect home.

> It is the place of Peace, the shelter, not only from all injury, but from all terror, doubt, and division. In so far as it is not this, it is not home; so far as the anxieties of the outer life penetrate into it, and the inconsistently-minded, unknown, unloved, or hostile society of the outer world is allowed by either husband or wife to cross the threshold, it ceases to be home.[8]

While Ruskin charges both man and woman to guard peaceful domesticity by maintaining private sanctuary, home measured the woman the way work measured the man. It was her job to guarantee that the home provided what he needed: a private domain, a personal retreat from public life, and a place of restoration for the body and the soul. The wife's worth grew in proportion to her meeting her husband's needs; *his* comfort, *his* wishes, *his* pleasure, *his* ambition constructed her destiny and tested her accomplishment.

In its finished form, the *Idylls of the King* opens with Arthur embracing the markers of manhood in work and in marriage. "The Coming of Arthur" tells of a nation in waste and ruin, torn by the conflicts of petty kings and devastated by waves of heathen hordes. Men lost their humanity and turned to bestial ways. In the land of Cameliard, King Leodogran, driven to despair, called upon Arthur, newly crowned but not yet tested, to fight the forces that struck from all sides, pleading, "Arise, and help us thou! / For here between the man and beast we die" (ll. 44–45). Arthur came, he fought and prevailed, conquering foe after foe, gaining strength with each battle and new allies with each victory. And the challengers fell.

> *Carados, Urien, Cradlemont of Wales,*
> *Claudius, and Clariance of Northumberland,*
> *The King Brandagoras of Latangor,*
> *With Anguisant of Erin, Morganore,*
> *And Lot of Orkney.*
>
> (ll. 111–15)

With his knights of the Round Table, Arthur triumphed. Bringing peace to the land and unity to the nation, Arthur succeeded in the challenge of his work: he "made a realm and reign'd" (l. 18).

But Arthur found no pleasure in his victory. "What happiness to reign a lonely king?" (l. 81). He yearned for a wife, for Guinevere, Leodogran's daughter, whose beauty inspired him in battle after battle. Without her, his efforts meant nothing.

> *For saving I be join'd*
> *To her that is the fairest under heaven,*
> *I seem as nothing in the mighty world,*
> *And I cannot will my will nor work my work*
> *Wholly, nor make myself in mine own realm*
> *Victor and lord. But were I join'd with her,*
> *Then might we live together as one life*
> *And reigning with one will in everything.*
>
> (ll. 84–92)

Arthur built his kingdom and wed his wife, but a bad marriage undid all his good works and brought the nation back to ruin.

In the traditional story, Guinevere betrays her marriage vows, driven by her adulterous love for

ARTHUR AND GUENEVERE
KISS BEFORE ALL THE PEOPLE

Henry Justice Ford. "Arthur and Guenevere Kiss before All the People," *The Book of Romance*. London: Longmans, Green, 1902. Courtesy of The Newberry Library, Chicago

Lancelot. From his first appearance before her, Lancelot plays the perfect courtly lover, risking life, limb, and honor for her whims and her attention. Courtly love heated into romantic passion, and the knight, performing feats of courage to amuse his lady, became her lover as well. Arthur looked the other way. But Mordred, Arthur's malicious illegitimate son, acting upon his desire for power and his hatred of Lancelot, exposed the affair and forced Arthur to declare war upon his favorite knight and charge his wife with treason. It was not Guinevere's betrayal that devastated the kingdom, but the way her betrayal was used against the king.

Although the Victorian story preserves the traditional account, it judges Guinevere's role by a different ethical standard. Guinevere bears the full brunt

above left:
Eleanor Fortiscue Brickdale. "As in the Golden Days,"
"Idylls of the King" by Alfred Lord Tennyson. London: Hodder
and Stoughton, n.d. Private collection

above right:
Eleanor Fortiscue Brickdale. "The sombre close of that
voluptuous day," *"Idylls of the King" by Alfred Lord Tennyson*.
London: Hodder and Stoughton, n.d. Private collection

opposite:
Florence Harrison. "She made her face a darkness from the
king," *Tennyson's "Guinevere" and Other Poems*. London:
Blackie and Son, 1912. Courtesy of The Newberry Library,
Chicago

of the blame. Long before Mordred confronts Arthur with the harsh reality of the adulterous love, rumors about her infidelity poison the court. Geraint, fearing that the rumors are true, comes to doubt his own wife Enid's fidelity and puts her through trials of devotion that nearly cost her life. Young Pelleas comes to Arthur's court in innocence but falls under the spell of a cold, arrogant beauty, Ettarre, and longs to make her his Guinevere. "I love thee, tho' I know thee not. / For thou art fair and pure as Guinevere . . . For I will be thine Arthur when we meet" ("Pelleas," ll. 41–42, 45). His declaration is truer than he expects, for once they become lovers, she betrays him. Even Tristram, crafted by tradition as a victim of star-crossed love, bears the marks of corruption. In Tennyson's poem "The Last Tournament," Tristram is exposed as a cynic, devoid of soul or conscience. An advocate of free love, he sheds responsibility and blame for his blatant adultery with Queen Isolt, chiding Lancelot to follow his example. "Great brother, thou nor I have made the world; / Be happy in thy fair Queen as I in mine" (ll. 203–4). Guinevere's behavior set a pattern. Her disdain for her vows and her responsibilities sparked the flames of conflict and betrayal that engulfed Arthur's kingdom.

Nowhere is this more vividly portrayed than in Tennyson's idyll "Guinevere." The setting is a modest chamber in Almesbury Abbey. The chain of events that brought Guinevere to seek sanctuary with the holy sisters is told in rapid sequence. Mordred spies on Lancelot and Guinevere. Unnerved, they try to sever their attachment. They share a chaste and final farewell but are caught, and Lancelot's fierce defense gives truth to a false charge that Mordred found them in the heat of passion. Before Arthur can confront her, Guinevere flees to the abbey. She hides from the court, but she cannot escape her husband's wrath. As she reflects upon her life, torn between her passion and her guilt, a cry is heard from the outer corridor, "The King!" (l. 408). Ringing steps mark his progress down the gallery, and when the door flies open, Arthur—armed for battle—bursts into the chamber with his anger and his accusations.

In a long, impassioned speech, Arthur confronts Guinevere. The scene is Tennyson's invention; there is no medieval equivalent to it, and through his own words Arthur defines and defends his manhood

James Archer. *The Parting of Arthur and Guinevere.* 1865. Oil sketch. Private collection. Courtesy of the FORBES Magazine Collection, New York

from his wife's corruption. He has come from his battle with Lancelot, which ended in an act of knightly courtesy—Lancelot spared his life—rather than decisive victory. Now he prepares to face Mordred, who has usurped the kingdom in his absence, and Arthur senses that the upcoming conflict will, as prophesied, mean his doom. But now, he confesses, he has little desire to live, and he blames both the events and his despair on Guinevere. "Thou hast spoilt the purpose of my life" (l. 450). He reminds her of the chaos at the dawn of his reign, of the beastlike men who terrorized her father's kingdom. He recounts his own victory, how the warring realms made peace and enjoyed unity, how he founded the Table Round, "A

Henry Justice Ford. "Sir Mordred," *The Book of Romance*. London: Longmans, Green, 1902. Courtesy of The Newberry Library, Chicago

glorious company, the flower of men, / To serve as a model for the mighty world" (ll. 461–62). He swore each of his knights to a set of oaths, "To reverence the King as if he were / Their conscience, and their conscience as their King" (ll. 465–66). With his rules and his loyal order of knighthood, he achieved his purpose to make a realm and reign.

But, looking back, Arthur sees that her sin with Lancelot struck the first blow to his realm. Others followed: Tristram with Isolt, Pelleas with Ettarre, and others, "Following these my mightiest knights, / And drawing foul ensample from fair names, / Sinn'd also, till the loathsome opposite / Of all my heart had destined did obtain, And all thro' thee!" (ll. 486–90).

Guinevere, in failing to honor her vows to her husband and her duty to her king, defied her obligation as wife and queen. Her defiance ran counter to Arthur's efforts—spoiling the purpose of his life—and she undid his work, returning his realm to the broken, bestial state in which he found it and from which he thought he had saved it. She wrecked his kingdom and violated his home. She defiled the dominions of his manhood in work and marriage.

Arthur declares he cannot take her back. "I leave thee, woman, to thy shame" (l. 508). His position and reputation prevents her return to his home. "Better the King's waste hearth and aching heart / Than thou reseated in my place of light, / The mockery of my people, and their bane" (ll. 521–23). But in all his anger, Arthur proves that he is as true a husband as she is false a wife. He forgives Guinevere, and in this singular action the Victorians saw that Arthur's commitment to work and marriage mirrored their own.

To Tennyson's readers, this was Arthur's finest moment. The subject, known as the Parting of Arthur and Guinevere, proved popular and appeared in painting, illustration, and even the decorative arts. The imagery softens the harsh condemnation of the narrative, presenting the king after his rage is spent. In the Parting of Arthur and Guinevere, Arthur is depicted as he grants his wife forgiveness. James Archer painted the subject in 1865, and in all his details, he follows Tennyson's invention. The chamber is spare and gloomy, and Guinevere, in a lush green gown, with her magnificent blond hair hiding her anguished face, sprawls on the floor at the feet of the king. But Arthur is the focus of the painting. Archer paints him as heroic in his presence. His dark mantle over his surcoat and mail emphasizes his massive physique, and his gold-crowned helmet with its dragon crest exaggerates his lofty height. He is a tower of righteous indignation. As in Tennyson's poem, every facet of Arthur's character is consolidated in this portrayal: the strong king, the noble warrior, the enraged husband, the agent of earthly order. But as his body signifies the range of his powers, his face reveals his capacity for kindness. The Victorian world revered Arthur in a role unimagined by his medieval interpreters. They hailed him as a model of husbandly virtue. His rage redeemed his

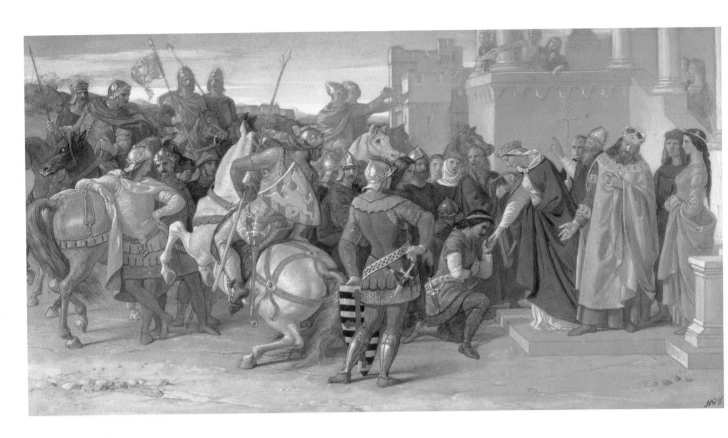

William Dyce. *Piety: The Knights of the Round Table Departing on the Quest for the Holy Grail.* 1849. Watercolor, 9⅛ x 17⅜". National Galleries of Scotland, Edinburgh

manly dominance and his forgiveness affirmed his marriage vows. The Victorian Arthur corrected a vision of the past that the present could neither understand nor abide.

The Victorian Arthuriad altered the traditional narrative in another telling way. Tennyson discarded the traditional bond between Arthur and Mordred, making his king childless. Mordred's own history can be traced all the way back to the first mention of Arthur in the Welsh chronicles, where "Medraut's" fall in battle is joined with Arthur's own defeat.[9] Geoffrey of Monmouth brings Mordred into Arthur's family. As the child of Arthur's sister Anna, he becomes Arthur's nephew. He also gains notoriety— and his characterization as a villain—when, in Arthur's absence, he tries to seize his uncle's queen and crown. In the thirteenth century, Mordred's villainy deepens. More than simply power hungry, he is seen as cruel, hating his uncle and all the knights, desiring only their downfall. His origins explain his deprivation; as Arthur's illegitimate son—the issue of an incestuous relation with Arthur's half sister Morgause—Mordred's evil is inherent. His very conception was in sin. While some subsequent versions

rejected the motives of illegitimacy and incest, Mordred endured as the agent of treachery.

Victorian readers found the suggestion that Arthur's promiscuity led to Mordred's suspect paternity repellant. Many artists and writers simply ignored the issue, but Tennyson gave his king the opportunity to deny any charge of moral trespass. In "Guinevere," when Arthur tells his wife of his unflagging devotion—"I was ever virgin save for thee" (l. 554)—he also reassures his audience that he never had an extramarital liaison, incestuous or otherwise. And in speaking of Mordred as his enemy, Arthur refuses to accept the man as family. "I must strike against the man they call / My Sister's son—no kin of mine" (ll. 369–70). When Mordred does appear in the *Idylls*, renamed by the poet "Modred," he seems more a monster than a man, "like a subtle beast . . . / Ready to spring, waiting for a chance" (ll. 10, 12). Artists rarely painted him, and when Mordred was depicted, it was in his fatal combat with the king.

Disconnecting Arthur with his traditionally sin-born son cleansed his reputation and proved his moral fiber. But without children Arthur was denied the most cherished of all masculine roles: that of the paterfamilias. Charles Kingsley saw it as the basis for the manly spiritual experience: "Fully to understand the meaning of 'a Father in Heaven' we must be fathers ourselves."[10] In the paternalistic society of Victorian England, the father crowned the hierarchy of the family structure. Like the monarch in the nation, he was the sovereign in his home. The father set the rules for his household, but he also set the example. If a father fulfilled his responsibility with conscience and commitment, it was the son's duty to strive to match his standard. Although childless, Arthur proved to be a model for the paterfamilias. He treated his knights like sons, giving them his trust and his fatherly support, but he also expected them to live by his example and up to his expectations.

Arthur is seen as the father to his circle of champions in William Dyce's watercolor *Piety: The Knights of the Round Table Departing on the Quest for the Holy Grail*.[11] As his knights get ready to leave the court on a quest into the unknown, Arthur expresses his grief. Dyce found his inspiration in lines from Malory's *Morte Darthur*. Upon hearing Gawain urge his fellow knights to join him in search of the myste-

rious holy relic, Arthur laments, "Ye have set me in great sorrow, for I have doubt that my true fellowship shall never meet here more again."[12] A good father would never bar his son's path to manhood, but he would also never hesitate to express his disapproval when that path was chosen rashly. Dyce presents Arthur as a father figure. Massive, grand, solid, he looks like a biblical patriarch. With his graying hair and broad but bending shoulders, Arthur seems much older than his knights. Eager for their adventure, they fill the courtyard with their restless movement. They turn to speak with one another, they hoist their flags and banners, they strain to control their rearing horses. Only Arthur takes the time to think about their actions, and his gestures—left hand clasped to his heart, right hand extended open in resignation—signal both his disapproval and his acceptance of his "sons'" behavior.

According to Tennyson, Arthur did more than set an example for his substitute sons. He gave them the rules for manhood. To become a knight, Arthur required that each man swear an oath of loyalty, expressing allegiance to the king and to the purpose of his life. In the idyll "Guinevere," Arthur voices these chivalric vows; they are the guidelines to morality.

> *I made them lay their hands in mine and swear*
> *To reverence their King, as if he were*
> *Their conscience, and their conscience as their King,*
> *To break the heathen and uphold the Christ,*
> *To ride abroad redressing human wrongs,*
> *To speak no slander, no, nor listen to it,*
> *To honour his own words as if his God's*
> *To live sweet lives in purest chastity,*
> *To love one maiden only, cleave to her,*
> *And worship her by years of noble deeds,*
> *Until they won her.*
>
> (ll. 464–74)

Arthur's instructions were simple and clear. Obey the king and your conscience. Keep your faith, your word, your honor, and the law. Be constant in your love and win a woman's heart by the truth and fidelity of your actions. The oath placed duty above desire, and Tennyson saw it as the one way to triumph in the war of "Sense" with "Soul" ("To the Queen," l. 37).

These laws defined Arthur's expectations for his substitute sons. They were "Vows as is a shame / A man shall not be bound by," but they proved to be vows "No man can keep" ("Gareth and Lynette," ll. 265, 266). Arthur tried to make his knights over in his own image, but a real man can only strive for the ideal. By their nature alone, Arthur's "sons" were doomed to disappoint him.

Throughout the Arthurian tradition the knights of the Round Table were portrayed as real men, inspired by good intentions but impeded by human flaws. Gawain, Arthur's nephew and one of his oldest companions, enters the legend as a valiant warrior, from the Celtic tradition through Geoffrey of Monmouth's history. But the French romance writers reduced his reputation, contrasting his rough manners and his insatiable sexual appetite with the more refined chivalry of Percival and Lancelot. Although respect for Gawain endured in England, Malory followed the French innovation. His Gawain, despite a genuine desire to serve Arthur and follow the rules of the Round Table, is quick to anger, and he breaks the rules as often as he upholds them.

In the Victorian legend, rashness mars Gawain's every act. He is the first to embrace the challenge to seek the Holy Grail—Tennyson tells us he swore "louder than the rest" ("The Holy Grail," l. 202)—but he was also the first to give up the quest. William Dyce, who believed Gawain to be "greatly calumniated by Sir Thos. Malory," followed this tradition when he painted him.[13] In *Piety: The Knights of the Round Table Departing on the Quest for the Holy Grail*, Gawain, with his griffin-emblazoned shield slung across his back, can barely restrain his rearing horse. His impatient glance at Lancelot, who bids a tender farewell to the queen, reveals his only desire: to go without hesitation and with no regret. Dyce further explored Gawain's rashness in the Robing Room fresco *Mercy: Sir Gawaine Swearing to Be Merciful and Never Be against Ladies*. On the quest for the white hart, an adventure posed at Arthur's wedding feast, Gawain entered into battle with a knight who had—without intention—killed one of his hounds. After the first few blows, the knight begged for mercy, but Gawain fought on. The knight's wife, hoping to stir Gawain's sense of courtesy, entered the fray, but in his blind desire for vengeance, Gawain

beheaded her. He found the white hart, but on his return to court his crime overshadowed his achievement. For placing his own honor above that of a woman, Gawain was tried in a love court and sentenced by Guinevere always to protect the fair sex and never "to be against the Ladies." The Victorians didn't like Gawain, but his actions marked a strong—and instructive—comparison to those of the ideal king.

Some characters lost their traditional identities in the Victorian quest for moral rectitude. Tristram had a noble lineage. His love for Iseult riveted medieval audiences, and the couple's romance was one of the most popular of the whole tradition. But Tennyson changed Tristram's character. Using him to expose the moral failure that prevented a new generation of knights to live by Arthur's dream, the poet deformed him into a sensualist, bent on earthly pleasure. Arthur's vows meant nothing to him. "I came late, the heathen wars were o'er, / The life had flown, we sware but by the shell" ("The Last Tournament," ll. 269–70). The critics were appalled at the liberties Tennyson took with a beloved romantic hero. The

Dante Gabriel Rossetti, *Sir Tristram and La Belle Yseult Drinking the Love Potion.* 1867. Watercolor, 24½ x 23¼". Cecil Higgins Gallery, Bedford

William Dyce. *Mercy: Sir Gawaine Swearing to Be Merciful and Never Be against Ladies.* 1854. Fresco, 11′ 2½″ x 10′ 2½″. Queen's Robing Room, Palace at Westminster, London. Reproduced by kind permission of the House of Lords

London Quarterly questioned why Tennyson abandoned the ideals of mythic knighthood, giving his readers a Tristram who was "a common place man, of mere brute strength."[14] Other versions of Tristram's tale, by Matthew Arnold, by Algernon Swinburne, by Richard Wagner, had preserved the knight's high character and romantic appeal. But while Tennyson's "Last Tournament" was ignored by painters as a source of visual inspiration, the changes he made in Tristram nevertheless infiltrated the arts. Before the publication of "The Last Tournament," Tristram appeared as a victim of fate, imbibing a love potion meant for Iseult and King Mark on their wedding night, as seen in Dante Gabriel Rossetti's *Sir Tristram and La Belle Yseult Drinking the Love Potion*. But later works show the knight obsessed with adulterous love. Aubrey Beardsley suggests that Tristram was led by choice rather than fate. In *How Sir Tristram Drank of the Love Drink*, the knight's defiant gesture as he toasts his temptress queen reveals Tristram's acceptance of his own demise. Any sacrifice, even honor, is worth his Iseult's love.

But of all of Arthur's men, no one troubled the moral Victorians more than Lancelot. In almost every way he represented ideal manhood. Unsurpassed in prowess on the field, he dedicated his life to the workings of the Round Table. He joined in Arthur's purpose, and his bond with the king transcended ser-

Aubrey Beardsley. "How Sir Tristram Drank of the Love Drink," *Le Morte D'Arthur*. London: J. M. Dent, 1893–94. Courtesy of The Newberry Library, Chicago

vice; he was Arthur's most trusted friend. Yet his all-consuming passion for Guinevere burdened, and eventually betrayed, that trust, and the exposure of their adultery began the events that broke the table. Victorian feeling toward Lancelot was paradoxical. While they could not help but admire his public position, his private indulgence appalled them. As Arthur's greatest knight, Lancelot appealed to their romantic vision of the legend; as Arthur's wife's lover, Lancelot offended their belief in the sanctity of home and marriage. In poetry and painting, this duality is profoundly evident. In portrayals of Lancelot, Victorian writers and artists chose to love the sinner and hate the sin, and in his conflicted character Victorian audiences found the fullest testament of sense at war with soul.

Lancelot entered the legend through the French tradition in the late twelfth century. From his first appearance, in Chrétien de Troyes's *Chevalier de la charrete* (between 1160 and 1180), he loves the queen. In Chrétien's romance, the wicked King Meleagant abducts Guinevere, and Lancelot comes to her rescue. His journey to confront the villain presents life-threatening dangers; he even crawls across a bridge made of a giant sword blade. But, when he slips into the castle, ready to lead Guinevere to freedom, she rewards him only with scorn. Word had come to her that he had accepted a ride in a cart rather than walk

the long miles to save her. Promising to prove his love was worth any sacrifice, Lancelot defeats her captor and carries Guinevere back to his sovereign's court and Arthur's gratitude. Lancelot's character continued to evolve with the legend. He retained his position as the greatest knight and the ultimate exemplar of chivalry. But the anguish of his sin plagued his mind, drove him to bouts of madness, and prevented him from fulfilling the quest for the Grail. With the full development of Lancelot's role, the illicit love triangle became the central, and decisive, structure in the legend. Conflicts of love and loyalty, duty and desire deepened the dramatic power of the legend and made Arthur's downfall all the more tragic, combining his last—and fatal—political struggle with a profoundly human—and personal—defeat.

In the French romance tradition the trials of love that Lancelot endured to please Guinevere celebrated his chivalric character. The pragmatic Victorians enjoyed these swashbuckling adventures but saved their praise for Lancelot's devotion to duty and king. In the *Idylls*, the reader first encounters Lancelot as "the warrior whom [Arthur] loved / And honor'd most," who fought side by side with his new sovereign, and whose loyalty moved Arthur to exclaim, "Man's word is God in man; / Let chance what will, I trust thee to the death" ("The Coming of Arthur," ll. 124–25, 132–33). Only later is Lancelot's love for the queen exposed, and then it is as the dark, rather than the noble, side of his nature. Painters also sought subjects that portrayed Lancelot's uncompromised service to the king, such as William Dyce's *Generosity: King Arthur Unhorsed Spared by Launcelot*. Late in the narrative of Malory's *Morte Darthur*, Lancelot is given the opportunity to prove his untarnished loyalty, even when he is embattled against the king (bk. 20, chap. 13). After the queen's trial for treason, Arthur's forces face Lancelot's men on the field. Sir Bors, Lancelot's kinsman, knocks Arthur from his steed and draws his sword for a final blow. Lancelot interferes, commanding, "Not so hardy . . . upon pain of thy head, that thou touch him no more, for I will never see that most noble King that made me knight neither slaine nor shamed." The battle ends in a draw, and the two friends part in sorrow, despite the reaffirmation of their mutual devotion. The Victorians did not like to remember why Arthur

took up arms against Lancelot. Instead, they saw Lancelot as a man of virtue, upholding Arthur's law, even at the sake of his own victory. Dyce's image cast Lancelot in a role sympathetic to Victorian morality. The subject even appeared in children's books, to encourage respect for authority and a genuine sense of fair play.

When painters paired Lancelot with his queen, he invariably was the model of restraint. In Dyce's *Piety: The Knights of the Round Table Departing on the Quest for the Holy Grail*, Lancelot kneels before Guinevere, clasping her hand as he clutches his heart. He does not meet her gaze, nor does he mirror her expression of emotion. His actions, while motivated by passion, fall within the permissible boundaries of chivalric duty: the king's champion is expected to honor the wife of the king. James Archer portrayed a tryst in *Sir Launcelot and Queen Guinevere*. The sturdy knight seems troubled as he shares the secrets of his heart. A sad-eyed Guinevere listens to his confession, and the roses they both hold, plucked from the thorny bush in the foreground, forecast the pain that must accompany their passion. Even their moment of privacy is violated. In the distance, the queen's ladies pass, and one, the wily Vivien, suspiciously watches their modest encounter. Only rarely does the Victorian Lancelot exhibit his passion, and then it is within the realm of chivalric service, as in Dante Gabriel Rossetti's *Sir Launcelot in the Queen's Chamber*. Fierce and ready to face Mordred and his cohorts, this Lancelot defends not only the queen but three cringing ladies in her chamber. The legendary lovers had not been alone.

Despite their refusal to fully condemn Lancelot as a sinner, the Victorians never forgave him his sin. In the medieval tradition, Lancelot suffered for his passion. Time and again he descended into madness, leaving the court and living like a wild man in the woods. On his quest for the Grail, a vision of the holy vessel tormented him; he could see it but he could not attain it. But, in the Middle Ages, Lancelot was granted a form of redemption. His son, Galahad, reversed his fate, and in gaining the Grail, reigned as the Prince of Sarras, a holy city of angels. The Victorians, firm in their belief that the sins of the fathers must be borne by the sons, severed this redemptive paternal bond. And they made Lancelot

William Dyce. *Generosity: King Arthur Unhorsed Spared by Sir Launcelot*. 1852. Fresco, 11′ 2½″ x 5′ 10″. Queen's Robing Room, Palace at Westminster, London. Reproduced by kind permission of the House of Lords

James Archer. *Sir Launcelot and Queen Guinevere*. 1863. Oil
on canvas, 37½ x 28½". Private collection. Photograph by
courtesy of the Fine Art Society PLC, London

pay for his passion in a way unimaged in medieval times. In the Victorian legend, Lancelot punished himself. Rejecting all fame and honor, he wallowed in the darkness of self-hatred and guilt.

Tennyson's Lancelot bore his guilt in pain and silence, but he could not hide his despair. His face testified to the struggle within his soul, for "The great and guilty love he bare the Queen, / In battle with the love he bare his lord, / Had marr'd his face, and mark'd it ere his time" ("Lancelot and Elaine," ll. 244–46). Guilt paralyzed him. In "The Last Tournament," when Arthur leaves the court to fight an uprising in the North, Lancelot presides over a tournament in his absence. The knights, led by Tristram's disdain, ignore the rules set out for jousting. But Lancelot, "Looking o'er the lists . . . saw the laws that ruled the tournament / Broken, but spake

not" (ll. 159–61). He was too distracted by his own misery to call these actions into question. He could not, even in this small capacity, fill in for the presence of the king.

Tennyson even provides Lancelot a soliloquy to declare his self-hatred. At the close of the idyll "Lancelot and Elaine," Arthur's mightiest knight is a broken man, dwelling upon his inadvertent discourtesy that led to the death of Elaine. He leaves the court to think about the girl who died for his love, unknown and unrequited, and acknowledges that his obsession with Guinevere blinded his senses and stunted his compassion. "Ah simple heart and sweet / Ye loved me, damsel, surely with a love / Far tenderer than my Queen's" (ll. 1381–83). But in this recognition of the goodness of pure love, he sees no hope for redemption and wishes for only his punishment. "I

pray him send a sudden angel down / To seize me by the hair and bear me far, / And fling me deep in that forgotten mere, / Among the tumbled fragments of the hills" (ll. 1413–16). Lancelot's remorse became a popular subject for artists, and the public sympathized with the despondent figure, sunk in his own misery as he pays with his sorrow for his sin. In Gustave Doré's illustration for "Lancelot and Elaine" it is the embodiment of the great knight's paradoxical appeal. He is the counterpart to Arthur's emblematic existence. As real manhood enclosed in ideal man, Lancelot elicits genuine sympathy and reminds every man striving after Arthur's example to honor his own conscience as his king.

Arthur's disappointment in his substitute sons is a driving force in the Victorian legend. Over and over he grieves at their failures, and in the end he sees their lax obedience as the death blow to his dream. In "The Passing of Arthur," the king warns Bedivere, his last companion, not to regard Modred as the sole traitor, but to place the blame where it is due.

> 'My house has been my doom,
> 'But call not thou this traitor of my house
> Who hath but dwelt beneath one roof with me.
> My house are rather they who sware my vows,
> Yea, even while they brake them.'

(ll. 154–58)

Gustave Doré. "Lancelot's Remorse," *Idylls of the King.* London: Edward Moxon, 1868. Courtesy of The Newberry Library, Chicago

opposite:
Dante Gabriel Rossetti. *Sir Launcelot in the Queen's Chamber.* 1857. Pen and black and brown ink, 10¼ x 13¾″. Birmingham Museums and Art Gallery

It is in the uneven balance of Arthur's expectations and the knights' inability to meet them that the Victorians left their mark on the venerable legend. By revering Arthur as an ideal man—exemplary in word and action, blameless in all that occurred in his house and his kingdom—they envisioned a leader who could reign, for all time, over a perfect nation. But Arthur's full triumph would break the one inviolate convention of the legend: that Arthur must fall so that he may come again. So a perfect king commanded imperfect men, married an imperfect wife, and struggled to hold on to an impossible dream. The Victorian audience could make its choice: ideal manhood or real men. That selection held the lesson of the legend, changed now, like the inscription on Excalibur, written in their modern language, a language they taught the ancient king to speak.

Woman Worship

The best things that the best believe
Are in her face so kindly writ
The faithless seeing her, conceive
Not only heaven, but hope of it.

Coventry Patmore (1854)

If poets wrote the history of the Victorian era, it would be remembered as a time of unparalleled reverence and respect for women. Poems—as well as prose and pictures—celebrated the inherent virtues of womanhood. A good woman was born to be loving and giving. Her nature was to nurse and nourish; she cared for and saw to the comforts of others. She was, by inclination, chaste and faithful. The true feminine nature was not plagued by the battle of sense with soul. Unlike her masculine counterpart, she was ruled by morality—not passion. In the arts, symbolic references hailed her gentility and her purity: woman was a dove, a lamb, a lily. She brought to her home and family a sense of heaven on earth. As the

Edmund Blair Leighton. *The Accolade*. 1901. Oil on canvas, 71¼ x 42½". Private collection. Photograph by courtesy of the Christopher Wood Gallery

guardian of domestic peace and pleasure, woman was touched with a divine mission; she lived, as the poet Coventry Patmore named her, as "The Angel in the House."[1]

To the Victorian mind, tradition sanctioned this image of ideal womanhood. Like a noble title or a code of manly honor, it was part of the chivalric standard. Readers of the *Idylls of the King* learned that good women inspired men. Tennyson's Arthur swore his knights "To love one maiden only, to cleave to her, / And worship her by years of noble deeds" ("Guinevere," ll. 472–73). Through devotion and monogamy, a man honored a woman, but he also ennobled himself, for the king believed that passive womanly virtue inspired a man to active manly behavior.

For indeed I knew
Of no more subtle
master under heaven
Than is the maiden
passion for a maid,
Not only to keep down
the base in man,
But teach high
thought, and amiable
words
And courtliness, and
the desire of fame,
And the love of truth,
and all that makes a
man.

(ll. 474–80)

During the 1860s, the term "woman worship" entered the Victorian vocabulary.[2] It implied a definition of womanhood as an ideal moral existence, based in the realm of domesticity. In contrast to the masculine arena of public influence, the woman's place was at the hearth and in the

Arthur Rackham. "How Queen Guenevere Rode
A' Maying," *The Romance of King Arthur and His Knights of
the Round Table*. London: Macmillan, 1917. Courtesy of
The Newberry Library, Chicago

below:
Frank Dicksee. *Chivalry*. 1885. Oil on canvas, 72 x 53½".
Courtesy of the FORBES Magazine Collection, New York

home, and her reputation was earned through private endeavor. Woman worship was the counterpart to hero worship, and the dual standard that informed these two ideals defined contemporary gender roles and restrained women under the guise of reverence. For British women of the nineteenth century, the pedestal provided by woman worship often proved to be a prison. And the women of the Victorian legend—Guinevere, Enid, Elaine, and Vivien—struggled, as all Victorian women struggled, to reconcile their individual identities with contemporary ethics. Their battle proved more treacherous than that of sense at war with soul, and the example of their lives, intended to teach women the ideal, revealed that this noble dream, like that of Arthur's order, was ultimately unobtainable.

In 1857, two years before he presented his first set of *Idylls* to the public, Tennyson tested his new Arthurian poetry on a small, private audience. At his own expense, he printed and bound six copies of a "trial" book, *Enid and Nimuë, or The True and the False*. The successful reception of this little publication inspired him to expand the suite of poems from two to four, and in the summer of 1859, the first installation of the *Idylls of the King* appeared, comprising the poems "Elaine," "Enid," "Guinevere," and "Vivien." Despite the name change of one character and the new title for the collection, the first installment of the epic, with its two new poems, continued the pattern set in *The True and the False*. Each poem bore a woman's name, and each featured a narrative of a woman's experience. But that experience was shaped by men, proving the woman in each case true or false. In Tennyson's world, there were good women and there were bad women, and the power of judgment lay in the hands of men.

During the Victorian era matters of gender were as strictly delineated and regulated as matters of social class. With strict, impassable boundaries, men and women knew their places, and they kept to them. Endowed with physical strength and intelligent reason, man reigned as the active force in society. Blessed with a tender heart, vast compassion, and an innate sense of morality, woman remained passive, available for comfort and counsel when man found the need. These natural proclivities defined the con-

tributions of men and women in society. In matters of gender, Tennyson's thoughts typified those of his generation. Earlier, in 1847, he had written about the division of the sexes with clarity and conviction.

Man for the field and woman for the hearth;
Man for the sword, and for the needle she;
Man with the head, and woman with the heart;
Man to command, and women to obey;
All else confusion.

("The Princess," pt. V, ll. 437–41)

In a proper world man led with mind and might, while woman followed with heart and tenderness. These positions were ordained by God and nature, and to ignore them was to ignore the natural order of the universe.

The issue of a woman's place was not just a subject in poetry; it was clearly set down in law. Throughout most of the Victorian era, a woman's legal identity was indivisible from that of her closest male relative, whether father, husband, brother, or son. In 1854, the pioneer feminist Barbara Leigh Smith (later, Barbara Bodichon) published a pamphlet detailing the legal rights of women according to English Common Law. Her *Brief Summary, in Plain Language of the Most Important Laws of England concerning Women* revealed that Victorian women were bound by the same restrictions that were imposed upon their medieval ancestors. A woman under twenty-one could not marry without the consent of her guardian, and once she was betrothed, rights to her property were transferred to her future spouse. After marriage a husband could dispose of his wife's belongings—land, money, jewelry, household goods, even her clothes—as he saw fit. A wife had no legal rights outside those of her husband; she came under his protection, in a condition known as coverture.[3]

If a marriage failed, a woman faced limited options. Although a man could secure a divorce through a charge of adultery, a woman wishing to sever her relationship with an unfaithful spouse had to be able to prove physical cruelty, bigamy, bestiality, or incest as additional aggravating charges. Some social critics blamed the wife for a husband's strayed affections and even claimed that bearing a partner's infidelity was a true test of womanly character. In *The*

Wives of England (1843), Sarah Ellis declared that it was a woman's responsibility to "keep" her man and warned that if she failed, she should never look elsewhere for comfort. Instead, Ellis advised the moral high road: "How infinitely preferable is the feeling of having borne unfaithfulness than of having been unfaithful ourselves!"[4] If a woman proved that her husband's behavior was truly intolerable, she could obtain a divorce, but she risked losing all her property and the custody of her children. The Divorce Act of 1857 gave women a modicum of greater control over their destinies after divorce, but the expense of legal proceedings remained prohibitive, especially when there was no guarantee that property and custody would be granted with a divorce. Most women preferred to suffer in silence, living life in the shadow of their husbands, whose wishes were literally law.

Just as a woman's legal identity depended on that of her closest male relative, her social position was dictated by her relationship with a man. Every stage of a woman's life marked her subsidiary position, to a father, to a husband, to a son. The dutiful daughter became the patient fiancée, who, in turn, served as submissive wife, loving mother, and, ultimately, dignified widow. Although these roles reflected middle-class values, the working classes saw in them the means to better their own society. Even the upper classes conformed—and no one played these roles better than Queen Victoria.

True fulfilled womanhood was positioned in home and family. C. W. Cope celebrated this feminine ideal in his painting *A Life Well Spent*. In a snug, well-appointed drawing room, a young and lovely mother tends to her children. As she helps her eldest son review his lessons, she keeps her hands busy, skillfully knitting socks for her husband. She has trained her daughter well. Although engrossed in her own reading, the girl never loses her sense of responsibility; she rocks her cradle while she reads her book.[5] But there is a sense of confinement in this image of domestic industry. The art historian Susan P. Casteras has compared this type of setting to that of the *hortus conclusus*, or enclosed garden, a medieval emblem of the purity of the Virgin Mary.[6] It is an appropriate analogy, for in Victorian times a mother was held to be more divine than human, and no woman more worthy of worship than a true and loving mother. Tennyson described perfect motherhood and its beneficial effects in "The Princess."

C. W. Cope, *A Life Well Spent*. 1862. Oil on canvas, 23¾ x 19¾". Photograph by courtesy of the Christopher Wood Gallery

> *No angel, but a dearer being, all dipt*
> *In angel instincts, breathing Paradise,*
> *Interpreter between the gods and men*
> *. . . Happy he*
> *With such a mother! Faith in womankind*
> *Beats with his blood, and trust in all things high*
> *Comes easy to him, and tho' he trip and fall*
> *He shall not bind his soul with clay.*
>
> (Pt. VII, ll. 301–3, 308–12)

Tennyson praises fine and womanly instinct, which, although honorable in itself, deserves the most praise when filtered as influence through the higher actions of man.

The Arthurian women in the *Idylls* conformed to contemporary types. Young Elaine, once a dutiful daughter, became willful and, in defying her father, her brothers, and even the wishes of Lancelot, forfeited her chance to know the pleasures of ideal womanhood. Enid, the perfect wife, willingly bore accusations and indignities to prove to her husband that she was true. Guinevere scorned the role of wife and mother and paid for it with her happiness, her rank, and her destiny. Vivien tried to live outside the confines of home and family. Grasping for power, that male prerogative, she proved herself unnatural, disgracing all of womanhood through her actions. These women were the true and the false. Although they lived in legendary times, their lives bore the marks of the values and restrictions that shaped the existence of their modern-day female readers.

> Elaine the fair, Elaine the lovable,
> Elaine the lily maid of Astolat,
> High in her chamber up a tower to the east
> Guarded the sacred shield of Lancelot;
> . . . she lived in fantasy.
>
> ("Lancelot and Elaine," ll. 1–4, 27)

Contemporary readers of Tennyson's "Elaine" saw her life as a medieval mirror of modern girlhood. Elaine was a perfect daughter. As the youngest child—and the only girl—in a family of sons, she learned the proper relationship of women to men. The loss of her mother at an early age gave her responsibilities beyond her years, but she carried them out with industry and enthusiasm, happy to serve her father and brothers as she prepared herself for the day when she would serve a husband and sons of her own. The claustrophobic dimensions of Elaine's life were familiar to the Victorian audience. Home and family marked the boundaries of a middle-class daughter's world. A good girl in a good family needed only to wait for her father to select her husband and define her destiny.

The well-bred Victorian girl lived in an atmosphere of peace, quiet, and confinement. In a guide to education, published in 1865, Elizabeth Missing Sewell advised that "girls are to dwell in quiet homes, amongst few friends; to exercise a noiseless influence, to be submissive and retiring."[7] Too much stimula-

above:
Eleanor Fortiscue Brickdale. "Then to her tower she climb'd," *Idylls of the King" by Alfred Lord Tennyson*. London: Hodder and Stoughton, n.d. Private collection

opposite:
Eleanor Fortiscue Brickdale. "Elaine Sewing," *Idylls of the King" by Alfred Lord Tennyson*. London: Hodder and Stoughton, n.d. Private collection

tion—physical, mental, or emotional—would harm a girl's delicate constitution and fragile sensibilities. A girl occupied a special place in the family. Writing in the *Mother's Companion* of 1887, Sarah Tyler observed that "a family without a girl . . . lacks a crowning grace, quite as much as a family without a boy misses a tower of strength."[8] But the girl was always mother to the woman, and female responsibility formed the core of a good upbringing. According to Tyler, "the mother of the little woman-child sees in her the born queen, and, at the same time, the servant of the home; the daughter who is to lift the burden of domestic cares and make them unspeakably lighter by taking her share of them; the sister who is to be a little mother to her brothers and sisters; the future wife and mother in her turn."

A girl's upbringing prepared her for the life of wife and mother. A male suitor entered her life with the approval of her family, and a betrothal required the sanction of her closest male relative. When courted, a girl encountered a new set of restrictions, the elaborate code of Victorian courtship etiquette. Propriety curtailed every action. Chaperons had to be present. Only certain topics of conversation were allowed. A girl could not borrow items of value from a suitor, nor should her gifts to him be too expensive. The tightest restriction harnessed the girl's expression of feeling toward the man she desired. An 1844 courtesy book instructs the feminine reader that it was her proper part "to repress excess of ardour."[9] A woman in love learned to be patient. Just as her father chose her mate, her suitor set the pace for the developing relationship. Like a hothouse flower, a young Victorian woman waited to be picked. No wonder girls like Elaine "lived in fantasy."

Although her story resonates with the restrictions of Victorian girlhood, Elaine first entered the Arthurian tradition as a nameless maiden, the *demoiselle d'Escalot* in the *Vulgate Morte Artu* (French; 1215–35), who dies in grief for the unrequited love of Lancelot. When Malory added the tale to his own *Morte Darthur*, he named the maiden Elaine and gave her the attribute of the lily, reminiscent of the Virgin Mary's symbol of purity. In writing the idyll "Elaine" (later, "Lancelot and Elaine") Tennyson followed Malory's narrative. But Tennyson's version of the maiden's romantic demise encoded a chilling lesson

for contemporary female readers. Elaine did not simply die for love, she died in defiance of her proper place and her father's counsel. A streak of will flawed her feminine nature, and self-destruction, rather than Lancelot's rejection, caused her untimely and unnecessary death.

When Lancelot came to Astolat, Elaine knew little of the world, or of men. She lived a sheltered life, indulged by an adoring father and protected by two devoted brothers. As "little mother" in a motherless household, her hours were filled with happy domesticity. Safe inside her father's castle, Elaine was a true hothouse lily. She flourished in her innocence. But Lancelot brought the outside world into Astolat. His own motive was innocent. Fearing that his reputation rather than his skill now brought him victory on the tournament field, he sought the shield of an unknown knight as a disguise for an upcoming challenge. Elaine did not recognize the esteemed visitor. Nor could she differentiate between his courtly manners and romantic attraction. As her father's hostess, she showered him with attention, and when he rewarded her with a tender smile, "Of manners and of nature" (l. 327), her ignorance of etiquette led her to mistake his gratitude for love. A woman's passion ignited in her girlish heart, and in her lack of experience "she lifted up her eyes / And loved him, with that love which was her doom" (ll. 258–59).

Throughout Lancelot's brief stay at Astolat, Elaine misinterpreted his actions. He accepted a token from her, a red velvet sleeve, which he agreed to wear on his helmet, but only to complete his disguise. "I have never worn / Favour of any lady in the lists" (ll. 361–62), he confessed, realizing that doing so now would hide his identity. But Elaine saw this as a public declaration of his true love. He also accepted her brother Torre's unmarked shield, leaving his own with Elaine. "Do me this grace my child, to have my shield / In keeping till I come" (ll. 380–81). She embraced the shield like a lover, retreated with it to her tower, now possessing proof that he would return. As the days passed, Elaine kept her hands busy sewing a cover for the shield, but her mind wandered in fantasy, weaving her unknown knight's past and anticipating her place in his future.

News from Camelot disrupted Elaine's reverie. Gawain arrived at Astolat, seeking the knight who

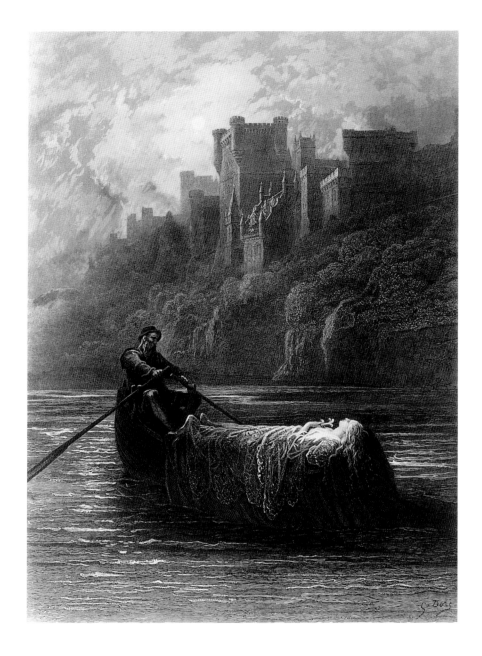

Gustave Doré. "And the dead, Oar'd by the dumb," *Idylls of the King*. London: Edward Moxon, 1868. Courtesy of The Newberry Library, Chicago

wore the red sleeve and bore an unmarked shield. His tournament triumph had been marred by injury, and he had left the field before revealing his identity and collecting his prize. Gawain recognized Lancelot's heraldry on the shield left behind, and he cautioned Elaine to guard her heart, but he gave her the diamond that Arthur had designated as the victor's reward. She then insisted that she be taken to the ailing knight, and her father, unable to deny her, reluctantly granted permission, lamenting, "Being so very willful you must go" (l. 772). When Elaine found Lancelot, he was near death, but he took the diamond from her hand and thanked her with an innocent kiss, "As we kiss the child / That does the task assign'd" (ll. 823–24). Once again she mistook courtesy for love, and seeing that her sleeve, "Tho' carved and cut, and half the pearls away" (l. 802) was still bound around his helmet, she believed that he wanted to tilt in her honor again.

Victorian readers embraced Elaine's deluded obsession with pathos. But it was her stage of life, rather than her circumstance, that drew their compassion. The girl Elaine hovered on the brink of womanhood. Deep, womanly emotions stirred her heart, but

her sheltered childhood prevented her from understanding and controlling them. Had her mother lived, she would have guided Elaine through this treacherous transition. Elaine suffered for the absence of a woman's wisdom. As she explained to Gawain, "My brethren have been all my fellowship; / And I, when often they have talk'd of love, / Wish'd it had been my mother . . . so myself / I know not if I know what true love is" (ll. 668–72). But this self-realization was not enough to keep her from danger.

The reasons for Elaine's universal popularity with Victorian audiences split along lines of gender. Men wanted to rescue her, while women wanted to mother her. But to both, Elaine seemed tender and troubled, the true child-woman, capable of feeling love but not ready to receive it. Arthur Hughes captured this delicate balance in the painting *Elaine with the Armor of Lancelot*. Cradling Lancelot's helmet still adorned with the red sleeve, Elaine is lost in fantasy. She gazes upon the battered armor as if upon a lover's face. Her delicate girlish features express a woman's compassionate desire. Her dress is modest and her hair loosely bound, as suited her age. Even the way she holds the armor, stretching her arms as if the headpiece is too large and too heavy, reminds the viewer of her inno-

Arthur Hughes. *Elaine with the Armor of Lancelot.* 1867. Oil on wood, 17¼ x 9″. Collection of Mr. and Mrs. W. S. Taylor

cent youth. But her high, well-shaped breast and the flush of excitement on her cheeks reveal the woman within her. Hughes's Elaine stands on the threshold of womanhood, but in her sweet and tender reverie she is safe forever, in the impossible dreams of a girl.

When Elaine tries to make her dreams come true, she transgresses the sanctuary of her girlhood and suffers for not knowing her place as a woman. Through Elaine's expert nursing, Lancelot regains his health and, to show his gratitude, he offers her a gift of her choosing. She eludes him, afraid to speak her heart's desire, but when he presses her, she exclaims, "I have gone mad. I love you" (l. 925) and asks for love and marriage. With characteristic gentility, Lancelot explains that she has asked for the thing he cannot give. "Had I chosen to wed, / I had been wedded earlier, sweet Elaine: / But now there will never be a wife of mine" (ll. 929–31). He reminds her of the disparity between their ages and assures her that in time a more suitable husband will come. Being refused as a woman, she asks to join him as a child, as a girl servant, "To serve you, and to follow you thro' the world" (l. 934), but Lancelot knows that the world would not regard that bond as innocent.

Edward Corbould. *Elaine, the Lily Maid of Astolat.* 1867. Watercolor, 23½ x 33¼". Private collection. Photograph by courtesy of the Maas Gallery, London

Elaine's fantasy of womanly love shatters, but she cannot return to a state of girlhood. Her father appeals to Lancelot to cure her of her obsession—"Too courteous are ye, fair Lord Lancelot. / I pray you, use some rough discourtesy / To blunt or break her passion" (ll. 966–68)—so Lancelot leaves her without a word or a gesture of farewell. But what her father asks proves too cruel for Elaine to bear; she is plunged back into a reality she refuses to accept.

Elaine then enters into a final act of defiance. She scorns the healing potential of time with its possibility of future love, and she wills herself to die. Her father and her brothers are powerless to save her. She even convinces them to arrange her funeral according to her will.

> *. . . take the little bed on which I died*
> *For Lancelot's love, and deck it like the Queen's*
> *For richness, . . .*
> *And let there be prepared a chariot-bier*
> *To take me to the river, and a barge*
> *Be ready on the river, clothed in black.*
> *I go in state to court, to meet the Queen.*
> *There surely I shall speak for mine own self,*
> *And none of you can speak for me so well.*
>
> (ll. 1110–12, 1114–19)

In a final request, she asks her brother Lavaine to write a letter, to tell the court who she was and how she died. True to the pattern of her life, her brothers and father cannot refuse her bidding. Upon her death, they perform the solemn ceremony, placing the letter in one hand and the lily in the other. Arrayed according to her wishes, Elaine departs for her grisly presentation at court, her sole companion a mute family retainer who steers the barge on its journey. This powerful image of "the dead, / Oar'd by the dumb" (ll. 1146–47) was a favorite for Victorian painters. In *Elaine, the Lily Maid of Astolat* (1867), Edward Corbould contrasts her simple garments with the rich funeral regalia, the oarsman's age with her timeless youth. Through death Elaine escaped the transition from child to woman. Her life was at its end, but her ideal girlhood was preserved.

Mixed emotion greeted her arrival at Camelot. The king felt pity and puzzlement; the queen seethed with anger and jealousy. For Lancelot, Elaine's letter was a revelation. He had not imagined that her infatuation was more than childish fantasy, or that a simple act of discourtesy would have such a grievous consequence. Lancelot's refusal to return Elaine's love bewildered Arthur. She seemed "shaped . . . By God for thee alone," and could have given Lancelot what every man desired and needed, "sons / Born to the glory of thy name and fame" (ll. 1355–56, 1360–61). To honor her memory, Arthur built a tomb emblazoned with the story of her tragic end. Her likeness in death reposed on the lid, a lily in her hands and Lancelot's shield at her feet. For the court, the tomb celebrated Elaine's perpetual innocence, but for the Victorian reader, it signified the dangers of girlish will, fueled by the premature stirring of womanly desire.

When a young woman put aside her girlish fantasies and tempered her childish will, she was ready for matrimony, the most hallowed of all Victorian institutions. As bride, wife, and mother, a Victorian woman fulfilled her destiny. Through marriage she attained social standing, a secure future, and the responsibilities and joys of running a household. But more than just ensuring her own happiness, a woman's place in marriage was central to the natural order of life. In the poem "Vastness," Tennyson describes the ideal wife in the perfect marriage.

> *Love for the maiden, crown'd with marriage, no*
> *regrets for aught that has been,*
> *Household happiness, gracious children, debtless*
> *competence, golden mean.*
>
> (Stanza 12)

A woman who rose to this standard proved worthy of worship. Her reward was her husband's love and, even more valued, her husband's trust.

Tennyson celebrated the sacrifices a good wife would make for her husband's trust in the longest of the first four *Idylls*, "Enid" (later split into "The Marriage of Geraint" and "Geraint and Enid"). The roots of the story are Welsh—the hero Geraint sharing the name with a seventh-century Dumnonian king—and date to the thirteenth century, but Chrétien de Troyes's romance *Erec et Enide* features a corresponding narrative. Geraint, prince of Wales (Chrétien's Erec is a prince of Breton) wins the hand of his love, Enid, in a tournament and takes her to reign with him in his homeland. His devotion to his wife, however, distracts him from his obligations as a knight of the Round Table. Rumors spread through the court that Geraint's love has unmanned him and subjugated him to his passions and his wife. Misunderstanding the idle talk, Geraint accuses Enid of infidelity, and he forces her to join him on a rough adventure to regain his reputation and test her devotion. In every trial, Enid proves her constancy, and ultimately she dispels all the rumors and regains Geraint's loving trust. In his medieval source Tennyson discovered more than romance and adventure. He found an ancient role model for the ideal Victorian wife.

When a Victorian wife promised to love, to

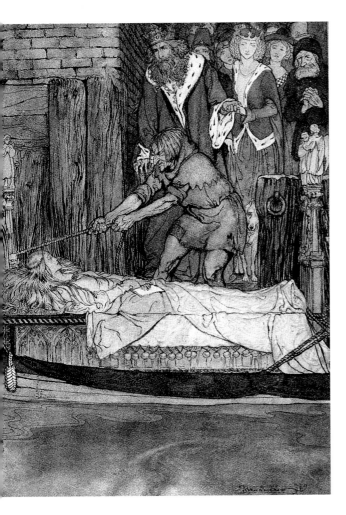

Arthur Rackham. "The Arrival of Elaine at Camelot," *The Romance of King Arthur and His Knights of the Round Table.* London: Macmillan, 1917. Courtesy of The Newberry Library, Chicago

pressed man . . . who send forth husband and brother each morning with new strength for his conflict, armed, as the lady armed her knight of old, with a shield which he may not stain in any unseemly conflicts, and a sword which he dares only use against the enemies of truth, righteousness, and god."[10] Carlyle saw empowerment in this supporting role, which was "the true destiny of a woman . . . to wed a man she can love and esteem, and to lead under his protection, with all the grace, wisdom, and heroism that is in her."[11] Only through submission would a wife find the true strength and value of her feminine nature. And no wife was more submissive and true than Geraint's wife Enid as portrayed in the *Idylls.*

Of all the heroines in Tennyson's *Idylls* only Enid enjoyed the three cherished roles of womanhood: bride, wife, mother. Her nature—"so sweet and serviceable" ("The Marriage of Geraint," l. 393)—was suited to wifely selflessness and maternal compassion. When Geraint first saw Enid, living in poverty with her parents, happy to be both daughter and maidservant, he longed to wed her, take her to court, and present her to the queen, who promised to love the bride he chose as a sister and "clothe her for her bridals like the sun" (l. 231). But, like a knight proving his manhood to his sovereign, Enid's worth and dedication were tested, time and again. Although she seemed born to the natural roles of womanhood, barriers stood in her way, and the tale of how she met each challenge portrays the infinite patience of the perfect wife and the power of her husband to control her desires and her destiny.

Enid was not always poor. Her father's estate and worldly treasures were destroyed by an angry suitor, rejected for his temper and his cruelty. When Geraint chose Enid for his bride, he rescued her from poverty and reversed her fortunes. He even defeated the suitor, Sparrowhawk, in a tournament, unknowingly avenging the wrongs done to the gentle family. At Arthur's court, Guinevere kept her promise and dressed Enid in the finest gowns and jewels, and cultivated a sisterly bond of kindness and affection. But as the rumors rose of Guinevere's adulterous passion, Geraint sought to break that bond, fearing the association would corrupt Enid's innocent nature. On the pretext that his father's land was besieged by bandits and rebels, he took Enid to his home in the West,

honor, and to obey her husband, she did so in earnest commitment. Although the household was her domain and its management her responsibility, he was the lord and master. This inequality of power within a marriage was not seen as restricting the woman's role and influence. To the contrary, it was regarded as natural, based on feminine ability and inclination. J. Baldwin Brown defined womanly power as the "power to love, to serve, to save." In his sermon *The Home Life*, he praised feminine devotion as an enhancement to masculine endeavor and compared a modern woman's support and service to the romantic tradition: "I know women whose hearts are an unfailing fountain of courage and inspiration to the hard-

where he spent his days worshiping her beauty and basking in her attentions. Arthur Hughes depicted Geraint as the devoted husband in the painting *The Brave Geraint*, who casts aside his sword for the more delicate pleasures of love. But this excess of woman worship diminished his knightly reputation, and as Enid heard her husband derided as "a prince whose manhood was all gone" (l. 59), she knew it was her fault that he neglected his manly pursuits.

> *Forgetful of his promise to the King,*
> *Forgetful of the falcon and the hunt,*
> *Forgetful of the tilt and tournament*
> *Forgetful of his glory and his name,*
> *Forgetful of his princedom and its cares.*
> *And this forgetfulness was hateful to her.*
>
> (ll. 50–56)

To protect Geraint, Enid bore the sting of the rumors in silence. But Geraint, noticing a change in her temperament, believed that her love, like the queen's, had dwindled and strayed, and he began to regard her with suspicion. Late one night, as Geraint slept, Enid, admiring her handsome husband—"Was ever man so grandly made as he?" (l. 81)—longed for a means to stop the charges of effeminacy that tarnished his reputation. She swore that she would rather see him die in battle than in shame, and prayed for the courage to tell him of the slander, feeling the guilt of keeping a secret from her husband. "O me," she whispered, "I fear that I am no true wife!" (l. 108). Rising from sleep, Geraint heard her quiet words, but did not know the circumstance that prompted them. To his mind, Enid had confessed. She had betrayed him, just as the queen had betrayed the king.

In his fury, Geraint prepared for a journey into the wilderness. Seeking to prove that he had "not fallen so low as some might wish," he commanded his wife, "Put on thy worst and meanest dress / And ride with me" (ll. 129–31). Bewildered, Enid obeyed. Donning the tattered and faded silk she had worn when he first fought for her hand, she joined him, mute and submissive. As they rode through the woods, Geraint gave her orders but no explanations. She was to ride ahead of him, not at his side for company and not at his wake for protection. She was forbidden to speak, no matter the circumstances. "I

Eleanor Fortiscue Brickdale. "To make her beauty vary day to day," *"Idylls of the King" by Alfred Lord Tennyson*. London: Hodder and Stoughton, n.d. Private collection

charge thee on thy duty as a wife / Whatever happens, not to speak to me / No, not a word!" ("Geraint and Enid," ll. 16–18). The woods were fraught with peril, and Enid saw every danger first. Repeatedly she tried to warn Geraint of enemies lying in wait, seeking to overpower the unaccompanied knight, ready to take his horse, his armor, his weapons, and his wife. Her docile attempts to help him only fueled his anger, and he met each group of challengers with a fierceness and power that restored his reputation. Challenge after challenge ensued, and they rode on, Geraint rigid and silent, Enid obedient but looking to

Arthur Hughes. *The Brave Geraint*. 1863. Oil on canvas,
9 x 14″. Private collection. Courtesy of Christie's Images,
London

her husband for some explanation. In his stubbornness, Geraint refused to admit to being wounded—Enid would want to nurse him—and finally they had to seek shelter at the castle of the lord Limours, known as the Bull. Like Sparrowhawk, Limours had sought Enid's hand but was rejected for his drunkenness and rough behavior. Now, with her husband on the brink of death, he pursued her again, but this time with force rather than flirtation. Her cries roused Geraint and returned him to his strength. He defeated the Bull and now, convinced of his wife's true nature and fidelity, restored to her his trust and his worship.

Throughout her trials, Enid wondered at Geraint's behavior but never questioned his commands. It was her duty to love, to honor, and to *obey*, and she kept her vows as sacred. In regaining his trust she nearly lost her life, but, good wife that she was,

without his trust her life was worthless. When they returned to Camelot, she enjoyed the renewal of friendship with the queen and the restoration of her husband's reputation. But her true reward waited until they returned to Geraint's lands in the West, where her ladies, who once called her "Enid the Fair," now hailed her as "Enid the Good." The years brought contentment, as "in their halls arose / The cry of children, Enids and Geraints / Of times to be" (ll. 962–65). But her greatest treasure was her husband's trust, hard won but all the more precious for being tested and proved true.

Guinevere was the other wife in the *Idylls*, but by Victorian standards she was better suited to be cast as the other woman. Contrary to the submissive ideal of womanhood, Guinevere placed her own needs and desires above those of her husband. Tennyson portrayed her as an earthly woman, who felt stifled in the rarefied atmosphere that surrounded her king. For Guinevere, high-minded reverence was no substitute for physical satisfaction. She wanted a partner, not a paragon; a flawed character appealed to her more than a "passionate perfection." When Lancelot protested that Arthur was the better man, she let him know her preference.

> *Arthur, my lord, Arthur, the faultless King,*
> *That passionate perfection, my good lord—*
> *But who can gaze upon the Sun in heaven?*
> *. . . to me*
> *He is all fault who hath no fault at all:*
> *For who loves me must have a touch of earth;*
> *The low sun makes the color: I am yours.*
>
> ("Lancelot and Elaine," ll. 121–23, 131–34)

Because she placed desire above duty, Guinevere's own passion led to tragedy. But through that tragedy she discovered her true feminine destiny. And when she finally recognized that her husband represented "the highest and the most human too" ("Guinevere," l. 644), she won a small victory in the battle of sense at war with soul.

The taint of infidelity has accompanied Guinevere throughout her life in the legend, but she was not always the willing adulteress. In Geoffrey of Monmouth's *Historia*, Arthur's nephew Mordred usurps the kingdom, and takes the queen by force.

But other early chroniclers, including Wace (c. 1155) and Layamon (c. 1200), suggest her complicity in the treason. Guilty or innocent, she pays for the sin; her stigma is her barrenness.[12] In the French romances, the code of courtly love diminishes the shame of Guinevere's straying affections and provides her with Lancelot, a lover worthy of her respect and her station. Malory adopted his characterization of Guinevere from the French tradition, and although he portrayed her unfaithfulness as part of the tragic narrative, he praised her as a true lover and redeemed her in the end. A trace of sympathy for the doomed queen accompanies her throughout the medieval tradition, but the modern era passed a harsher judgment. For the crime of marital betrayal, the Victorian Guinevere feared that her name would "ever be a name of scorn" ("Guinevere," l. 622), and, by contemporary moral standards, that punishment would be justified.

The restrictive Victorian view of marriage allowed no excuse for a wife's infidelity. "Normal" women rose above their sexual desires and did not seek physical satisfaction even within the sanctions of matrimony. In his pioneering study of sexuality, *The Functions and Disorders of the Reproductive Organs* (1857), William Acton suggested that a modest wife was "serviceable" but basically asexual, submitting "to her husband, but only to please him . . . and for the desire of maternity."[13] Susan P. Casteras interprets Acton's distinction between sexless wives and sexualized mistresses as fully consistent with a wife's obligation to serve as guardian of household morality and savior from masculine promiscuity. Intimacy blessed by marriage literally "'saved' her libidinous husband from the 'sins' of his own sexuality."[14] In every aspect of their relationship, intimate or otherwise, a wife assumed the responsibility for preserving her husband's steadfast morality. A popular marriage manual advised a prospective groom to choose a bride who "will raise the tone of his mind from . . . low anxieties and vulgar cares."[15] A good marriage elevated the spiritual bond over the physical bond, defining love as an ethical rather than a romantic force, fully distinct from sexuality. Charlotte Yonge illustrated this higher type of love in her novel *The Heir of Redclyffe* (1853), when the hero, Sir Guy Morville, reflects on a dream of his beloved Amy.

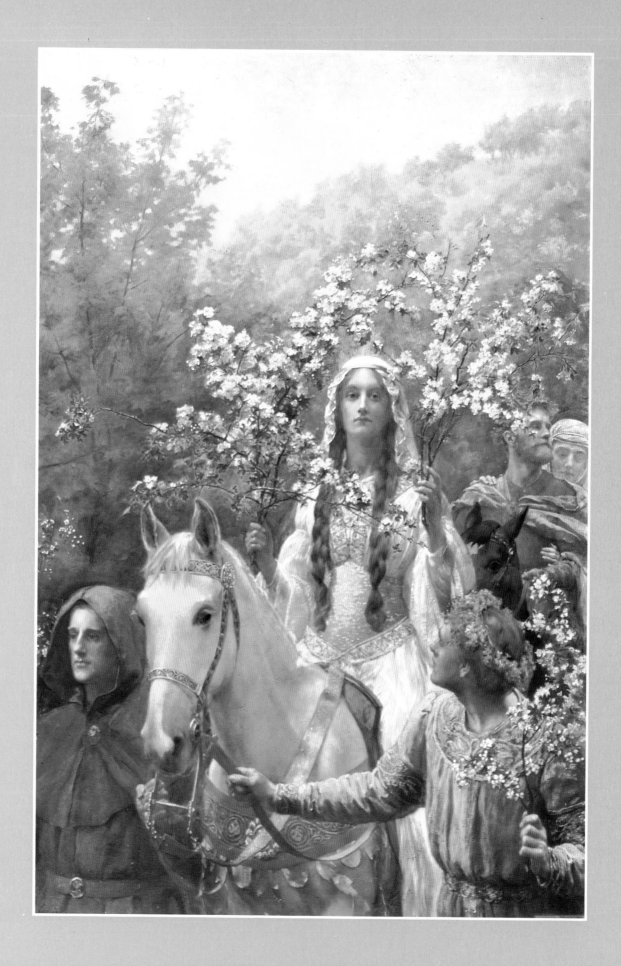

*Sternly as he was wont to treat his impulses, he did
not look on his affection as an earthborn fancy,
liable to draw him from higher things, and there-
fore to be combatted; he deemed her rather a guide
and guard whose love might arm him, soothe him,
and encourage him.*[16]

A proper wife did not experience desire beyond the
wants and needs of her husband. Little wonder that
Victorians—especially men—had no sympathy for
Guinevere. No wife could have asked for a higher
destiny than to marry "ideal manhood closed in real
man."

In general, the Victorian audience found
Guinevere's conduct reprehensible, but not inexplica-
ble. Rather than condemn the queen as lascivious and
unnatural, modern interpreters of the legend sought
the cause of her selfish and misdirected desires. In the
Idylls, Guinevere's infidelity to Arthur was the result
of a single, tragic flaw in her character: she could not
distinguish between attention and devotion. As a girl,
Guinevere was foremost in her father's thoughts. She
was his only child and his pride, for "She was the
fairest of all flesh on earth, / . . . and in her his one
delight" ("The Coming of Arthur," ll. 3–4). She came
to believe in her own worth and beauty to such an
extent that she could not recognize the more subtle
yet more profound virtues of others. When Arthur
entered her father's precincts, his modesty deceived
her. He "rode a simple knight among his knights,"
without "The golden symbol of his kinglihood" on
his helmet or his shield (ll. 51, 50). Although she did
not recognize him, he loved her at first sight. But his
duty was to wage her father's wars, and he delayed his
courtship until his kingdom was secure. Guinevere
never understood that his devotion to duty did not
detract from his devotion to her. She longed to be the
center of his life and his endeavors, and his cool
reserve confused and hardened her. As their tragedy
unfolded, she felt that his failure to confront her
indiscretions indicated his lack of interest, based in a
lack of love. "He never spake word of reproach to
me, / He never had a glimpse of mine untruth, / He
cares not for me" ("Lancelot and Elaine," ll. 124–26).
The indulged girl became the hurt and prideful
woman, jealous of anything that drew her husband's
interest away from her.

Lancelot's ardent attention sparked Guinevere's passion. From their first hours together, when Arthur sent his closest friend to bring his betrothed to court, he charmed and flattered her. As they journeyed to court, his interest in her interests made the time pass swiftly, "Rapt in sweet talk or lively, all on love / And sport and tilts and pleasure" ("Guinevere," ll. 383–84). He sought only to distract her from the hardship of their travels, but by the journey's end, Guinevere was enthralled with the knight's sweet attentiveness and courtly manner. And when she saw her future husband, she "thought him cold, / High, self-contain'd, and passionless, not like him, / Not like my Lancelot" (ll. 402–4). As their love grew and deepened, Guinevere's true nature, like Lancelot's, was tortured by her guilt, but she was also distracted by jealousy. The slightest fear that she shared his attentions sent her into a rage. Believing Lancelot wore Elaine's red sleeve as a token of love, she retreated from the court into her chamber, "and there flung herself / Down on the great King's couch, and writhed upon it, / And clench'd her fingers till they bit the palm, / And shriek'd out 'Traitor!' to the unhearing wall, / Then flashed into wild tears" ("Lancelot and Elaine," ll. 606–10). But in public, she kept her composure, "And moved about her palace, proud and pale" (l. 611). Pride was both her downfall and her saving grace. It blinded her to the true nature of men, but it allowed her to maintain the dignity demanded by her station.

As the saga moved toward its tragic and inevitable conclusion, Guinevere progressed slowly to self-realization. Her terror that Arthur would discover her infidelity deprived her of peace, pleasure, and even sleep, and it was at her request that she and Lancelot parted. "O Lancelot, get thee hence to thine own land, / For if thou tarry we shall meet again, / And if we meet again some evil chance / Will make the smouldering scandal break and blaze / Before the people and our lord the King" ("Guinevere," ll. 86–91). She admitted her guilt: "The end is come, / And I am shamed for ever" (ll. 109–10). But her redemption was far from complete. During the wars between her husband and her lover, she found no solace in her anonymous sanctuary at Almesbury. As she tried to retreat into fond memories of her former love, a little novice interrupted her reverie with

Florence Harrison. "It was their last hour," *Tennyson's "Guinevere" and Other Poems.* London: Blackie and Son, 1912. Courtesy of The Newberry Library, Chicago

questions about the court, "About the good King and his wicked Queen" (l. 207). Convinced that the novice meant to shame and torment her—"Lo! they have set her on, / Our simple-seeming abbess and her nuns, / To play upon me" (ll. 306–8)—Guinevere drove her from her cell. The pride that had protected her now stripped away her last shred of dignity. When Arthur invaded her sanctuary and confronted her with the consequence of her actions, the burden of her guilt left her nothing but humiliation.

> *. . . prone from off her seat she fell,*
> *And grovell'd with her face against the floor.*
> *There with her milk-white arms and shadowy hair*
> *She made her face a darkness from the King.*
>
> (ll. 411–14)

When Arthur broke her pride, he gave her a glimpse into a higher reality. As he rode out of Almesbury, she saw him as she should have in that first moment, in the glory of his honor and his purpose, with "The Dragon of the great Pendragonship / Blaze, making all the night a steam of fire" (ll. 594–95). She recognized him—"now I see thee what thou art, / Thou art the highest and most human too" (ll. 643–44)—and she saw that her true purpose was to reverence and respect him. And that realization brought her redemption.

> *It was my duty to have loved the highest;*
> *It was surely my profit had I known;*
> *It would have been my pleasure had I seen,*
> *We must love the highest when we see it.*
>
> (ll. 652–55)

In the end Guinevere saw beyond her own needs and desires, and saw that the best life is lived not in the pursuit of self-satisfaction but to a higher and a greater good. In her penance, a life of service and sacrifice as a nun in Almesbury, she foreswore all attention, learning the true meaning of devotion, using every moment of her remaining days to provide for the needs of others.

Throughout Tennyson's *Idylls*, Guinevere's slow and painful transformation explains, and to some degree excuses, her actions. "The Defence of Guenevere," written by the Pre-Raphaelite William Morris, allows her to speak for herself. Morris chose a powerful moment from the traditional narrative that Tennyson deleted: Guinevere's trial for treason against the king. As in the *Idylls*, Lancelot and Guinevere meet in her chamber, agreeing to part. But Mordred and his brothers invade their privacy. Lancelot fights and then flees, while Guinevere is dragged off to face her accusers before the king. The poem opens as Guinevere gathers her composure, proud before her enemies, dignified under their scrutiny.

> *But knowing now that they would have her speak,*
> *She threw her wet hair backward from her brow,*
> *Her hand close to her mouth touching her cheek,*
> *As though she had there a shameful blow,*
> *And feeling it shameful to feel aught but shame.*
>
> (ll. 1–5)

She admits her error in loving Lancelot over her husband, but also maintains the innocence of her decision. She asks her accusers to imagine their last moment before death, when a "great God's angel" would hold before them two pennants on wands—one blue and long and waving, one red and blunt—commanding them to choose. Would they have any greater control over the consequences? "No man could tell the better of the two. / After a shivering half-hour you said, / 'God help! heaven's colour, the blue;' and he said 'hell'" (ll. 36–38). In her own defense, Guinevere pleads ignorance and innocence, and admits she has had to live with the tragic results of a moment's decision. For Morris's Guinevere, pride is dignity and self-awareness is recognition. Neither broken nor humiliated, this Guinevere enthralls her accusers, makes them listen to her side of the tale, and stalls for time until hoofbeats ring out of the distance, as Lancelot approaches, ready to undertake her rescue. Morris's commanding portrayal of Guinevere displeased most of the contemporary critics, and his presentation of the queen as unrepentant but fully redeemed drew little sympathy from the general Victorian audience.[17]

When Morris painted the queen, he tempered her pride with self-absorption. *Queen Guenevere* features a tall, composed but solitary figure. She is neither the agent of her actions, nor even a part of a nar-

above:
Florence Harrison. "We needs must love the highest,"
Tennyson's "Guinevere" and Other Poems. London: Blackie
and Son, 1912. Courtesy of The Newberry Library,
Chicago

right:
Eleanor Fortiscue Brickdale. "Guinevere as a Nun," *"Idylls
of the King" by Alfred Lord Tennyson*. London: Hodder and
Stoughton, n.d. Private collection

rative. Alone in her chamber, the rumpled bedclothes behind her marking either the broken sleep of a night's passion or despair, she pauses as she buckles her belt, lost in her thoughts. Guinevere's face hides her emotion; it is a mask of ambiguity. The mood— heartsore, sorrowful, introspective—reveals how difficult it was for the Victorian world to understand the legendary queen. She was neither true nor false, but both: true to her own passionate nature, but false to her faultless king. Despite her transgressions, she was a sympathetic heroine, a character that learned too late to reverence "the highest and most human too."

The flaw in Guinevere's character was tragic. Her limited vision and her greed for self-satisfaction defamed her marriage, betrayed her husband's trust, and sent his dream of a perfect order on a spiraling descent toward destruction. But her final redemption, however restricted, reveals that although her modern audience could not forgive her actions, they did not totally condemn her intentions. In the end, the modern Guinevere possessed a womanly heart, deserving of forgiveness and capable of retribution. Guinevere's falseness proved her own punishment, and it taught her to be true. Only a woman without a woman's heart knowingly destroyed the men around her. Greedy for power—a man's prerogative—the truly false woman could not be redeemed. Disguising her quest for ambition with stunning beauty and skillful charms, the false woman deceived men, gaining their love, their trust, and, eventually, dominion over their destinies. She incarnated perversity by reversing the natural order: she wanted to command and gave her victim no choice but to obey. Using her womanly ways as weapons, the false woman's flaw was fatal. She was beyond redemption, and the havoc she wreaked upon those she deceived led to their own destruction. The Arthurian legend presented models for this fearsome woman of power in the forms of sorceress and spell caster, women who sought and possessed power. The mysterious names of Morgan-le-Fay, Nimuë, and Vivien gained infamy in the Victorian era. False to their feminine nature, they destroyed rather than nurtured. They were femmes fatales.

In the character of the *femme fatale*—literally, fatal woman—the nineteenth-century fear of and fascination with female sexuality converged. Her irre-

William Morris. *Queen Guenevere.* 1858. Oil on canvas, 28¼ x 19¾". The Tate Gallery, London

sistible beauty captivated men and drew them to her side, and under her power. Her motives were rarely explained, but her dangerous potential was fully comprehended. Enemy to all men and to the male order, she incarnated the deeply rooted misogyny of the period. A woman who scorned family, responsibility, her proper place, and male superiority endangered all who came in contact with her. She was in every sense a deadly force. But unlike the tragic heroine who suffered for the consequences of her flawed soul, the femme fatale had no conscience, and others paid dearly when victimized by her perversity.

The Arthurian legend offers many women to cast in the loathsome role of the femme fatale. Temptation and distraction often took womanly form. For example, the devil, disguised as a beautiful maiden, appeared to Percival on his quest for the Holy Grail, using feminine charms and a poisoned potion to seduce him from his spiritual commitment. As illustrated in the painting by Arthur Hacker, Percival almost succumbs. But the sight of his sword hilt reminds him of the holy cross and gives him strength to resist the devil and resume his holy mission. Time transformed some women from innocence to malevolence. Morgan-le-Fay makes her first appearance in Geoffrey of Monmouth's *Vita Merlini* (c. 1130) as a magical being, a shape-shifter who can fly, a skilled practitioner of herbal medicine. Chrétien de Troyes establishes her sibling relationship to Arthur and praises her benevolence as a healer. But later medieval sources corrupt her soul with jealousy, and she becomes Arthur's enemy. In the Victorian era, Morgan-le-Fay turns fatal. Edward Burne-Jones painted her as a comely seductress, but the poisonous daphne she holds to her lips betrays the danger that would accompany the pleasure. Frederick Sandys's portrayal of Morgan-le-Fay, concocting a spell in her satanic den to harm her royal brother, blends the attraction and repulsion that riveted Victorian interest in the femme fatale. Contemporary critics reveled in terrifying descriptions of the evil temptress. Morgan-le-Fay presented a "beauty prostituted to malicious and lustful cruelty." The *Art Journal* saw her as "a petrified spasm, sensational as a ghost from a grave," and reassured readers that the admirers of this perverse image were few in number.[18]

But of all the seductresses in the Victorian

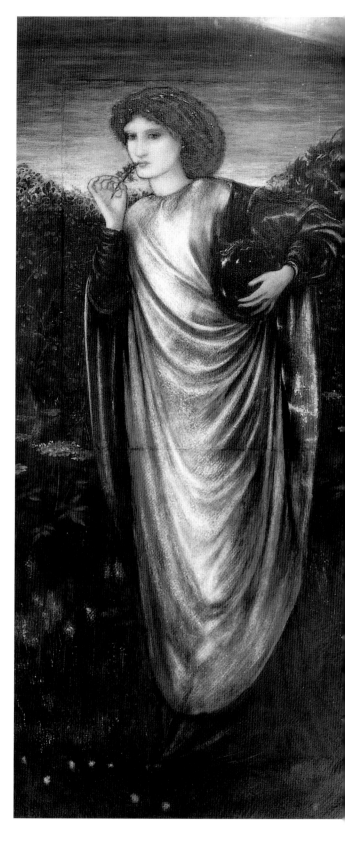

Edward Burne-Jones. *Morgan-le-Fay*. 1862. Watercolor, 38 x 19″. By permission of the London Borough of Hammersmith and Fulham Archives

Arthuriad, Vivien reigned supreme. Although based on traditional sources, this queen of malevolence was in great part Tennyson's invention and among the false women in the *Idylls* she was "the wiliest and the worst" ("Guinevere," l. 29). Her name derives from a circle of mysterious women associated with the character of the Lady of the Lake. Variously known also as Nimuë, Niviene, Eviene, and Viviane, she played an elusive role in the legend: the keeper of Excalibur, the foster mother of Lancelot, one of the queens who bear Arthur to Avalon. In Malory's *Morte Darthur* and other traditional sources, Nimuë comes to court, but she is unrelentingly pursued by Merlin, who "would let her have no rest . . . he was so assotted upon her, that he might not be from her."[19] Given Merlin's vast knowledge of spells and witchcraft, Nimuë fears he is the devil's son, and she seeks release and retaliation. Convincing him to teach her magic, she turns his power back on him, trapping Merlin in an impenetrable prison beneath a rock. She thus frees herself and deprives Arthur of his sage adviser. In the idyll "Vivien" (later, "Merlin and Vivien"), Tennyson gave this tradition an ugly twist. Giving Nimuë a new name, he made her the pursuer and Merlin the prey. With power as her desire and hatred her motive, Vivien exercised her deadly charms in the Victorian vision of Camelot.

From her first moments of life, Vivien knew only slaughter and devastation. Her father, fighting against Arthur in the wars to settle the kingdom, fell in battle, and her mother, heavy with child, died at his side in her grief. "Born from death" (l. 44), Vivien had her father's corpse as her nativity bed and her mother's cold breast as her source of nurture. The lessons she learned from the tragedy of her birth and girlhood deformed her feminine nature and inverted her sense of ethics. But they also made her fearless. She proudly declared: "Virtues? fear them? no, / As love, if love be perfect, casts out fear, / So hate, if hate be perfect, casts out fear" (ll. 39–41). As she grew to womanhood, she fed her hatred, dwelling on her desire for vengeance, against Arthur, his court, and the morality it represented. In Vivien, ravishing beauty housed and hid a degenerate soul. Frederick Sandys depicted her hybrid nature in a portrait of 1863. Framed by a screen of peacock feathers—a symbol of the vice luxury—Vivien appears as a raven-

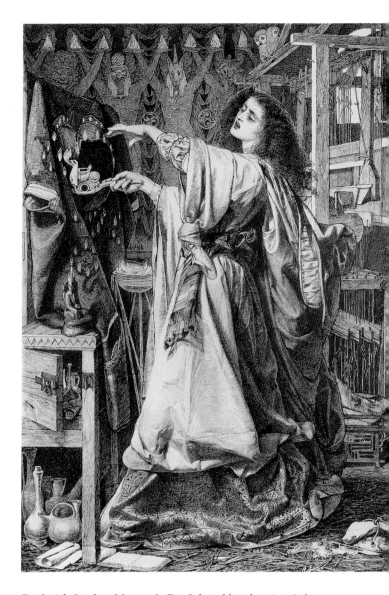

Frederick Sandys. *Morgan-le-Fay*. Ink and brush point, 24½ x 17½″. Sotheby's, Inc.

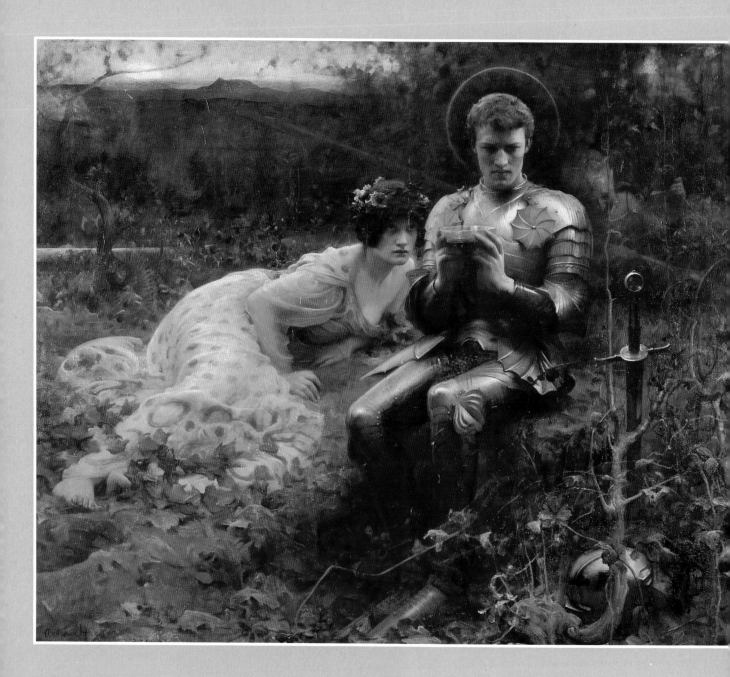

above:
Arthur Hacker. *The Temptation of Sir Percival*. 1894. Oil on canvas, 52 x 62″. Leeds City Art Galleries

opposite:
Edward Burne-Jones. *The Beguiling of Merlin*. 1874–76. Oil on canvas, 73 x 43½″. Board of Trustees of the National Museums and Galleries on Merseyside (Lady Lever Art Gallery, Port Sunlight)

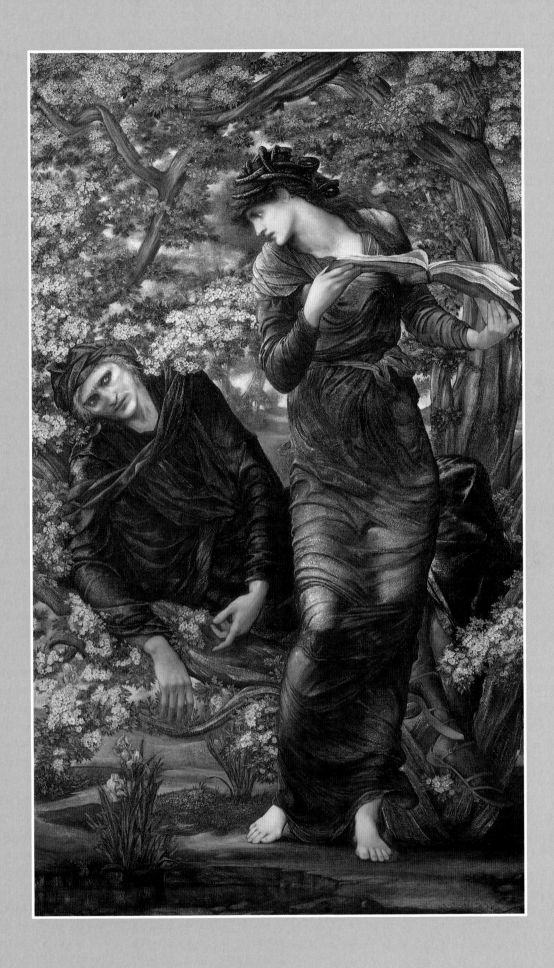

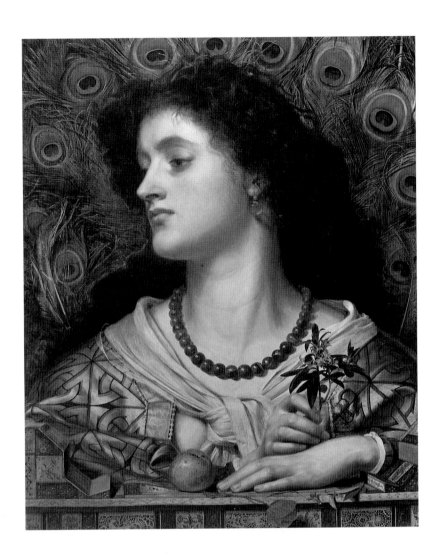

Frederick Sandys. *Vivien*. 1863. Oil, 25³/₁₆ x 20¹¹/₁₆″. Manchester City Art Gallery

haired patrician, with chiseled features and porcelain skin. She warns the viewer of her true nature, holding forth a sprig of poison daphne and fingering a dry and faded rose. An apple calls to mind original sin, but it also draws the viewer's attention to her open bodice and her full, rounded breast. As well as beauty, she cultivated the art of deception and entered Arthur's court as a friendless and pitiable orphan, longing for family and protection. Once firmly established in Guinevere's circle, she found her means to strike her blow against the king.

Choosing her target shrewdly, Vivien set her sights on Merlin. Through seduction and feigned love, she sought to win the mage as an ally. She tried flirtation but could not disguise the taint of her nature. She drew Merlin's interest, but not in the way she sought. "The seer / Would watch her at her petulance and play, / Even when they seem'd unlovable,

and laugh / As those that watch a kitten" (ll. 172–75). As he grew used to her presence, her pursuit became more ardent, and she falsely professed her love. Merlin dismissed her attentions, and Vivien began to stalk him. She followed him out of the court, across the seas to the forest of Broceliande, where she found him at the base of a giant oak, lost in melancholy contemplation. Here, deep in the woods, Vivien approached him and began to work her wiles. Her first seduction was physical.

> *There she lay all her length and kiss'd his feet,*
> *As if in deepest reverence and in love . . .*
> *And while she kiss'd them, crying, "Trample me,*
> *Dear feet, that I have follow'd thro' the world,*
> *And I will pay you worship; tread me down*
> *And I will kiss you for it;" he was mute.*

(ll. 217–18, 224–27)

To Merlin, Vivien incarnated the serpent in Eden. She "writhed toward him" (l. 237), and when she embraced him, her arm "clung like a snake" (l. 240).

Frustrated at his lack of response, she begged for pity, then she turned to rage. She professed her interest in his knowledge, urging him to talk about his own masters in the mystic arts. If she could not have his love, might she have instead his instruction? He cautioned her of the difficulty and the danger, but she would not relent. When pleas no longer had effect, she returned to seduction, and in her arms "The pale blood of the wizard at her touch / Took gayer colors, like an opal warm'd" (ll. 947–48). Interspersing her kisses with tears, she broke the old man down, until Merlin succumbed and "overtalk'd and overworn, / Had yielded, told her all the charm, and slept" (ll. 963–64). Grasping her advantage, Vivien rose and enchanted the wizard. As seen in Edward Burne-Jones's painting *The Beguiling of Merlin* (1874–76), Vivien reveled in her triumph. Statuesque as an Amazon, she vibrates with power. Her body twists like an ancient column, and, as she drones an incantation from Merlin's own magic book, she rivets her gaze on her victim, like a snake eying its prey. Limp and helpless, Merlin stares back at his captor, expressing his fear and resignation. His fate, now in her hands, marks the inversion—and perversion—of the natural hierarchy. She would command, he would obey. And her femininity proved fatal, destroying Arthur's mage and damaging Arthur's order.

It is ironic, and even cruel, that a society that claimed to worship women judged them so harshly. The image of ideal womanhood presented a standard few could attain, and the legend taught its Victorian readers that only a man could be the "highest and most human too." The legend also warned that man's flaws were tragic, but woman's were fatal. When Vivien complained to Merlin of the unequal treatment of men and women in Arthur's court, the mage countered with the expectations of the Victorian era.

Not mount as high! we can scarce sink as low;
For men at most differ as heaven and earth,
But women, worst and best, as heaven and hell.

(ll. 811–13)

Disguised in reverence for the "weaker sex," woman worship confirmed the patriarchy, keeping women in their place, passive, submissive, and subsidiary to men. On their own they were nothing. They needed men to raise them, save them, rescue them, love them. When they acted in their own interest they defied—and defiled—the order. Encoded in the cult of woman worship was the force of masculine control. A person on a pedestal is positioned without an alternative. She must stay put or risk a misstep, with the result a long and dangerous fall.

Gustave Doré. "Merlin and Vivien Repose," *Idylls of the King*. London: Edward Moxon, 1868. Courtesy of The Newberry Library, Chicago

Arthur Hughes. *The Rescue*. Oil on canvas,
43 x 21″. Private collection. Courtesy of
Christie's Images, London

opposite:
W. Goscomb John. *Merlin and Arthur*.
Bronze, 22⅞″ h. National Museum of
Wales, Cardiff

The "Bright Boy Knight"

*Train up a child in the way he should go,
And he will not depart from it.*

Proverbs 22:6

An aura of sentiment enfolds and embellishes most Victorian reminiscences of childhood. No era more firmly believed in it as a stage of innocence, and no society seemed to try as hard to shelter its children from the world's harsh realities. Victorian children appear in art and literature as angelic beings. Unsullied by experience or bad example, they were pure in nature and their instincts were genuine and good. They were loved because they were lovable, and if their circumstances brought them to tragedy, the pathos made them all the more dear. This vision of childhood as a realm of joy and security, when innocence prevailed and dreams were restricted only by the boundaries of imagination, informed the communal memory. Reflecting back on youth, most writers of the era looked through a lens tinted by nostalgia. In an essay on homesickness of 1849, James Anthony Froude reminded readers of their own age of innocence. "God has given us each our own Paradise, our own childhood, over which the old glories linger—to which our hearts cling, as all we have ever known of Heaven upon earth."[1] Childhood's fleeting years offered the adult populace a glimpse of a lost Eden, a purer, simpler time, when the potential to remain pure and simple still existed.

The reality of Victorian childhood was far more complex. The romantic notion of untouched innocence hid the contradictions inherent in youthful experiences. Childhood was regarded as a special phase of life, but the legal system did not distinguish

William Burton. *The Knight's Esquire*. By courtesy of the Board of Trustees of the Victoria and Albert Museum

to serve as a saga of national character and a didactic narrative for national morality, the Victorian legend addressed an adult audience. Many early interpreters recalled that in the eighteenth century King Arthur and his knights survived in children's fairy tales, companions to Tom Thumb and Jack the Giant Killer. Now that the legend regained its original status, few wanted to see it returned to the nursery. Most parents and educators felt that the legend depicted—and even celebrated—incidents that were inappropriate for innocent listeners, and they agreed that children would be far better off not knowing about Guinevere's adultery, Vivien's trickery, and Mordred's treachery. But, as the legend attained an increasingly dominant position as an allegory of national identity, the tradition expanded to encompass the needs and interests of children, drawing them into the domain of the Once and Future King. With the same resilient elasticity that allowed Victorian interpreters to revise the saga to suit their worldview and their standard of morality, writers and illustrators envisioned a story suitable for youth. The conflicts were simplified and the trespasses were censored. Characters were transformed and, wherever possible, tragic results were replaced with happy endings. The legend, like the whole idea behind Victorian childhood, took on an aura of goodness and innocence. A new hero emerged, the "bright boy knight," an energetic youth dedicated to manly achievement but motivated by the pure and naive ideals of a boy's innocent exuberance. In "The Holy Grail," Tennyson used the phrase "bright boy knight" to describe Galahad in his early days at Arthur's court (l. 156), but the image became a model for all children to follow. Through this fantasy of boyhood perfection, ancient wisdom was passed to modern youth, changing both childhood and the legend.

children from adults. Gender and class dictated the boundaries of play, education, and individual future. Only the upper middle class and the wealthy could give their children the protection, the shelter, and the material luxuries that composed the current fantasy of juvenile existence. Children of the working-class poor quickly lost their innocence. Their childhood companions were poverty, hunger, hard labor, and deprivation. Even the privileged child learned that the idyll had its limits, for parental love and protective care went hand in hand with rigorous moral training and restrictive codes of behavior. Victorian childhood might have been defined as an age of innocence, but in reality it was a preparatory stage for adult life, when society's regulations and strictures marked the boundaries of the individual's realm of experience.

The Arthurian legend played a distinctive role in the construction of Victorian childhood. Revived

Victorian child rearing was guided by the belief that, with proper training, a child's nature could achieve a delicate balance between reason and instinct. The concept of reason descended from John Locke's theories of the human intellect. In his *Essay concerning Human Understanding* (1690), Locke described the young, untutored mind as the tabula rasa, or clean slate. The slate received all sensory impressions, and to differentiate between them, the

John Morgan. *Playing at Soldiers*. Oil on canvas. 27½ x 35½". Blackburn Museum and Art Gallery

mind had to cultivate reason. The idea of instinct drew from Jean-Jacques Rousseau's sentimental definition of childhood explained in his novel *Emile* (1762). It was the one time in life that innocence dominated human nature. A child who grew in a free and unstructured atmosphere would preserve that innocence, forming the spiritual foundation for the adult soul. Victorians embraced both these seemingly contradictory principles, celebrating children as free, almost angelic beings but subjecting them to a rigorous education based on rote rather than empirical learning and a religious upbringing that instilled as much a fear of God as a comfort in the prospect of salvation. Parents did not see the inherent paradox in this attitude, and children's instinctual simplicity was regarded as their advantage over maturity, one that made them all the more responsive to structured training. When Charles Kingsley, for example,

William Bromley. *Playing at Marbles.* c. 1871. Oil on canvas, 17 x 23″. Courtesy of the FORBES Magazine Collection, New York. Photograph by Otto E. Nelson

opposite:
William Hippon Gadsby. *Portrait of May and Violet Craik.* 1883. Oil on canvas, 36 x 28″. Private collection. Photograph by courtesy of the Christopher Wood Gallery

advised a young curate in a spiritual crisis, he suggested that the young man follow the example of children. "You may think too much! . . . A child goes straight to the point, and it hardly knows why . . . Remember that habit . . . If you wish to be like a little child, study what a little child could understand . . . Use your senses much and your mind little."[2]

High rates of infant and juvenile mortality also shaped the Victorian vision of childhood. All too often a child's life was brief. Chilling statistics reveal that many children had little hope of reaching adulthood. In 1831, 50 percent of all children born in England died in their first year. Thirty years later the mortality rate had dropped to around 30 percent, and by the end of the century, only 14 percent were in genuine danger. The diminution of the mortality rate reflects improved sanitation, better infant care—especially among the poor—and better nutrition in the early years, but well into the twentieth century, epidemics of influenza and typhoid fever regularly decimated the juvenile population.[3] Despite this toll, children constituted a large part of the population, between 30 and 35 percent, during Victoria's reign.[4] Large families were seen as a national resource and

the guarantee of Britain's future. The queen and Prince Albert set the example with nine surviving children, and parents from every social class followed suit.

In a childhood defined as precious and fleeting, the role of play was essential. In the development of a child's instinct, play stimulated the imagination while it dispelled excess energy. But playtime also held instructional value. Children were encouraged to act out stories from history or literature, learning to pattern their own responses after the great men and women of the nation. Role-playing prepared them for the challenges and responsibilities of adulthood. These pastimes proved to be a favorite subject in art, emphasizing the joy and enthusiasm children had for make-believe. John Morgan captured the high spirits of a happy, ragtag army in *Playing at Soldiers*. Marching to the accompaniment of a pennywhistle and a tambourine, these little defenders of the nation are at the ready, with broomstick guns resting on their shoulders. Although Morgan joins girls and boys in his image of playtime, for the most part children's games were strictly gendered. Activities for boys encouraged masculine instincts, such as bravery,

loyalty, initiative, and even aggression. Boys were allowed to be rough, rowdy, even destructive; it was believed to make them manly. They approached their games with competitive seriousness, as seen in the intense concentration of the shooter in *Playing at Marbles* by William Bromley. Similarly, girls engaged in play that taught them feminine roles and characteristics. They pretended to be mothers, teachers, and nurses. They often instructed younger siblings in reading, drawing, or music. Passivity was encouraged, and girls learned to keep quiet and sit still, as seen in the double portrait of the Craik sisters, painted by William Hippon Gadsby in 1883. Following the adage, "Just as the twig is bent, so the tree is inclined," Victorian parents did their best to shape their children's minds, manners, and destinies.

A good home and home life were essential factors in raising good children. Home constituted the world for a small child, and for an adult, through family life and memory, home anchored the heart and the spirit. Family was central to the Victorian social order, giving unprecedented importance to the stability and routines of domestic life. For the father, it was a sanctuary of tranquility, a private source of spiritual rejuvenation away from the public arena of work. For the mother, it was the domain in which she nurtured her loved ones and sheltered them from worldly concerns and dangers. For children, home offered life's lessons, while keeping them safe and secure as they developed a moral core for self-sufficiency. Children of the middle and privileged classes spent most of their youth at home. In the early decades of the era, children received their education in the domestic setting. The wealthy hired nurses and tutors, while the average family relied on the skill of mothers and older siblings. Until 1870, when a national system of education was instituted, learning varied widely among households. During this time, public schools grew to prominence for both resident students and "day boys," taking the male children out of the house in their later boyhood. Girls did not fully share this opportunity. It was not common for them to obtain an education outside the home until the early years of the twentieth century.

The fashion for decorating in the medieval style likely gave children their first view into the past, but the rooms that featured medieval appointments

were usually reserved for entertaining and adult activity. Although children were rarely welcome guests in formal chambers, it is easy to speculate that some decorative schemes had didactic benefits, teaching the children of the household the noble family's history. For example, a fantastic chimney piece in the form of a castle keep, surrounded by murals depicting scenes of battle, was designed by William Burges for the banquet hall of Cardiff Castle in the 1870s and commemorated the life of a famous family ancestor, Robert the Consul, a Norman lord of Glamorgan. But medieval furnishings could be found in the homes of families without a claim to the national patrimony. In fact, the newly rich industrial class widely used medieval appointments to create the atmosphere of an old, established lineage when history did not

John Gilbert. *Young Couple Contemplating a Suit of Armor.* 1869. Watercolor, 18 x 14″. Private collection. Sotheby's, Inc.

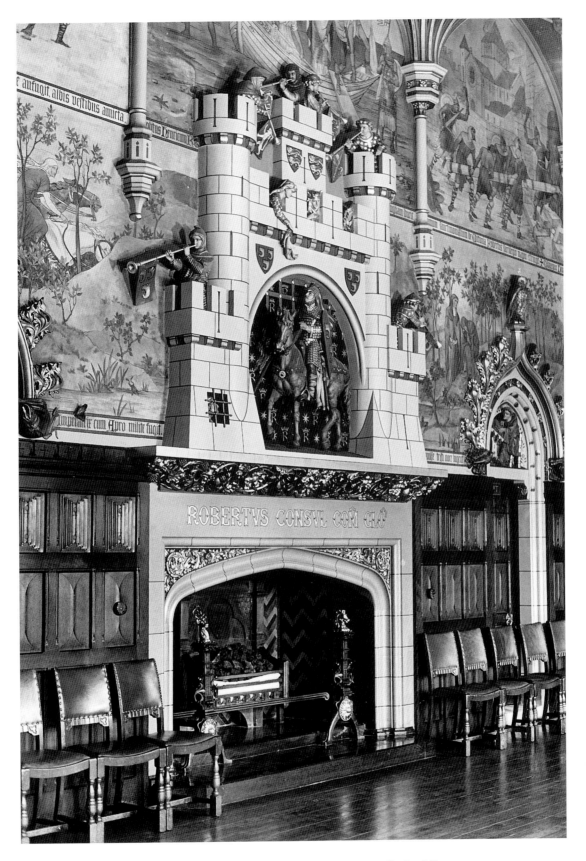

William Burges. Chimney piece, Banqueting Hall, Cardiff
Castle, Wales. 1870s. Cardiff City Council

Edward Burne-Jones. "The Arming and Departure of the Knights," *The Quest of the Holy Grail.* 1891–94. Wool and silk on cotton warp, 8′7⅝″ x 16′11⅞″. Birmingham Museums and Art Gallery

provide prominent predecessors. In 1891, W. K. D'Arcy, an Australian mining magnate, commissioned a set of six arras tapestries with additional dado hangings from William Morris's Merton Abbey tapestry works. Designed by Edward Burne-Jones, they traced the saga of the Grail Quest, from the Grail Maiden's first appearance in Arthur's Hall to Galahad's attainment of the sacred vessel. Installed in Stanmore Hall in Uxbridge, the tapestries transformed a modern dining room into a medievalized chamber where a Victorian industrialist could offer his guests a trip back in time along with their dinner.[5] Any child who would see the story, so gracefully told, with elegant knights and ladies in fabulous costumes, could also be transported on an imaginative journey.

Victorian adults firmly believed that relics of the past enchanted their children and informed their flights of fancy. The evidence is seen in the popularity of images depicting a child, usually a young boy, gazing in awe at an ancient weapon or a suit of armor, imagining the hero who used them in more heroic

Joseph Noël Paton. *I Wonder Who Lived in There?* 1867. Oil on canvas, 24 x 28½″. Sotheby's, Inc.

times. In 1867, Joseph Noël Paton portrayed his own son lost in daydreams of chivalry in *I Wonder Who Lived in There?* From his adolescence, Paton nurtured his own dreams of chivalry. As a young man he walked over twenty miles to attend the Eglinton Tournament and as he gained wealth and reputation as a painter, he built one of the finer collections of arms and armor in Great Britain.[6] The setting is Paton's own studio. Surrounded by relics of medieval history—a lance, a hunting horn, a hauberk, and a crossbow—a little boy sits on a pile of books. He leans forward, propping his elbow on a velvet footstool, and he stares into the open visor of an old, battered iron helm. The title, *I Wonder Who Lived in There?*, is hardly necessary, for the boy's intense concentration and rapt expression reveal that he sees the

William Henry Hunt. *A Warrior Bold.* c. 1835–40. Watercolor. Towneley Hall Art Gallery and Museums, Burnley Borough Council

warrior who once wore the helmet. The battle-scarred hero, resplendent in his armor, skilled with his weapons, and fearless in the face of danger, lives in the boy's imagination. Dreams of glory and adventure take on a dimension of reality for the boy, teaching him to revere the noble code of the chivalric past and preparing him to shape his own life according to traditional models of manhood. The staunch work ethic of the day allowed boys their dreams, if their dreams helped them learn to be men.

Playacting offered children an active role while learning lessons from history, and tales from the Middle Ages dominated this form of play. Memoirs, diaries, letters, and biographies reveal a preference for chivalric games for boys, and on occasion girls were allowed to participate. Like many children of his generation, Dante Gabriel Rossetti learned history and literature through play, but the artistic sensibilities of his home life encouraged creative endeavor as well. With his brother and two sisters, he wrote poetry, composed and acted in little plays, and sketched illustrations for books, all set in the romantic world of knights and ladies.[7] He even designed frontispieces for proposed novels based on chivalric themes of his own invention, and as teenagers, he and his brother William shared a subscription to a boy's magazine called *Tales of Chivalry.*[8]

In his German homeland, Prince Albert had a childhood parallel to that of his English contemporaries. His own play, enriched by his position and privilege, gave dreams of chivalry a sense of reality. He and his brother Ernest owned and wore miniature suits of armor. His grandmother the duchess dowager of Coburg read him the novels of Sir Walter Scott and tales of Saxon knights and heroes. She recalled that Albert's favorite book featured drawings of these noble men and that her grandson made "wonderful eyes in telling that one was called Albert like himself."[9] Albert's own diary, which he began as a precocious four-year-old, features entries describing his early interest in chivalric play. On 23 January 1823, he wrote: "I did a little drawing, then I built a castle and arranged my arms."[10] Even the prince's renowned sense of right and wrong, justice and fairness, could be traced back to boyhood pastimes. His cousin Count Arthur Mensdorff, a childhood companion, shared the following reminiscence with

Queen Victoria in 1863, one year and a half after Albert's death.

> *Thus I recollect one day when we were children . . . [we] were playing at the Rosenau, and some of us were to storm the old ruined tower on the side of the castle, which the others were to defend. One of us suggested that there was a place at the back which we could get in without difficulty. Albert declared that this "would be unbecoming in a Saxon knight, who should always attack the enemy from the front."*[11]

Children from homes less artistic than Rossetti's and from circumstances more modest than Prince Albert's were limited only by their own imaginations. In *Ivanhoe* of 1871, Charles Hunt portrays an enactment from Scott's novel, set in an attic and played with enthusiasm. Using padded sticks and improvised "armor," two boys joust in the tournament of Ashby-de-la-Zouche. "Ivanhoe" sports a feather in his helmet, and his noble steed is a bench covered with a quilt. He unseats his adversary "Sir Brian de Bois-Guilbert," who tumbles from his own mount, a chair turned sideways with a thatch mat for a saddle. The evil Bois-Guilbert has no helmet, but he has a painted mustache and a little padded hauberk bearing his name. On the right of the canvas two boys read the narrative that is acted out in the pantomime, and to the left, one boy applies makeup to another, to prepare him for his role. Girls are allowed to participate in this theatrical, but their parts are limited. Ivanhoe's true love "Rowena" watches her hero with admiration. Her "lady-in-waiting" stands at her side and two "servants" hold a royal canopy—a discarded umbrella—to shade her from the sun. These roles forecast their futures: boys act, while girls watch. Games of chivalry, for the most part, emphasized masculine action; the pretense was encouraged as good and instructional play.

Books provided another form of instructive and imaginative diversion, and books introduced the Arthurian legend to Victorian children. Respected authors and publishers undertook the task of editing—and expurgating—the legend for younger readers, eliminating the conflicts of passion that drove the traditional saga to its tragic conclusion. The frame-

work of the legend remained the same. England, torn by war between petty kings, is set to order and justice by a young and determined knight named Arthur. The traditional characters, and some of their more innocent adventures, survived the well-meaning censors, as did Mordred's struggle for power and the war that destroyed the kingdom. As in the adult's version of the saga, Arthur's retreat into Avalon was tempered with the promise of his return. But, in general, the child's legend was transformed into a series of challenges taken and triumphs achieved by young, spirited heroes, like Gawain, Gareth, Galahad, and Lancelot. Women had little place in these books. The real protagonist of the child's legend was a composite figure: the bright boy knight, scrappy, enthusiastic, energetic, and destined for greatness. The boyhood adventures of Arthur and his men moved to center stage, offering the child reader an association with the legend through identification. A boy who read about Galahad's first appearance in court, or Gareth's rise from kitchen boy to Round Table knight, or Lancelot's fight with a dragon could imagine himself in the role and spark his desire to emulate these figures as men when he himself attained manhood. Almost without exception, the legend was rewritten not simply for children, but for boys, and the word "boys" often figured in the title.

Authors of children's books ranged from well-known men in publishing, such as Tennyson's friend the editor J. T. Knowles, whose *Story of King Arthur and His Knights of the Round Table*, illustrated by G. H. Thomas, appeared in 1861, to anonymous figures with maternal pen names, such as "Your Loving Granny," whose *Six Ballads about King Arthur* appeared twenty years later. Many of these publications were illustrated in black and white, but the development of inexpensive photomechanical color reproduction in the 1890s added quality and variety to new volumes. Andrew Lang's *Book of Romance* of 1902 featured eight colorplates and more than thirty black-and-white images designed by Henry Justice Ford. The pictures are as lively and vivid as the stories they illustrate, and almost every one features the bright boy knight. For his illustrations, Ford chose subjects such as the young Arthur drawing the sword from the stone; the young king gazing at the questing beast; and a surprised and humiliated Gareth, cring-

Charles Hunt. *Ivanhoe*. 1871. Oil on canvas, 29¼ x 44⅜″.
Courtesy of the Forbes Magazine Collection, New York

ing when Lynette, rejecting him as a suitor, proclaims, "Faugh sir! You smell of the kitchen." It is easy to imagine a parent reading this book to a child, pausing at points in the narrative to discuss the appropriate picture. The life of Arthur and his knights presented a pattern for boys' behavior, but the message was more than just didactic; with this lighthearted humor, it became endearing and entertaining.

One book that held a special appeal for young and old alike was Henry Gilbert's *King Arthur's Knights: The Tales Re-Told for Boys and Girls*, published in 1911. With fine reproductions after the watercolors and drawings of Walter Crane, it was one of the handsomest volumes of the era. Crane's paintings and interior designs made him a leader of the Arts and Crafts movement, but he gained his popular reputation through his children's illustrations. As early as the 1870s, his imaginative and colorful pictures appeared in "toybooks," published by Edmund Evans, including *The Baby's Opera* (1877), *The Baby's Bouquet* (1878), and *The Baby's Own Aesop* (1887). Expensive and finely produced, toybooks emphasized picture over text, and it is possible that Crane's exquisite designs appealed to parents for their fine aesthetic sense as much as they appealed to children for their animated illustrations.

Gilbert based his text on Malory's *Morte Darthur*, recrafting the complicated saga to suit the attention span of young readers and featuring the most exciting of the knight's adventures to hold their interest. Crane made similar selections. He chose to illustrate the scenes that would have an immediate appeal to his audience, including "Arthur Draws the Sword from the Stone," "Beaumains Wins the Fight at the Ford," and "Young Percival Questions Sir Owen." In each image a boy dominates the scene, a bright boy knight, ready for adventure. The scene in "Sir Galahad Is Brought to the Court of King Arthur" suggests how Crane captured a child's imagination. The setting is King Arthur's Hall, and the full company of knights gathers round the table. Their shields, hanging on the wall, create a festive air, just right for the feast in progress. In the open center of the table, Merlin presents his young charge, Galahad. Tall, straight, and classically handsome, Galahad serves as a fine model for youth, recalling the words of Tennyson's Arthur, who said to the boy upon his

Henry Justice Ford. "Faugh sir! You smell of the kitchen," *The Book of Romance*. London: Longmans, Green, 1902. Courtesy of The Newberry Library, Chicago

Arthur Rackham. "How Sir Lancelot Fought a Fiendly Dragon," *The Romance of King Arthur and His Knights of the Round Table*. London: Macmillan, 1917. Courtesy of The Newberry Library, Chicago

Walter Crane. "Sir Galahad Is Brought to the Court of
King Arthur," *King Arthur's Knights: The Tales Re-Told for
Boys and Girls*. London: T. C. and E. C. Jack, 1911.
Courtesy of The Newberry Library, Chicago

investiture, "God make thee good as thou art beautiful!" ("The Holy Grail," l. 136). The details of the image are descriptive rather than narrative. The drinking horns, the pies on the table, the bowl in the form of a galley ship could offer points of interest, making medieval life seem all the more real. Through a picture like this one, many boys imagined what it would be like if they were presented to King Arthur. In the figure of Galahad, Crane gives them a port of entry into a magical world, as well as a fine knight to emulate.

Later children's books emphasized fantasy over instruction, as seen in Alfred W. Pollard's *Romance of King Arthur and His Knights of the Round Table*, illustrated by Arthur Rackham and published in 1917. Pollard's text, like Gilbert's, offers an abridgment of Malory's classic saga, this time for a slightly older audience, but Rackham's pictures raise the tale to a higher imaginative plane. Rackham's reputation as an illustrator of fairy tales was well established early in the century. He designed images for some of the most fabulous of Victorian stories, including *Peter Pan in Kensington Gardens* (1906) by J. M. Barrie, Lewis Carroll's *Alice in Wonderland* (1907), and *The Allies' Fairy Book* (1916) by Edmund Gosse. Rackham reinvented the practical world of the modern Arthuriad, bringing it closer to the nursery vision than it had been since the dawn of the revival. Like Crane, he chose subjects that would appeal to boys. In "How Sir Galahad Drew Out the Sword from the Floating Stone at Camelot," the hero is the young and eager knight, ready to prove his worth. Among the attentive crowds are all types of cunning characters, the plump squire with his ridiculous profile, the foxy-faced merchant behind him, the droll-looking jester deep in the crowd. These comic figures mingle with the beautiful ladies, proud knights, and the handsome king, all cheering the boy on to glory. This is a safe and slightly silly world, a nursery-rhyme fantasy, where the terrible is tempered with whimsy, and grotesqueness is funny rather than fearsome.

The troubled world of Tennyson's *Idylls* was not deemed hospitable to children. In general, selections from Malory's *Morte Darthur* provided the source for juvenile Arthurian literature. Perhaps the distance of Malory's Arthuriad from contemporary society and its sentiments removed it from the child's

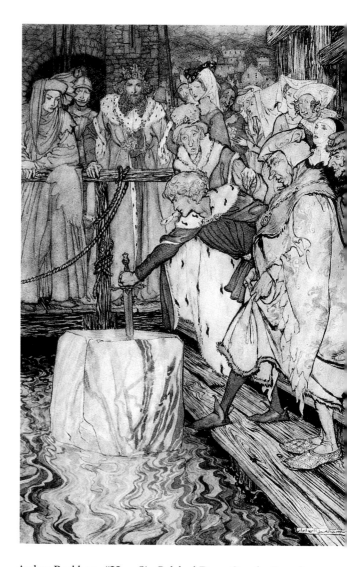

Arthur Rackham. "How Sir Galahad Drew Out the Sword from the Floating Stone at Camelot," *The Romance of King Arthur and His Knights of the Round Table*. London: Macmillan, 1917. Courtesy of The Newberry Library, Chicago

reality, while Tennyson's vision of Camelot seemed too close to home in its conflicts and its cares. Images of childhood do appear in the *Idylls*; they are rare, but they are telling. And, like the portraits of the principal characters in Tennyson's Arthuriad, they are modernized, illustrating present convictions disguised in forms from the past.

The children in the *Idylls* prove that the child is the father to the man. The boy Gawain enters the legend with vigor and spirit. On a visit with his mother, Bellicent, to Leodogran's court, he can barely contain his high energy. He "ran like a colt, and leapt at all he saw." He tears through the chamber like a fresh new force, "follow'd by his flying hair," "breaking into song" ("The Coming of Arthur," ll. 319–21). Gawain embodied the ideal of the free and happy boy, but his brother Modred's suspicious nature turned sour, even in youth. While Gawain sped from the room, eager to be off at play, "Modred laid his ear beside the doors" (l. 322), wanting to hear adult secrets, spoiling his childhood with adult desires before his maturity could temper them. Gareth, the youngest of Bellicent's sons, yearned to take on manly responsibilities. But Bellicent felt strongly protective of him so she allowed him to travel to court to serve in Arthur's kitchen, not as a knight in his order. Gareth's bold spirit and chivalric nature set him apart from his companions in the scullery, and no matter how low the task, "Gareth bow'd himself / With all obedience to the King, and wrought / All kind of service with a noble ease / That graced the lowliest act in doing it" ("Gareth and Lynette," ll. 476–80). This dedication did not go unnoticed, and when Gareth approached Arthur to convince the king to give him a challenge before he fulfilled his term of indenture, Arthur relented. But he instructed Lancelot to follow the boy and ensure his safety. "Look therefore when he calls for this in the hall, / Thou get to horse and follow him far away. / Cover the lions on thy shield, and see / Far as thou mayest, he be nor ta'en nor slain" (ll. 569–72). Lancelot follows and fulfills the king's command. The perfect guardian, he knows when to intervene and when to let Gareth try his own hand. In this way, Gareth makes the perilous passage from boyhood to manhood, and at the end of the tale, he is ready to take his place with the knights of the Round Table.

Arthur Rackham. "The Questing Beast," *The Romance of King Arthur and His Knights of the Round Table*. London: Macmillan, 1917. Courtesy of The Newberry Library, Chicago

The brevity of Tennyson's account of Arthur's boyhood often disguises its significance. Arthur's mysterious origins concern Leodogran, and he hesitates as he considers Arthur's wish to marry his only daughter. He calls Bellicent to court; as Arthur's half sister, she can confirm his lineage. But Bellicent's recollections are wrapped in ambiguity. Although she was very young, she remembered that Uther died, "moaning and wailing for an heir" ("The Coming of Arthur," l. 367). As a girl, she knew of the local legend, how Merlin and his teacher, Bleys, stood by the sea, and watched wave after wave break at the shore, until the ninth wave "slowly rose and plunged / Roaring . . . And down the wave in flame was borne / A naked babe." Merlin caught the infant and lifted him to the sky, proclaiming his identity to the world. "The King! / Here is an heir for Uther" (ll. 380–85).

Merlin delivered the child to Anton, a local knight of modest means and good character. Bellicent encountered the boy and cherished fond memories of his manly nature, already manifest in youth. Once, as a girl, Bellicent bore a beating in silence for something she did not do. Hurt and angry, she gave full vent to her emotions afterward. "I ran / And flung myself down on a bank of heath, / And hated this fair world and all therein" (ll. 341–43). As if by magic, and perhaps by Merlin's agency, Arthur came to comfort her.

> He was at my side,
> And spake sweet words, and comforted my heart,
> And dried my tears, being a child with me.
> And many a time he came, and evermore
> As I grew greater grew with me; and sad
> At times he seem'd, and sad with him was I,
> Stern too at times, and then I loved him not,
> But sweet again, and then I loved him well.
> And now I see him less and less,
> But those first days had golden hours for me,
> For then I surely thought he would be king.
>
> (ll. 347–57)

Every trait that graced Arthur's character in manhood—his protective nature, his sense of justice, his constancy, his commitment to a higher cause, his gentleness and chivalry—distinguished his demeanor in his youth. Even before the grand moment of

recognition, Arthur proved his worth. He was born to be king.

Through his brief account of Arthur's early years Tennyson justified manly destiny, but to explore the possibility of boyhood perfection, Tennyson used another character in a poem that predated the *Idylls*. Although Tennyson wrote "Sir Galahad" in 1834, it did not appear until the publication *Poems* of 1842. In it, the poet cast an image of ideal male youth, brave and eager, innocent and true. Tradition inspired Tennyson in his portrayal. The young knight, fully dedicated to his spiritual search for the Holy Grail, was offered as "the type of chastity," and Tennyson described him as "something of a male counterpart to St. Agnes."[12] The story of Galahad as the superior knight worthy of finding the Grail first appeared in full as part of the medieval French romance *Queste del Saint Graal*. Fathered by Lancelot through a liaison with the daughter of King Pelles, Galahad takes a lifelong vow of virginity to redeem his illegitimate origins. Upon his arrival at Arthur's court, the young knight impresses his sovereign with unmatched prowess and extraordinary beauty, both seen as evidence of his moral perfection. He triumphs in supernatural challenges—drawing a sword from a stone and sitting in the "siege perilous" that had destroyed all other occupants—and through these achievements he is recognized as the preordained victor of the holy quest. When he finally discovers the Grail and understands its spiritual mystery, he fulfills the single purpose of his life and he dies in ecstacy, but his spirit lives on, reigning as a prince over the holy city of Sarras, in the company of angels. Malory's vision of the Grail knight followed the French example. But in the nineteenth century, when William Wordsworth revived the character in "The Egyptian Maid" of 1835, Galahad was rewarded with marriage rather than apotheosis.

Unlike Wordsworth, Tennyson preserved Galahad's medieval role as the pure knight who spurned earthly reward for heavenly promise. The poem, written in Galahad's own voice, proclaims the young knight's creed of chivalry, dedication, and purity. His first words celebrate his confidence and his convictions. "My good blade carves the casques of men, / My tough lance thrusteth sure, / My strength is as the strength of ten, / Because my heart is pure"

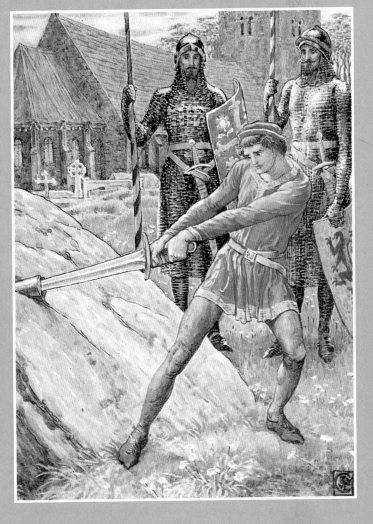

above:
Florence Harrison. "Three angels bear the Grail,"
Tennyson's "Guinevere" and Other Poems. London: Blackie
and Son, 1912. Courtesy of The Newberry Library,
Chicago

right:
Walter Crane. "Arthur Draws the Sword from the Stone,"
King Arthur's Knights: The Tales Re-Told for Boys and Girls.
London: T. C. and E. C. Jack, 1911. Courtesy of The
Newberry Library, Chicago

Gustave Doré. "They found a naked child," *Idylls of the King*. London: Edward Moxon, 1868. Courtesy of The Newberry Library, Chicago

(ll. 1–4). True to his oath of honor, he respects women and never hesitates to give them his protection. Just like any mortal man, he draws inspiration from feminine charm, declaring, "How sweet are looks that ladies bend / On whom their favors fall! / For them I battle till the end, / To save from shame and thrall" (ll. 13–16). But he rejects their gratitude as earthly pleasure; he envisions a higher reward than physical fulfillment. "More bounteous aspects on me beam, / Me mightier transports move and thrill; / So keep I fair thro' faith and prayer / A virgin heart in work and will" (ll. 21–24). In the course of the poem, Galahad describes his solitary journey through life. He faces dangerous adventures and supernatural phenomena but continues on his quest, never doubting, always determined, his fate guided by angelic voices that reassure him, "O just and faithful knight of God! / Ride on! the prize is near" (ll. 79–80). The path he has chosen is in every way traditional and true to the legend, but his exuberance, his earnestness, and his unrestrained joy in his youth, his strength, and his destiny resonate with the enthusiasm of Victorian boyhood rather than medieval spirituality.

The glittering verses of Tennyson's "Sir Galahad" flashed before the Victorian public like sunlight on shining armor. No Arthurian poem enjoyed greater popularity. It quickly became a favorite work, praised for its realization of an ideal youth, motivated by honor and dedicated to a life of service and purity. Just as Arthur would reign in the *Idylls* as the epitome of manhood, Galahad in this new poem rose as a role model for youth. He was the true "bright boy knight," a medievalized symbol of contemporary hopes and aspirations. Little attention was paid to the object of his quest; his code of conduct and strength of character appealed to the contemporary audience. When Tennyson published the first four *Idylls* in 1859, without Galahad as a featured character, critics openly expressed their disappointment. One writer in *Blackwoods Magazine* implored Tennyson to return to the subject of Galahad and continue the adventures of that "noble type of true Christian chivalry—of that work on earth which only pure hearts love, only clean hands can do."[13]

Edward Burne-Jones, although twenty years old and an undergraduate at Exeter College at Cambridge, responded to the poem with boyish enthusiasm. When he first discovered it, he wrote to his childhood companion Cormell Price, urging him to join him in his admiration. "I have my heart set on our founding a Brotherhood," declared Burne-Jones. "Learn Sir Galahad by heart. He is to be the patron of our Order." He signed the letter "General of the Order of Sir Galahad."[14] Several years later, Burne-Jones met Tennyson while staying at the London home of his friend Valentine Prinsep. Although he had long abandoned his notion of "The Order of Sir Galahad," he kept alive his infatuation with the poet's vision of the Arthurian hero. He produced a small, exquisitely rendered drawing based on the first two and the final stanzas of the 1842 poem. Burne-Jones portrayed Galahad as a dreamy, self-contained youth, barely out of adolescence. He armed the knight according to Tennyson's description. Galahad's "good blade" is secured in its saddle sheath and the "tough lance" is cradled in his arm. His sweet expression—beautiful, boyish, and pensive—testifies to his strength-giving purity. In the background, knights dally with beautiful damsels, but Galahad pays them no heed. Flirtation and seduction are no match for his thoughts of "more bounteous aspects" and "mightier transports." He holds a chalice, the symbol of his destiny, and rides with unwavering conviction toward the fate he knows awaits him. Burne-Jones's portrait of Galahad as a serene youth, untroubled by question or doubt, striving toward his rightful purpose, set a visual standard that endured as long as the poem's popularity.

Despite the continual urgings of his friends, his family, and the critics, it took Tennyson almost thirty years to resume work on the story of Galahad. It was not the character that made him hesitate, but the quest, which Tennyson found difficult to translate into modern terms. Spiritual mysteries and holy vessels conflicted with Tennyson's own religious convictions, and he feared a contemporary version of the Grail Quest would compromise both his own beliefs and the saga's original significance. He wrote to his friend the duke of Argyll, "I doubt whether such a subject could be handled in these days without incurring a charge of irreverence. It would be too much like playing with sacred things. The old writers *believed* in the Grail."[15] But, after considerable

Edward Burne-Jones. *Sir Galahad*. 1858. Pen and ink, 6 x 7½″. Fogg Art Museum, Harvard University, Cambridge. Bequest of Grenville L. Winthrop

below:
Arthur Hughes. *Sir Galahad.* 1870. Oil on canvas, 44½ x 66″. Board of Trustees of the National Museums and Galleries on Merseyside (Walker Art Gallery, Liverpool)

encouragement from his wife, Emily, voicing the wishes of the queen and the crown princess, Tennyson completed his second poem featuring Galahad. "The Holy Grail" appeared in a collection of new poems published in 1869, and in 1870, Tennyson gave it its place in the *Idylls*.

"The Holy Grail" shocked the public. Rather than telling a triumphant tale of unwavering spiritual commitment, Tennyson offered his readers a tragedy, a saga of failure, exhaustion, ambivalence, and denial. Percivale serves as the narrator of "The Holy Grail." After failing to complete his vow to find the holy vessel, he retreats into a monastery and reflects upon the wrenching series of events that decimated the court and damaged his life. Obsession, not spiritual commitment, motivated the quest. His own sister, the first to hold the vision, starved herself in devotion. Lancelot descended into madness. Galahad, who rides through the poem like a phantom, severs all ties with the world, crying, "If I lose myself, I save myself!" ("The Holy Grail," l. 178). These self-destructive acts contrast with Arthur's refusal to join the quest. When the knights vow to undertake the futile adventure, Arthur is away, defending his outlying provinces against a brutal invasion. Arthur makes the socially responsible choice, placing public obligation over private aspiration, even if that aspiration is spiritually sanctioned.

In "The Holy Grail," Tennyson questions more than an arcane religious belief. He confronts the viability of boyhood perfection in an adult world dependent on masculine action. At the end of "The Holy Grail," Arthur chastises his men for abandoning their manly duty, challenging their motivation— "What are ye? Galahads? . . . nay . . . but men" (ll. 306–7)—and explaining why he refused the quest.

> The King must guard
> That which he rules, and is but as the hind
> To whom a space of land is given to plow,
> Who may not wander from the allotted field
> Before his work be done.
>
> (ll. 901–5)

A boy may lose himself in an impossible dream, but a man puts aside his fantasies and applies his strength and soul to practical, worldly service. Within this vision of ideal manhood, Galahad is condemned to perpetual boyhood. By losing himself to save himself, he deprives his community of the services he can render. Fulfilling his own desire over that of his society blocks his passage into maturity and prevents him from taking his proper place among Arthur's men. Tennyson was not alone in challenging the prevailing view of Galahad. In 1870, Arthur Hughes portrayed the Grail knight's fear at the uncertainty of the quest. With shoulders hunched, he clasps his hands around his lance, as if hoisting a holy banner. A rugged road stretches before him; his horse tentatively enters the rocky terrain. Gone is the boyhood exuberance and fantasy of invincible immortality with strength as the strength of ten. This Galahad crosses the threshold from boyhood to manhood and comprehends the profound meaning of his passage.

Tennyson's revision of the Grail Quest did little to sway the Victorian public from their devotion to the ideal of the bright boy knight. "The Holy Grail" met a cool critical reception, while "Sir Galahad" of 1842 remained current and popular. Fans of the bright boy knight preferred to think only of his virtuous character. The course of his life, the consequence of his actions, and his position as a boy in the world of men contradicted some of the most cherished beliefs about childhood. Rather than change those beliefs, they separated Galahad from his tradition. Just as the Victorians adored Elaine, valuing her girlhood innocence over her life, they adored an ever-striving, ever-earnest, and ever-naive Galahad, always reaching for the Grail but never attaining his goal. Galahad gained an iconic significance, thriving outside of his narrative. Through his eternal quest, he personified the unlimited scope of adolescent potential, and his boundless and unquestioning determination—motivated by youthful energy and sheer naiveté—informed British boys' identities well into the twentieth century.

Although Galahad was the best known and best loved of all the bright boy knights, the type proved enduring and infinitely variable. In painting, any image of a young, untested warrior gained importance—and appeal—through association with Galahad's iconography. For example, John Pettie offers no clue to the identity of the novitiate in *The Vigil*. Alone in a chapel, he kneels before an altar,

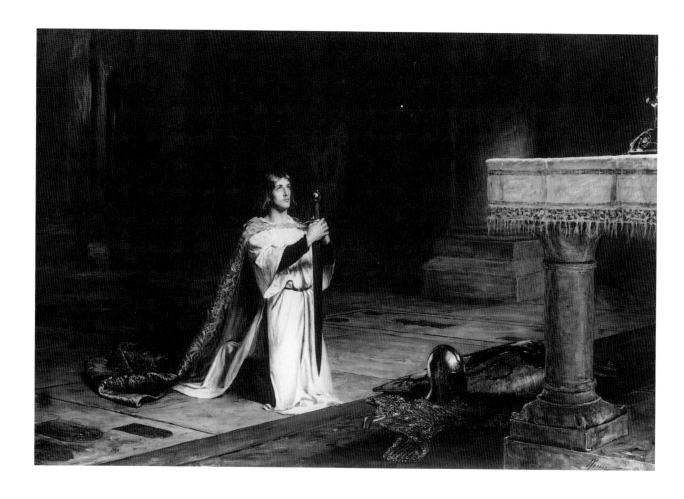

John Pettie. *The Vigil.* 1884. Oil on canvas, 44⅞ x 66⅛".
The Tate Gallery, London

preparing for his first battle through a night of prayer
and meditation. His helmet bears no emblem, his
shield is still unblazoned, and his surcoat is plain,
white as the robe of a monk or nun. But as he holds
his sword up to the altar, offering his youth and
strength to the Christian code of chivalry, the shadow
cast on his garment recalls Galahad's heraldry, a sim-
ple cross on a plain white field. Pettie's knight tran-
scends anonymity and joins with Galahad as a symbol
of resolute possibility, an invaluable resource for the
nation. Girls also drew inspiration from this icon of
purity and potential. If they were not content to think
of bright boy knights as their protectors, they could
emulate Jeanne d'Arc, whose image enjoyed an
unprecedented popularity in late Victorian Britain.
Jeanne's history needed a bit of adjustment to suit the
Victorian audience. Her role in the Hundred Years'
War, leading several victorious incursions against
British forces, and her death by burning at the stake
as a prisoner of war faded into obscurity, and, like
Galahad, she enjoyed an existence as an icon outside

of her narrative. Jeanne the French Catholic martyr became Joan the British heroine, transcending the limitations of her story as well as the boundaries of nationality and gender.

In popular literature, the spirit of the bright boy knight came to life through contemporary counterparts. The scrappy young hero of Thomas Hughes's *Tom Brown's Schooldays* (1857) waged a constant struggle against schoolyard bullies and childhood injustices. Tom never gave up. He faced every challenge, especially when the conflict involved a point of principle or the protection of the defenseless. With dogged determination, this "typical" British middle-class lad joined with Galahad to incarnate the kind of righteous innocence so admired by the Victorian public. The book saw over fifty reprints and editions before the end of the century, and the adventures

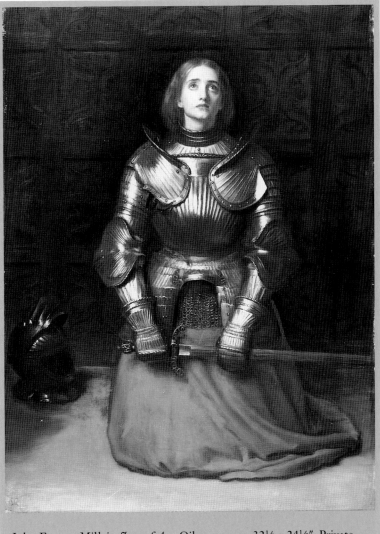

John Everett Millais. *Joan of Arc*. Oil on canvas, 32½ x 24½″. Private collection. Courtesy of Christie's Images, London

of Tom at Rugby symbolized British schoolboy life for young and old alike.[16] Few modern boy knights matched Tom Brown's plucky tenacity, but there were many boys in literature who followed in his footsteps. Journals such as the *Boy's Own Paper*, founded in 1879, chronicled the heroic acts of boys in fact and fiction. In novels, boyish bravery and determination were incarnated in many forms, including the delicate, satin-garbed, long-tressed Cedric Errol, who

proved a powerful protector of his mother and his estate in Frances Hodgson Burnett's *Little Lord Fauntleroy* of 1886. These stalwart boys even stood up against enemies of the nation, as in E. M. Green's *Little Military Knight* of 1911. The hero of the tale, Adrian Cunningham, enjoyed a boyhood well versed in the chivalric ideal. Raised on the grounds of Windsor Castle, he regularly visited St. George's Chapel to admire the emblems and the banners of the honorable Order of the Garter. He modeled his life on Charlotte Yonge's hero of *The Little Duke* (1854), and he drew inspiration from his tutor's reading of the *Idylls of the King*. It is hardly surprising, then, that Adrian did not shirk when duty called. Through his quick wits and a daring visit to the prime minister in London, he single-handedly foiled an assassination plot and saved the king.

Clubs for boys also helped promote this youthful ideal, directing the resource of adolescent energy toward national service. One of the first was the Boys' Brigade, brought into being in 1883 by William Alexander Smith, a Glasgow businessman.[17] Many of these societies had religious affiliations, such as the Church Lads' Brigade and the Jewish Lads' Brigade, both started in 1891. The most popular, influential, and enduring of these quasi-military boys' organiza-

tions was the Boy Scouts. Chivalry played an important part in the plan of its founder, Robert Baden-Powell. From its inception in 1900, the Boy Scouts looked to medieval knights as their role models. Baden-Powell dubbed his scouts "Young Knights of the Empire," and his best-selling handbook *Scouting for Boys*, published in serial parts in 1908, followed the form of Kenelm Digby's *Broadstone of Honour*, using the heroes of chivalry to illustrate the appropriate habits, ambitions, and patterns of behavior for bright boy knights of Baden-Powell's new "order."

Although the variations on the myth of the bright boy knight always found an enthusiastic audience, none stirred the imagination like Galahad. The enduring extent of the character's popularity and the profound effect the image had on the life of British youth in late Victorian England is powerfully illustrated in the history of a painting by George Frederick Watts. From its first appearance at the Royal Academy exhibition in 1862, Watts's *Sir Galahad* was praised as a perfect visual response to Tennyson's poem. As Watts portrayed him, Galahad is young, serene, and beautiful. His graceful composure echoes the confidence of Tennyson's exuberant knight, and his gaze into the uncertain distance affirms his unwavering dedication. The surrounding woods are dense but not forbidding, and his calm white horse, with its lowered head, mirrors its master's reverence. Watts inscribes Galahad's innocence and chastity in the knight's androgynous appearance. His features are delicate, almost feminized; the subject often was, and still is, mistaken for Joan of Arc.[18] This rarefied, genderless beauty marks a soul untouched by base love or carnal passion. Watts's *Sir Galahad* is a portrait of unbounded potential with the promise of true fulfillment.

Watts denied any connection between his painting and Tennyson's poem. When he exhibited the work in 1862, he avoided the common practice with literary paintings of including an extract of the text source in the catalogue. In 1882, he presented another version of the work at the Grosvenor Gallery without its Arthurian title, using instead a quotation from Chaucer's *Canterbury Tales*. It is difficult to understand why Watts so strongly desired to separate his image from Tennyson's popular poem. He and the poet were friends, and they even shared a residence—

the London home of Sara and Thoby Prinsep, where Burne-Jones had met the laureate—for a brief time in 1858, while Tennyson was working on the first four *Idylls*. Although Watts rejected the association with the poem, he kept returning to his picture, painting four versions of the image during the years 1862–1903.

When the work was displayed at the Grosvenor Gallery in 1882, it caught the eye of H. E. Luxmore, a young, enthusiastic schoolmaster from Eton. Luxmore wrote to Watts, inquiring if the painting could be lent for exhibition at Eton Chapel. Although Watts felt unable to comply, when Luxmore approached him again with the same request in 1897, the painter recovered an unfinished study of the work, completed it, and donated it to the school for permanent installation. Watts hoped that his portrait would inspire masters as well as the boys, writing to Luxmore, "I think it may be of use as a peg [on which] to hang an occasional little discourse . . . upon the dignity and beauty of purity and chivalry . . . brought more home to the minds of the youth hereafter to have so much to do with the Government and character of the Nation than by cut and dried lectures."[19] Luxmore did more than "hang" the random lecture on the image. He rewarded his best boys with prints of the painting on graduation.

These prints accompanied the boys as they made their way in the world of men. One of Luxmore's former pupils took the image with him when he fought the Boer War in South Africa. He lost his life in Ladysmith, but according to his mother, he never lost his faith in the chivalric ideal. She wrote to Luxmore that "his favourite picture was the one you gave him . . . he also was an innocent knight."[20] Watts's picture, given as an icon to boys, became a memorial to men. During the Boer War, the iconography was adopted for commemorative imagery. In stained glass and statuary the figure of Galahad honored the young men who made the ultimate sacrifice to their nation. Less than a decade later, Galahad and his fellow boy knights were pressed into service again, in imagery used to promote the patriotic initiative in the early days of the First World War. And in the aftermath, the bloody battles, the appalling death rates, the ghastly injuries of these two devastating conflicts stripped the image

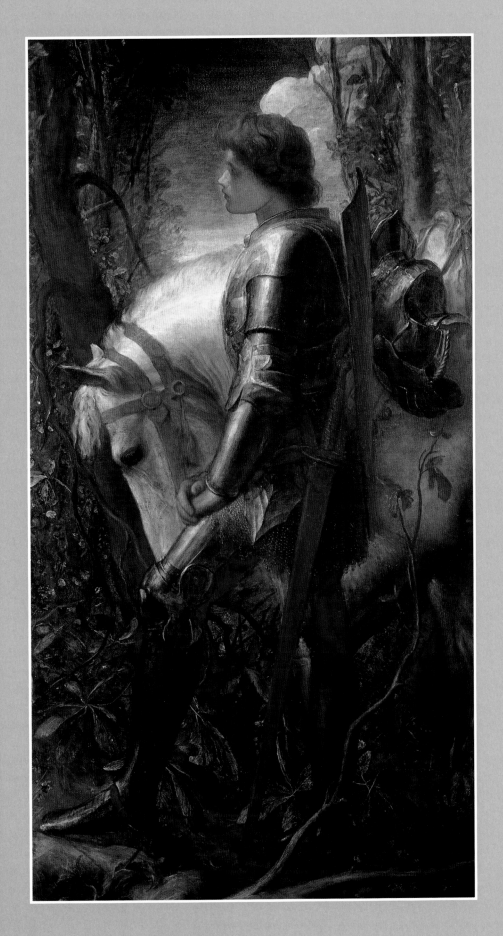

George Frederick Watts. *Sir Galahad.* 1862. Oil on canvas, 76 x 42". Fogg Art Museum, Harvard University, Cambridge. Bequest of Grenville L. Winthrop

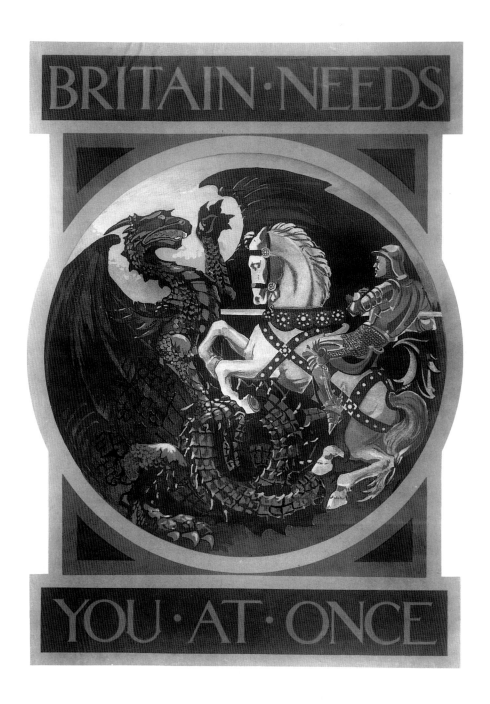

Britain Needs You At Once. World War I poster. Trustees of the Imperial War Museum, London

opposite:
Charles Spencelayh. *Dreams of Glory.* c. 1900. Oil on canvas, 30 x 20″. Courtesy of the FORBES Magazine Collection, New York

of its innocence. There was no doubt that a youth "trained up" "in the way he should go" would be willing to die for his country. But the reality of death and the horrors of modern warfare that left many survivors worse off than the dead destroyed the myth of the bright boy knight and his eternal quest. Blind idealism and naiveté provided feeble weapons against the bombs and the mustard gas and the disease-ridden trenches. Faith in Galahad and his idealism waned. He proved to be no more than a childish fantasy to be relinquished at the end of childhood.

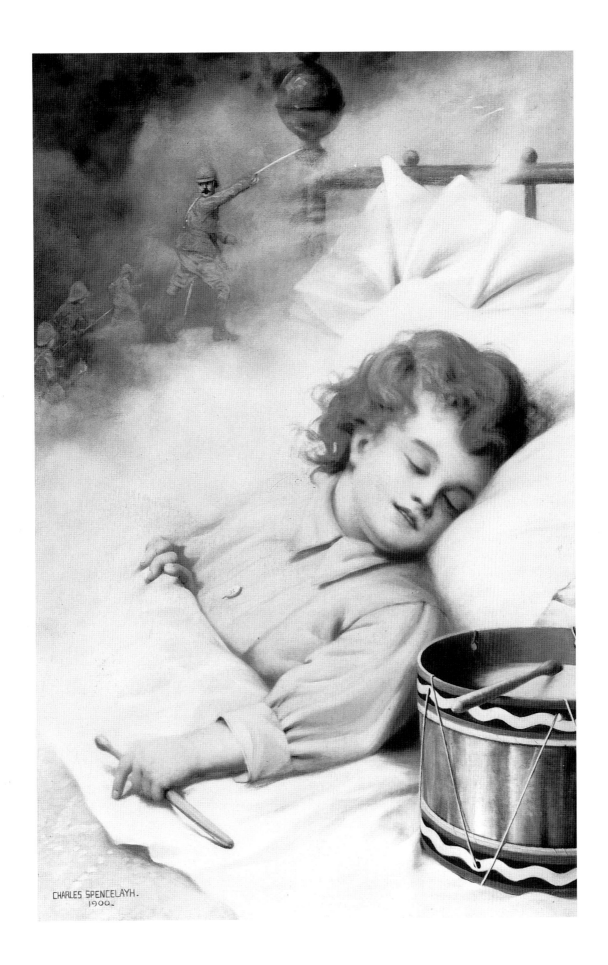

CHAPTER 6

To the Last Battle and Beyond

The old order changeth, yielding place to the new,
And God fulfills himself in many ways,
Lest one good custom should corrupt the world.

Alfred Tennyson (1869)

O n a grim barren battlefield, Arthur endured the final challenge of his destiny. Confronting his nephew Modred in "the last weird battle in the west" ("The Passing of Arthur," l. 28), Arthur struck against the treason and greed that destroyed his kingdom and devastated his dreams. His triumph was bitter. Still weary from the war with Lancelot, a war that broke the bonds of love, friendship, and loyalty that had held his world together, the death of his enemy offered little reparation to his damaged domain. The peace he had established through a lifetime of vigilance and just rule could not be recovered. The lives lost and reputations ruined could never be restored. The wound he sustained in the conflict with Modred would not be healed in the world in which he had once enjoyed victory. With only one knight remaining in his service, Arthur knew that he had fulfilled his fate: "for a space," he had "made a realm and reign'd" ("The Coming of Arthur," ll. 16, 19).

In the company of Bedivere, his last loyal companion, Arthur waited for his final—and most mysterious—journey to begin. A phantom barge loomed on the horizon. When it arrived at the shore and three stately queens took Arthur on board, Bedivere pleaded not to be left behind in a world he no longer understood. "Ah! my Lord Arthur," he cried. "For now I see the true old times are dead . . . And the days darken round me, and the years, / Among new

above:
Aubrey Beardsley. "How Sir Bedivere Cast the Sword Excalibur into the Water," *Le Morte D'Arthur*. London: J. M. Dent, 1893–94. Courtesy of The Newberry Library, Chicago

opposite:
Florence Harrison. "So like a shatter'd column lay the king," *Tennyson's "Guinevere" and Other Poems*. London: Blackie and Son, 1912. Courtesy of The Newberry Library, Chicago

men, strange faces, other minds" (ll. 395–97, 405–6). But Arthur, the voice of ideal manhood enclosed in true humanity, urged Bedivere to accept the inevitable and recognize that old ways must change to allow the new to flourish, "Lest one good custom should corrupt the world" (l. 410). He asked that Bedivere remember him, and pray for him, and tell his story so that his work would never be forgotten.

The powerful drama of Arthur's last battle and mysterious departure enthralled Victorian audiences from the earliest days of the revival to the waning of the legend's popularity after the First World War. The devastating collapse of the kingdom, the brutal waste of the senseless wars, and the wounding and departure of the beloved king touched the contemporary public as deeply as the events in a Shakespearean tragedy. And, true to epic tradition, the lessons of the legend justified the suffering of the hero. Arthur's noble embrace of his destiny presented a standard for men and for the nation. The loyalty of Bedivere proved that real men could serve the ideal. But above all, there was a special comfort in Arthur's tragedy, unparalleled in the secular canon of Western myth and literature. Arthur's departure ensured Arthur's return. In accord with the Arthurian tradition—once and future—the closure of the legend made it possible to begin the legend again. In telling the legend, modern Britain confirmed the grandeur of its past and committed itself to a glorious future. The uncertainties of the present mattered little in light of Arthur's memory and the promise of his return.

For four generations the Arthurian legend had recaptured the attention and stimulated the imagination of the British public. For the first, tales of chivalry inspired a romantic association. This generation revered the relics of older times, celebrated their ancestors in fact and fiction, and tried to revive the courtly world of the Middle Ages in their homes and in their actions. The sons of these nostalgic knights also played at chivalry, collecting weaponry and armor, jousting in the Eglinton Tournament, and sitting to artists in medieval costume. But to this new generation, chivalry also had practical applications. Neofeudalism suggested a way to secure the old paternalism in a changing economic world. Knightly obligation defined the relation of male British sub-

jects to their female monarch. And by mid-century, the Arthurian legend enjoyed a full revival, giving the nation a new, yet venerable, identity and inspiring artists with noble and patriotic iconography. The third generation enjoyed the full wealth of the revival. A new legend was written for their society, mirroring their thoughts, feelings, and beliefs. The *Idylls of the King* presented the men and women of Camelot as vivid, sharply drawn characters, and the legend took on a human dimension without losing its grandeur. The legend also taught the lessons of life. Old, but reshaped for the contemporary world, it preserved and illustrated the time-honored ethics and the roles for men and women that had made the nation great.

In the fourth generation, the reception as well as the interpretation of the legend began to change. By the last quarter of the nineteenth century, blind support for the pursuit of idealism—whether political, imperial, or Arthurian—began to wane. The social structures celebrated in the legend, including paternalism, the position of women, the class structure, even the monarchy, were thrown into question. The grandsons, and the great-grandsons, of the first modern devotees of chivalry challenged the validity of upholding their grandfathers' values and living by their rules. They had inherited the older generation's debts, they confronted its unsolved problems, and time and again, they died fighting its wars. Tennyson tried to address the inevitable generation gap as, decade after decade, he slowly produced the *Idylls*. "It is not the history of one man or one generation," he explained, "but a whole cycle of generations."[1] But the later *Idylls* turned on this precise conflict of old and new, as the younger generation of the Round Table knights challenged Arthur's authority by defying his rules. Still under the spell of the legend, late Victorian audiences continued to respond to it with interested attention. But their reception was tinged with a subtle skepticism, and as the century came to a close, the Once and Future King seemed less the "modern gentleman of stateliest port," as one critic put it, and more a "crushing reminder of Don Quixote."[2]

Tennyson always had rivals for his enviable position as the modern voice of the legend. In his own generation, Edward Bulwer-Lytton (1848) and

Matthew Arnold (1852) wrote serious Arthurian poetry, but their works were overshadowed by the grand popularity of the early *Idylls*. As poet laureate, Tennyson gained sanction to speak to and for the nation, and by dedicating the first four *Idylls* to Prince Albert and the complete epic to the queen, he bound his Arthuriad to the monarchy. Criticism of his work—and his hegemony—came early. William Morris undertook Arthurian themes in 1858, in response to his belief that Tennyson's poems lacked authenticity. To Dante Gabriel Rossetti as well, Malory's epic provided a richer and truer source than did the laureate's *Idylls*.

Algernon Charles Swinburne rose as Tennyson's loudest, and most persistent, detractor and eventually emerged as his most powerful rival. Swinburne began to write Arthurian poetry as an Oxford undergraduate in the late 1850s. Perhaps influenced by Morris, Rossetti, and Edward Burne-Jones, when they briefly resided at Oxford to paint Arthurian murals, Swinburne crafted "Queen Yseult," a lyric in ten cantos, and "Joyeuse Garde," which remained a fragment. He never abandoned his desire to write a more authentic Arthuriad than that of the laureate, which he derided as "the Morte d'Albert" and "The Idylls of the Prince Consort."[3] In 1872, in an extended critical essay called *Under the Microscope*, Swinburne charged Tennyson with manipulating the Arthurian tradition to promote his outmoded canon of ethics. By seeking to make each character serve a moral end, Tennyson had lost the real, human element of the legend. The *Idylls*, Swinburne claimed, betrayed the authentic spirit of the legend, "reducing Arthur to the level of a wittol, Guenevere to the level of a woman of intrigue, and Lancelot to the level of a 'co-respondant.'" In the laureate's hands, he charged, "the story is rather a case for the divorce-court than poetry." Worst of all, Tennyson's portrait of the king traded true human motivation for bloodless idealism. "By the very exaltation of his hero as something more than man," wrote Swinburne, "he has left him in the end something less."[4] Late in the century, Swinburne returned to Arthurian subjects, writing "Tristram of Lyonesse" (1882) and "The Tale of Balen" (1896). In the later poem, his own king, like Tennyson's, confronts the frailty of his men and laments their inability to place the ideal above their own individual desires.

> *Methought the wide round world could bring*
> *Before the face of queen or king*
> *No knights more fit for fame to sing*
> *Than fill this full Round Table's ring*
> *With honour higher than pride of place;*
> *But now my heart is wrung to know,*
> *Damsel, that none whom fame can show*
> *Finds grace to heal or help thy woe:*
> *God gives them not the grace.*[5]

In the end, the legend taught Swinburne a powerful lesson and left him with a view that mirrored Tennyson's: that human nature fell short of ideal aspiration. But, in the more skeptical spirit of his own generation, Swinburne raised an issue that was unthinkable to Tennyson. If the pursuit of the ideal proved vain, had the time arrived to close the cycle and relinquish the dream?

While most critics of the last quarter of the century hesitated to dismiss the Arthurian ideal as futile, many believed that the king and his legend had become all too familiar. As early as 1857, Elizabeth Barrett Browning proposed that if all men were "possible heroes," then "all actual heroes are essential men."

> *King Arthur's self*
> *Was commonplace to Lady Guenever*
> *And Camelot to minstrels seemed as flat*
> *As Fleet Street to our poets.*[6]

In Browning's day, the Arthurian legend seemed so vital and so enthralling that she could provoke her audience with the assertion that those who saw Arthur daily found him commonplace. But by the 1870s, with so many Arthurian poems and pictures proclaiming the legend for yet another generation, Browning's words became as true for one sector of the public as for her "Lady Guenever." The poet W. H. Mallock agreed that familiarity drained the legend of its power, but in his 1872 spoof of the *Idylls*, "To Make an Epic Poem Like Mr. Tennyson's," he implied as well that the image of the "modern gentleman" made Arthur prosaic. Using the form of a recipe, Mallock instructs his readers to start their poem by catching an appropriate hero, "namely a prig." These, Mallock assures his readers, are "very

KING ARTHUR'S DEATH.

ON Trinity Monday in the morn,
 This sore battayle was doomed to be,
Where many a knight cryed, 'Well-away!
 Alack, it was the more pitie!'

Ere the first crowing of the cock,
 When as the king in his bed lay,
He thought Sir Gawaine to him came,
 And there to him these wordes did say:

John Franklin. "King Arthur's Death," *The Book of British Ballads*. London: J. How, 1842. Courtesy of The Newberry Library, Chicago

plentiful, and easy to catch, as they delight in being run after."

> *Take, then one blameless prig. Set him upright in the middle of a round table, and place beside him a beautiful wife who cannot abide prigs. Add to these one marred goodly man; and tie these three together with a bundle of Destiny. Proceed, next, to surround this group with a large number of men and women of the nineteenth century, in fancy-ball costume . . . Next break the wife's reputation into small pieces; and dust them over the blameless prig. Then take a few vials of tribulation and wrath, empty them generally over the whole ingredients of your poem; and taking the sword of the heathen, cut into small pieces the greater part of your minor characters. Then wound slightly the head of the blameless prig; remove him suddenly from your table, and keep in a cool barge for future use.*[7]

Few critics were as brutal as Mallock on the subject of Tennyson's "blameless" king, but a growing number agreed that Arthur resembled a modern type of man who was more annoying than inspiring in his righteous posture. A writer in the *Literary World* declared: "His majesty, we must confess, is one of those utterly proper, high-stalking, clean-shaved, rather albuminous personages in whom we fail to take a lively interest."[8] Some readers grew tired of gazing "upon the sun in heaven" and longed, like Guinevere in Tennyson's "Lancelot and Elaine," for a hero with "a touch of earth" (ll. 123, 133). In *The Eustace Diamonds* (1873), Anthony Trollope associated admiration for Arthur with staid, old-fashioned ways. When Frank Greystock, a stolid young man as dull as his name, praises Arthur for not seeking the Grail "because he had a job of work to do," his flirtatious cousin Lizzie counters, "I like Launcelot better than Arthur." Frank had to admit, "So did the Queen."[9] Even the dangerous love triangle lost its glamor through translation. In 1876, Mary Neville updated the plot in her sentimental novel *Arthur, or A Knight of Our Own Day*. Her hero, Captain Arthur Antherson, watched helplessly as his beautiful but fickle wife, Ida, fell under the spell of his dashing friend Sir Lancelot Trevor. Despite the near loss of his marriage and respectability, the captain forgave

his friend and his wife when they came to their senses. Trevor then conveniently died of a mysterious illness, and Antherson and Ida recaptured their marital bliss.[10] If Browning suggested that familiarity led to the commonplace, Neville proved that banality brought only boredom.

Despite the increasing skepticism of these late years of the nineteenth century, the legend continued to fascinate a broad spectrum of the Victorian public. In fact, the last generation of the revival—and, to a certain extent, their children—brought a surprisingly neglected mode of expression to its highest development. During the Middle Ages, book illustration—in the form of manuscript illumination—dominated in the field of Arthurian imagery. Even after the printed book replaced the hand-copied codex, the Arthurian image continued to play a supporting role to Arthurian literature. But, through public monuments and popular paintings, the Victorian interpreters of the legend severed this traditional dependency and freed the visual image to function as a distinct expressive force, related to, but independent from, the text. It seems strange that in an era known for the creative design and production of illustrated books, painting would be so clearly preferred over illustration. But, near the end of the era, as the public began to trouble the modern canon of the legend—and were increasingly troubled by it—illustrated books regained their importance. The public act of viewing a painting in an offical building or in an open gallery was replaced by the very private act of reading an embellished book. Rather than communal identity, the legend now offered a personal means of escape. The Arthurian world, once grand enough to cover the walls of a governmental palace, found its final Victorian preserve between the decorated covers of a slender, handheld book.

Book illustration played only a minor role in the early publications of the Arthurian Revival. Most collections of poetry and prose on the subject featured no further visual embellishment than a frontispiece or chapter heading. When Arthurian illustration first appeared, it was generally just one of many subjects presented in pictorial collections of poems. Samuel Carter Hall's *Book of British Ballads* (1842) included only two poems with Arthurian themes among a diverse sampling of literary "relics" from the

William Holman Hunt. "The Lady of Shalott,"
Poems. London: Edward Moxon, 1857. Courtesy of
The Newberry Library, Chicago

below:
Dante Gabriel Rossetti. "The Palace of Art,"
Poems. London: Edward Moxon, 1857. Courtesy of
The Newberry Library, Chicago

Middle Ages and the Renaissance. Title and text were needed to identify the subjects. The grand old warrior in John Franklin's image for "King Arthur's Death," with his kingly manner and formidable appearance, holds an attribute to aid the viewer's understanding of the image. Without that sword inscribed "Excalibur," he could represent any medieval monarch presiding over a battle. In 1857, Tennyson's publisher Edward Moxon commissioned illustrations from popular and prominent artists to illustrate a collection of the laureate's best-known works. *Poems*, now better known as the *Moxon Tennyson*, featured only three Arthurian works, "Morte d'Arthur," "Sir Galahad," and "The Lady of Shalott," and one piece, "The Palace of Art," with a single Arthurian reference. The artists enjoyed a free range of interpretation, often to Tennyson's dismay. When the poet viewed William Holman Hunt's design for "The Lady of Shalott," he was bewildered by the extent of artistic license. Complaining to Hunt that the Lady's hair looked as if it were "tossed about by a tornado," the poet reminded him, "I didn't say her hair was blown about like that."[11] Tennyson believed that illustration should take the traditional secondary role, but the artists hired for the project did not fully agree. Dante Gabriel Rossetti, for example, approached the project with genuine enthusiasm, wanting to undertake only those subjects that gave the opportunity to "allegorize on one's own hook."[12] His claustrophobic vision of Arthur in Avalon, designed to accompany the poem "The Palace of Art," strays far from Tennyson's description: "Mystic Uther's sleeping son / . . . watch'd by weeping queens" (ll. 105, 108). In Rossetti's rendition, the queens are more curious than melancholy, and the way they crowd around the powerless body of the king conveys more erotic fervor than comforting ministration.

A decade later, Edward Moxon, in collaboration with Librairie Hachette, a Paris publishing house, presented British and French audiences a deluxe illustrated edition of the *Idylls of the King*. This time he hired a single illustrator, the highly respected Gustave Doré. For each of the *Idylls*, including "Enid," "Elaine," "Guinevere," and "Vivien," Doré designed nine images in pen, ink, and wash. These were then translated to steel plates by British engravers for publication in 1868. Despite his lack of fluency in the English language, Doré kept close to Tennyson's text. By emphasizing the drama of atmosphere and setting rather than action, he created a mysterious world removed from contemporary reference. Dense forests, storm-tossed seas, ruined castles, and lightning-rent skies drew inspiration from Tennyson's vivid evocations. The reader entered this distant pictorial world only through reading the text. This link between text and image was stronger than that forged by previous illustrators. As an integrated act, reading and viewing offered a new passage into the Arthurian world; both private and escapist, it allowed the audience a more personal journey of imagination than either image or text alone could inspire.

The private nature of illustrated books encouraged experiment, first in technique, then in interpretation. At the request of her friend Tennyson, Julia Margaret Cameron photographed a set of vignettes based on the *Idylls of the King* in 1874. Tennyson planned to have wood engravings made after the photographs for a new illustrated edition. Cameron drafted friends, family, and on occasion, a local workman or passerby, to serve as models. Striking dramatic poses in their piecemeal medievalized garments, the characters in Cameron's images echo the biting words of Mallock's satire. They are clearly "men and women of the nineteenth century in fancy-ball costume." This aspect of *tableaux vivants* did not bother either the photographer or the poet. Engravings based on Cameron's pictures appeared in a ten-volume cabinet edition of the *Idylls*, published in London in 1874–75, and, at her own expense, Cameron published a limited-edition gift book featuring only the photographs. If Tennyson instilled his Arthurian characters with modern sentiment, Cameron gave hers modern form. Like the poet, she attempted to bridge reality and the ideal, but succeeded instead to chart the vast difference between them.

One illustrator reveled in the disparity between the Arthurian legend and the Victorian ideal. In 1892, the publisher John Dent hired a young, inexperienced designer to produce a set of images to illustrate a three-volume edition of Malory's *Morte Darthur* (1893–94). Aubrey Beardsley's burgeoning style was reminiscent of Burne-Jones's nostalgic lyri-

Julia Margaret Cameron. "Vivien and Merlin," *Illustrations to Tennyson's "Idylls of the King," and Other Poems*. London: Henry S. King, 1874–75. Gernsheim Collection, Harry Ransom Humanities Research Center, The University of Texas at Austin

Gustave Doré. "Uther discovers the two brothers," *Idylls of the King*. London: Edward Moxon, 1868. Courtesy of The Newberry Library, Chicago

Aubrey Beardsley. "How Queen Guenevere Made Herself a Nun," *Le Morte D'Arthur*. London: J. M. Dent, 1893–94. Courtesy of The Newberry Library, Chicago

right:
Aubrey Beardsley. Chapter heading, *Le Morte D'Arthur*. London: J. M. Dent, 1893–94. Courtesy of The Newberry Library, Chicago

Aubrey Beardsley. Title page, *Le Morte D'Arthur*. London:
J. M. Dent, 1893–94. Courtesy of The Newberry Library,
Chicago

cism, and Dent believed that his handsome, well-illustrated publication would rival a similar project planned by William Morris, featuring the work of Burne-Jones (Morris's project never materialized). Even Dent was surprised by the results. Over the next year and a half, Beardsley submitted over four hundred ink drawings in black and white, including full-page illustrations, chapter headings, decorative boarders, and marginalia. The full-page pictures follow Malory's text, and even incorporate a line or two for a caption. Using an economic style of broad, flat patterns and bold calligraphic lines, Beardsley rendered the Arthurian world exotic and elegant, the visual language almost defying the actions it represented. In the decorative passages Beardsley let his imagination run wild. A woman rises from the waves, bearing a sword, but this Lady of the Lake is a nude seductress, brandishing a rose of passion. Nymphs and satyrs lurk in the woods. Serpents lie in wait for unsuspecting knights. On the title page, a foliate interlace traps grim-faced, muscular knights, who hack away at the choking branches—as well as at each other—with needle-thin swords. Beardsley's sardonic interpretation seemed at cross-purposes with the moral message of the legend. While Malory's words spoke of high human aspiration, Beardsley's pictures

appealed to baser instincts. Whether by design or by accident, text and image engaged in a powerful and telling debate. Yet, this conflicting interplay illustrates the conflicting sentiments of the late Arthurian Revival. The harder and longer the ideal is pursued, the more elusive it becomes. But like the knights in the thicket, human aspiration continues to struggle, reaching out in futility for a dream that might never be attained.

After the turn of the century, the publication of high-run, multivolume editions of the Arthurian works declined, and a more modest—and yet more precious—type of illustrated book appeared for the final, waning audience for the Victorian legend. Small, expensive, and produced by fine-arts presses, these works were valued for their aesthetic appeal as much as for their literary content. The stylistic preference was blatantly nostalgic, looking back to the early works of the Pre-Raphaelites and emulating, even exaggerating, their rarefied canon of beauty. The elegant, attenuated figures and the rich, jewel-toned palette presented the reader with an ethereal and fragile Arthurian world. These books depicted a realm that bore no resemblance to the practical present. Removed from the self-defining, and self-adulating, spirit of the early generations of the

Victorian era, these late illustrated books presented
the means to reject the world that didactic chivalry
could not improve.

Although most of the illustrators for the fine-
arts presses followed the Pre-Raphaelite aesthetic,
within that range they demonstrated great diversity
and an almost eccentric individualism. As early as
1896, Eleanor Fortiscue Brickdale exhibited a black-
and-white painting of Sir Lancelot, but she drew little
critical attention. She made her reputation over a
decade later as an illustrator, producing thirty-seven
watercolor designs for two editions of the first four
Idylls of the King (1911–12). Brickdale's meticulous
renderings are faithful to Tennyson's text, but the
touches of detail she adds to increase the sentiment—
the basket of bread Guinevere carries as she serves
out her days as a nun, or Elaine's little hand on
Lancelot's broad chest as she pleads to accompany
him on his adventures—impart a genuine humanity
to the legendary characters, turning Tennyson's epic
language into the words of a storyteller. Jessie Marion
King illustrated Morris's *"Defence of Guenevere" and
Other Poems* in 1904. Her exquisite black-and-white
drawings embellish the pages like fragile metal fili-
gree. The decorative elements, slender knights in
winged helmets wielding their weapons in borders
made of windblown banners and randomly strewn
roses, seem fresh and innocent, the antithesis of the
erotic vision of Beardsley. But the energy and sheer
nervousness of her line, and of her figures as they
twist and sway in dancelike gestures, betray his influ-
ence. King's Arthurian vision is light and brittle,
prompting the viewer to wonder how this legend sur-
vived for centuries. It is ironic that this last, poignant
flowering of modern Arthurian legend was led and
dominated by women. Like the guardian queens
portrayed in Florence Harrison's illustration to
Tennyson's "Morte d'Arthur," these artists protected
the last sanctuary of the masculine legend, surround-
ing the remnants of the ideal with true feminine
compassion.

Over the course of one thousand years, long
before the Victorian era hailed the Once and Future
King as its true monarch, poets, painters, and their
eager public gazed into the Arthurian legend, search-
ing for their own reflection. That sense of association
served as the motivation and the means to revive the

legend, shaping the tale to fulfill a common cultural need. As the interpretation of the legend shifted, its distinctive message was encoded in different aspects of the narrative, giving new weight and meaning to a moment or a character and, through this emphasis, defining the legend's connection to its new audience. The weary, defeated troops of post-Roman Britain found solace in their lengthy recitations of battle lore, reminding themselves that at one time their leaders brought them victory. In the Middle Ages, the chronicles of Arthur's "history" emphasized issues of lineage and political legacy, symbolically securing Britain's position in the emergence of new European monarchies. Sir Thomas Malory's account of a king's struggle toward national unity, celebrating this achievement and lamenting its loss, held a special tragic message to England in a time of brutal civil wars. Even today, as the legend enjoys another revival, we link ourselves to a type of hero who is distinctly Arthurian: the contemporary knight errant. Characters in films and popular fiction—Luke Skywalker in the *Star Wars* trilogy, Indiana Jones in his "Last Crusade," and the tough-talking protagonist of Robert B. Parker's "Spenser" novels—reassure us that through the efforts of singular men a solid code of ethics can exist in a destabilized world.

For the Victorians, the closing incidents of the legend gave meaning to the whole. Arthur's last battle and his passage to the great beyond never failed to draw an audience. It was the first part of the narrative to be revived and the last passage to be relinquished. At the dawn of the revival, with the "Morte d'Arthur" and its framing poem "The Epic," Tennyson taught his readers that Arthur's passing, in all its tragic implications, held a glimmer of hope. Even at the turn of the century, as Arthurian popularity reached its twilight, the passing of Arthur endured as a powerful theme in literature and an iconic subject in art. This fascination with the collapse of Arthur's order, his last bitter victory, and his retreat from the world of action into the realm of oblivion seems inconsistent with the Victorian temper. But underlying all the robust self-confidence and rigorous self-promotion that fueled British economic expansion and political domination was a growing trepidation, a fear of the uncertainties of the future. Arthur's final stance brought affirmation and reassurance.

Florence Harrison. "Guinevere," title page, *Tennyson's "Guinevere" and Other Poems*. London: Blackie and Son, 1912. Courtesy of The Newberry Library, Chicago

opposite:
Arthur Rackham. "How Sir Mordred Was Slain by Arthur," *The Romance of King Arthur and His Knights of the Round Table*. London: Macmillan, 1917. Courtesy of The Newberry Library, Chicago

Briton Riviere. *Requiescat.* 1889. Oil on canvas, 25 x 35½".
Courtesy of the FORBES Magazine Collection, New York

In the "Morte d'Arthur" of 1842, Tennyson gave the Victorian audience its canonic tale of Arthur's last battle and his mysterious disappearance. In 1869, when he expanded the poem for inclusion in the *Idylls*, the poet remained faithful to his early narrative structure, but he surrounded the original telling with small incidents—Arthur's preparation for battle, his anger with Modred, Bedivere's reflections on his king's departure—that reveal the true nature of the Once and Future King. As portrayed in "The Passing of Arthur," the king embraces his predestined tragedy with all the depth and dignity of his true character, as ideal manhood enclosed in real man. His fears and his grief betray his fragile humanity. Ghostly nightmares haunt his sleep on the night before the battle. He questions the purpose of his life, wondering if he had "but stricken with the sword in vain" (l. 23). He realizes the impermanence of human endeavor and laments as all his realm "Reels back into beast" (l. 26). On the morning of the battle the field is thick with mist. Arthur, like his loyal men and his dreaded enemies, fights mindlessly, in blind confusion, "For friend and foe were shadows in the mist, / And friend slew friend not knowing whom he slew" (ll. 100–101). When at last the savage noise of the battle stilled, three men remained. As Bedivere watched, Arthur defeated Modred with a single blow, "Striking the last stroke with Excalibur, / Slew him, and all but slain himself, he fell" (ll. 168–69). His earthly task completed, not in vengeance, but in "one last act of kinghood" (l. 162), Arthur succumbed to his injuries and submitted to Bedivere's care.

In his fearless confrontation with his mortal enemy and in his willing acceptance of his fate, Arthur proved himself the ultimate Victorian hero. He used his strength, courage, and prowess to carry out the purpose of his life, and when that purpose was fulfilled, he faced his death with dignity. The image of Arthur as a dying warrior gave rise to a popular subject in painting: the Fallen Hero. Throughout the second half of the Victorian era, the image of an anonymous knight, mortally wounded or at peace in death, served as the emblem of ultimate masculine sacrifice. Often the scenes had obscure literary sources, or even no source at all. In *The Knight of the Sun* (1860), Arthur Hughes paid tribute to an unknown warrior, identified only by a blazing sun on his shield. His once-powerful body, carried by his young attendants, sags as his life drains from him, but he clasps his hands in a final prayer and raises his eyes in reverence. While not Arthurian in origin, Hughes's subject gained intelligibility and eloquence when associated with Arthur's example. Although not a monarch himself, this knight died with kingly dignity, well aware that a man's actions meant more than his station. To emphasize this message, Hughes inscribed two lines from a poem by George MacDonald on the frame: "Better a death when work is done / Than life's most favoured birth."[13] A man did not have to be a king to be a hero. He needed only to understand the value of sacrifice and commit himself to his faith, his society, and his sovereign.

Even the monarchy used this evocative emblem. In 1874, Queen Victoria unveiled a commemorative cenotaph honoring Prince Albert in a special chapel at Windsor. Armed as a fourteenth-century knight, Albert rests in peace. His earthly battles done, he sheaths his sword. The inscription around the lid—"I have fought the good fight. I have finished my course" (2 Timothy)—celebrates a life well spent. Albert was never a soldier, but he was a true Fallen Hero. It was widely believed that his unstinting service to the nation undermined his health and led to his early death. He gave his life to his queen and country and through sacrifice, like Arthur, earned a hero's rest. Late in the century, the iconography of the Fallen Hero grew stark and spare but lost none of its potent message. Briton Riviere offers no key to the identity of the knight lying in state in *Requiescat*. The chapel is empty, evoking the austerity of the warrior's life. Golden laurel leaves entwine the sword held in the stiff, mailed hands, a tribute to hard-won victories. Like the loyal bloodhound, whose vigil attests to a worthy master, the viewer gazes at the knight with reverence, respecting the invocation of the title: "Let Him Rest." Riviere's audience did not know this knight's name, his history, or even the results of his final battle. But as a Fallen Hero, associated with Arthur's pattern of sacrifice and reward, the anonymous knight earned a place in society's most honored circle.

In the deadly stillness after the battle, one remaining earthly task impeded Arthur's reward of rest. He needed to fulfill his oath to the Lady of the

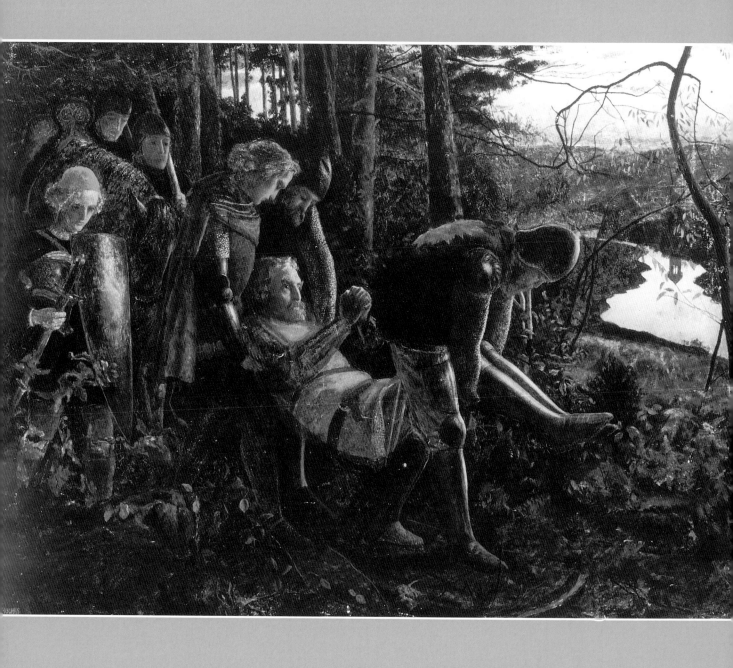

Arthur Hughes. *The Knight of the Sun.* c. 1860. Oil on
panel, 11 x 15½". Private collection. Sotheby's, Inc.

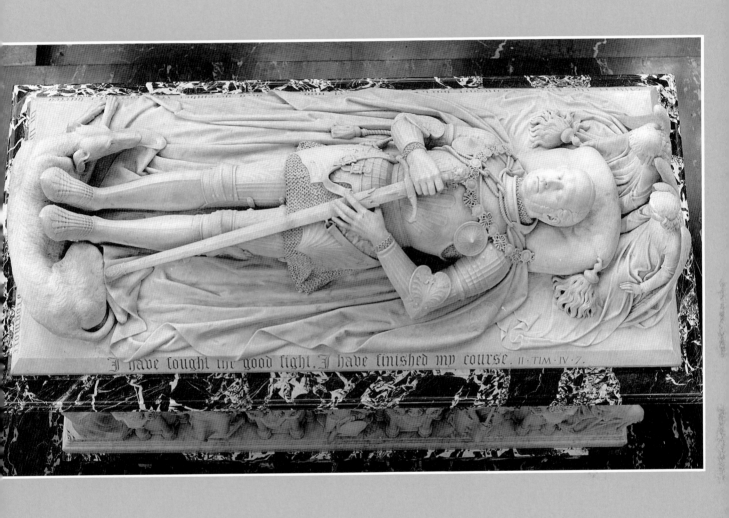

I have fought the good fight. I have finished my course. II·TIM·IV·7.

Henri de Triqueti. *Cenotaph Effigy of Prince Albert.* 1864–73.
Albert Memorial Chapel, Windsor. The Royal Collection,
© 1994 Her Majesty Queen Elizabeth II

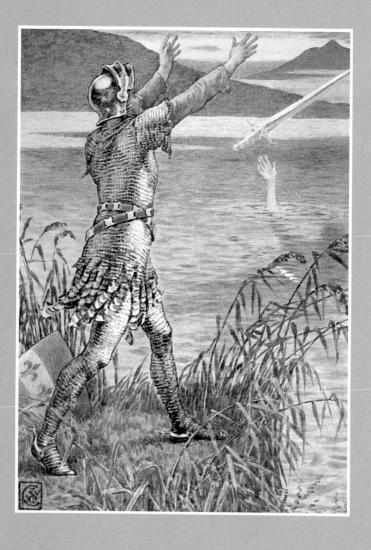

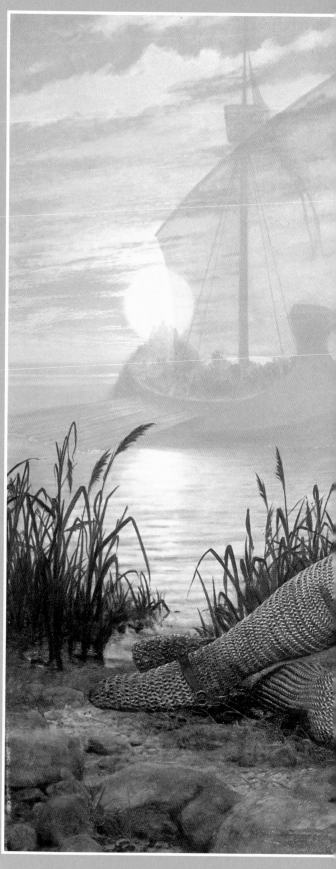

above:
Walter Crane. "Sir Bedivere Casts the Sword Excalibur into the Lake," *King Arthur's Knights: The Tales Re-Told for Boys and Girls*. London: T. C. and E. C. Jack, 1911. Courtesy of The Newberry Library, Chicago

right:
John Mulcaster Carrick. *Morte d'Arthur*. 1862. Oil on canvas, 39¼ x 54″. Private collection. Sotheby's, Inc.

Lake and return his brand Excalibur, for his work with the sword was completed. But his wounds made it impossible to honor the pact, and Arthur asked Bedivere to return the sword for him. Although Bedivere's origins may be traced to ancient Welsh literature, mention of his returning Excalibur appears for the first time in the Stanzaic *Morte Arthur* of the fourteenth century and remains a constant feature of the English interpretation. Here an interesting tradition begins. Despite Bedivere's desire to obey the king, he defies him twice, hiding the sword rather than casting it in the waters. But he cannot conceal his disobedience from Arthur, who demands to know what Bedivere saw when the sword entered the lake. In the third attempt, Bedivere obeys, and he sees an arm rise from the waters to catch Excalibur and draw it down beneath the waves.

Tennyson preserved this tradition of the two acts of defiance followed by obedience. Using Malory's brief account of the incident, Tennyson expanded the scene, allowing the king full vent to his anger when Bedivere disobeys his command. But when Bedivere carries out the order, he is rewarded with a fabulous vision. He hurls the sword in a mighty arch toward the lake, watching the sun glint on the metal as it wheels hilt over blade. As the sword nears the surface of the lake, an arm in white samite, "mystic, wonderful" (l. 312), breaks the waves and catches the hilt, and brandishing the sword three times, draws it down out of sight. Bedivere returns to his sovereign, awed by his experience. "I never saw, / Nor shall see, here or elsewhere, till I die, / Not tho' I live three lives of mortal men, / So great a miracle as yonder hilt" (ll. 321–24). For the Victorians, Bedivere played an essential role in the legend. He was the last knight to obey Arthur, and the last to learn from his oaths and example. Readers would reverence Arthur, but they would see themselves in Bedivere, hoping to grasp the lessons of the legend before it was too late.

Secure in his last companion's loyalty, Arthur entrusts his fate to Bedivere. He senses his impending doom—"My end draws nigh; 't is time I were gone" (l. 331)—and asks Bedivere to carry him to the shore. The knight staggers under the king's weary weight, but Arthur urges him on. "Quick, Quick! / I fear it is too late and I shall die" (ll. 347–48). When they

reach their destination, another vision, as wondrous as the arm in white samite, awaits them. A ghostly ship appears on the horizon, "a dusky barge, / Dark as a funeral scarf from stem to stern" (ll. 361–62). John Mulcaster Carrick painted this scene, conveying Bedivere's astonishment as he turns from the exhausted king to stare at the shadowy craft sliding through the water. Here, Arthur portrays the true type of the Fallen Hero. Collapsed in his companion's arms, he relinquishes his will to his fate, ready for his well-earned rest. Once again, Bedivere provides the associative link to the legend. As he gently rouses the lethargic king, he represents Arthur's last mortal bond before the moment of the king's passing to immortality.

Three queenly figures disembark from the phantom ship, and Arthur resumes his command. He instructs them to take him aboard, and they follow without question or hesitation. Wearing golden crowns and stately black robes, the queens embody dignity. But in their heartfelt lamentation, "A cry that shiver'd to the tingling stars" (l. 367), and their gentle acts of compassion, loosening his helmet, stroking his hands, whispering his name, they incarnate the female ideal. At the moment of departure, Bedivere calls to his king, terrified to face life alone. "Ah my Lord Arthur, whither shall I go? / Where shall I hide my forehead and my eyes?" (ll. 395–96). And Arthur, in a final act of kingly strength and manly spirit, advises his last loyal knight to accept the inevitable but to preserve the ideal. To soothe Bedivere, he speaks of his own destination, "To the island-valley of Avilion; / Where falls not hail, or rain, or any snow, / Nor ever wind blows loudly" (ll. 427–29), and of his destiny—"I will heal me of my grievous wound" (l. 432). And Bedivere, ready to carry out his king's last wishes for prayer and remembrance, watches the barge depart and disappear beyond the range of human sight into the realm of memory and imagination.

In the visual arts, one image encapsulated the full significance of Arthur's last battle and his journey to the great beyond. That subject was Arthur in the death barge. Although it made only rare appearances in the medieval lexicon of Arthurian imagery, Victorian artists and their audience favored it and invested it with iconic status. Like its source in the narrative, the image enjoyed consistent popularity

Daniel Maclise. "Arthur in the Death Barge," *Poems*.
London: Edward Moxon, 1857. Courtesy of The Newberry
Library, Chicago

Joseph Noël Paton. *The Passing of Arthur.* 1862. Sepia, 16¾
x 21¼″. Glasgow Museums: Art Gallery and Museum,
Kelvingrove

James Archer. *La Morte d'Arthur*. 1861. Oil on paper, 6½ x
7½". Private collection. Photograph courtesy of the Maas
Gallery, London

throughout the revival. It was one of the first subjects depicted and among the last to endure. No other image so richly consolidated the message of the legend for the Victorians. Proof of Arthur's heroism, the mystery of his destiny, and the promise of his return converged in a single dramatic moment. But in the context of the revival, the subject engaged viewers in a powerful—and reciprocal—association. Gazing at the king, separated by a distance no human being could cross, the viewers became Bedivere, bound to the legend through obedience, reverence, and memory. Like the last loyal knight, they too stood between the king's former glory and his promised return. And they pledged themselves to preserve the ideal in his absence. Through this bond of association, modern men and women drew themselves into the legend, and the legend, for a space, became their own. The image of Arthur in the death barge was more than a pictorial subject. It served as an emblem of belief—belief in the power of the legend and belief in a culture that could make Arthur come again.

The image first appeared as an illustration for Tennyson's poem "Morte d'Arthur." In 1857, Daniel Maclise provided a design to accompany the poem in the *Moxon Tennyson*. Within the tight boundaries of a small-scale wood engraving, Maclise achieved an image of epic proportions and enduring influence. Although lying "like a shatter'd column" ("Morte d'Arthur," l. 272), the king remains an impressive presence. Pain racks his body; his head reels, and his fist clenches in convulsion. Cradling his head in strong, rounded arms, one of the queens attends his agonies, "dropping bitter tears against his brow" (l. 262). Using Tennyson's poem as an authority for his own invention, Maclise fused two scenes into one, the queens' compassionate care for Arthur and his mysterious journey to Avalon. As an emblem, the image celebrates Arthur's heroic duality: a man who sacrifices and suffers, but an immortal force that human suffering and sacrifice cannot deplete. Artists after Maclise added to the iconography but kept his vision as the matrix. In *The Passing of Arthur*, Joseph Noël Paton embellished the boat with Arthur's heraldry. Dragon heads flank the prow of the barge, arrow-tipped tails coil at the stern, and a rearing beast decorates the sail. Tempering these fierce guardians are Christian symbols. A crusader's flag flutters from the mast and two angels raise a cross in triumph on the prow. The duality remains, and it is given a spiritual dimension. Pagan and Christian, man and immortal, once and future, Arthur's identity and purpose are proclaimed in the emblem.

After Arthur's departure, Bedivere climbed to a cliff, high above the sea, to watch the ghost barge disappear into the distance. He kept his vigil until "the hull / Look'd one black dot against the verge of the dawn" ("The Passing of Arthur," ll. 438–39), and he tried to draw comfort from the king's last words. "He passes to be king among the dead, / And after healing of his grievous wound / He comes again" (ll. 449–51). But racked by doubt and dwelling on his own fate, Bedivere once again defied his king, wondering what would happen "if he would come no more" (l. 451). Here, the Victorians proved truer than Arthur's last loyal knight and, in visual testament, expressed their faith in the myth of the return.

Through the subject of Arthur in Avalon, painted time and again throughout the revival, the Victorians confirmed their belief in the Once and Future King. Bedivere could not imagine Arthur's rest and recovery. But Arthur's modern audience gave itself the privilege of gazing at the king in his realm of retreat. Descriptions of Avalon were rare in literature. Malory only named the isle, and Tennyson just suggested it was an Edenic paradise, "Deep-meadow'd, happy, fair with orchard lawns / And Bowery hollows crown'd with summer sea" (ll. 430–31). But visual imagination afforded Arthur's latest loyal subjects the reassurance Bedivere never attained. They could see that their king was safe and secure, resting in Avalon and gathering strength for the dawn of another reign.

To create their vision of Avalon, artists drew on the whole tradition of the legend. As seen in James Archer's *Morte D'Arthur*, Avalon provided a secure and quiet haven. Grassy meadows ringed with trees protect Arthur from the gentle sea waves washing up on the sandy shore. His guardian queens keep their compassionate vigil, stroking his fevered brow and reading the Bible to soothe his soul. As the death barge retreats in the distance, Merlin—with a patriarch's beard hiding his face and a monk's robe covering his wizened frame—confers with a blue-gowned attendant. Arthur will need his adviser's wisdom in

the times to come. A ghostly figure, nearly transparent, enters with nourishment for the king's spent spirit. She is the Grail Maiden. Here, away from the world of men, Arthur achieves the blessed salvation that eluded his knights in their life. Arthur rests his broken body, but his gaze, hollow-eyed in a gaunt and weary face, is fixed and vital. He sees the Grail, a symbol of sacrifice rewarded and a confirmation of his belief in the ideal. The Victorian public found comfort in Archer's vision. The artist did as well, and he returned to it repeatedly, painting five versions of the subject in the course of his long career.[14]

Archer gave the public a comforting view into Avalon, but in taking the king's haven as a personal emblem, Edward Burne-Jones infused the subject with the spirit of the revival in twilight. *The Sleep of Arthur in Avalon* was commissioned in 1880 from the painter by his longtime friend and patron George Howard. Burne-Jones embraced the subject with vigorous enthusiasm. It was to be the largest and most important picture of his career. But the work was never completed. Burne-Jones repeatedly delayed delivering the painting. He increased the size of the canvas, and he kept adding figures and iconographical detail. Sensitive to his friend's involvement with the subject, Howard eventually released Burne-Jones from his contract, and the painter continued to work on the canvas until

Florence Harrison. "Morte d'Arthur," *Tennyson's "Guinevere" and Other Poems*. London: Blackie and Son, 1912. Courtesy of The Newberry Library, Chicago

his labors were ended, not by choice, but by his death in 1898.

Despite Burne-Jones's claims to the contrary, *The Sleep of Arthur in Avalon* bears every mark of completion. Highly finished, fully conceived, it conveys the suspension of time that gives the subject its enduring appeal and entrancing mystery. In the center of a marble cloister, the king reclines on a richly draped couch. He is sheltered by a bronze canopy embellished with gilded plaques that tell the history of the Holy Grail. Seated at his head and feet are the guardian queens, keeping their vigil in silent contemplation. Attendants play gentle music to soothe their sovereign's slumbers, and to the right, noble women bear his arms and armor. Guards are stationed at the entries to the cloister. They hold horns and trumpets instead of weapons, and they will wake the king at the time of his return. In this tranquil atmosphere, safe from harm and disturbance, Arthur enjoys the sleep of revitalization. His pain is passing, his wounds are healing. He rests content in the knowledge that his former task is concluded and his future challenge is not yet at hand.

For Burne-Jones, The Sleep of Arthur in Avalon was more than a popular subject. True to the spirit of the revival, he drew himself into the legend, and the painting of Arthur's rest became a personal

Edward Burne-Jones. *The Sleep of Arthur in Avalon*. 1880–98.
Oil on canvas, 9′ 3″ x 21′ 2″. Courtesy of Museo de Arte de
Ponce, Puerto Rico

testament. His wife, Georgiana Burne-Jones, claimed that for years the subject "lay deep in Edward's mind" and that he regarded the work not as a commission but as "a task of love to which he put no limit of time or labour."[15] The huge canvas—eleven and a half by twenty-one and a half feet—required the use of an outsized studio. But in 1891, he moved the work, at great inconvenience, to his home. Close at hand, it became a private sanctuary. Although Burne-Jones had no plans ever to sell or exhibit it, in the last years of his life he devoted three days of every work week to his favorite picture. So deep was his personal attachment, he developed an eccentric habit of referring to the picture as a location, as well as a symbol for his artistic creed. During the spring of 1898, while his wife was on vacation, he kept her informed of his progress as if he were charting a journey, writing, "I am *at* Avalon—not yet *in* Avalon . . . I shall let most things pass me by. I must, if I ever want to reach Avalon."[16] More than a picture or a place, to Burne-Jones, Avalon suggested a state of mind. No other tribute to past achievement offered such a strong belief in future potential. Even in closing, the legend kept its promise, preserving the ideal for generations yet to come.

When the Victorians called Arthur out of Avalon, they gave him a hero's welcome. His return was met with cheering crowds, and for the first time in his tradition he took the helm of a nation in ascent, hungry for greater triumph. The course of his Victorian reign fulfilled the words of Sir Thomas Malory, for in his new incarnation, "he changed his life." He appeared to his new subjects as one of their own, "a modern gentleman / Of stateliest port," but he changed their lives as well. As a symbolic monarch, Arthur served his country and its queen. He set a standard for a new definition of contemporary manhood, bound with honorable vows and inspired by chivalric aspirations. He called to women to support their men, in their work in this world and their dreams to improve it. And he acted as a father to generations of children, teaching them the value of his long-cherished ideal. But through the course of the revival, the world built by Victorian energy and ambition was also subject to change. Modern warfare, new technology, and shifts in the balances of global power and social structures conflicted with the Arthurian vision. At the close of his reign, Arthur lamented the loss of his realm and of his companion, but with a wisdom born of ancient ideals and Victorian pragmatism, he graciously accepted his fate. With his words to Bedivere, "The old order changeth, yielding place to the new . . . Lest one good custom should corrupt the world," he closed his cycle and went back to Avalon, comforted by the faith of his most recent subjects who held confidence in his return. To preserve the ideals of the society that pulled him into the present, he retreated in peace to the realm of the once and the future, waiting for the time when he would be summoned forth again.

HE·GAVE·THEM·CHARGE·
ABOUT·THE·QUEEN·

Florence Harrison. "He gave them charge about the
Queen," *Tennyson's "Guinevere" and Other Poems*. London:
Blackie and Son, 1912. Courtesy of The Newberry Library,
Chicago

Notes

Chapter 1
"The Style of Those Heroic Times"

1. James D. Merriman, *The Flower of Kings: A Study of the Arthurian Legend in England between 1485 and 1835* (Wichita: University Press of Kansas, 1973), 12. See also Norris J. Lacy and Geoffrey Ashe, *The Arthurian Handbook* (New York: Garland, 1988), 3–149, for a full account of the evolution of Arthurian literature.

2. Lacy and Ashe, *Arthurian Handbook*, 19–23.

3. *The Gododdin: The Oldest Scottish Poem*, trans. Kenneth Hurlstone Jackson (Edinburgh: Edinburgh University Press, 1969), 112.

4. Geoffrey Ashe, "Glastonbury," in *The New Arthurian Encyclopedia*, ed. Norris J. Lacy (New York: Garland, 1991), 198–202. See also James P. Carley, *Glastonbury Abbey* (Woodbridge, Suffolk: Boydell and Brewer, 1988), and R. F. Treharne, *The Glastonbury Legends* (London: Cresset, 1967).

5. See Roberta Brinkley, *Arthurian Legend in the Seventeenth Century* (Baltimore: Johns Hopkins, 1932), 10, for a discussion of Campion's and Jonson's masques.

6. See ibid., 81.

7. As quoted in Elizabeth Jenkins, *The Mystery of King Arthur* (London: Michael Joseph, 1975), 183.

8. Kenneth Clark, *The Gothic Revival: An Essay in the History of Taste* (1928; New York: Charles Scribner's Sons, 1929), 53.

9. Ibid., 31.

10. David Mallet, "The Excursion," in *The Poetical Works of David Mallet* (Edinburgh, 1789), 39, ll. 259–60.

11. These were *The History of the Renowned Prince Arthur, King of Britain*, published by Walker and Evans, and *La Mort D'Arthur*, edited by Joseph Haselwood and published by R. Wilks. See Merriman, *Flower of Kings*, 129–31, for a complete discussion of the republication of Malory's *Morte Darthur*

Chapter 2
For Queen and Country

1. Richard Hurd, *Letters on Chivalry and Romance* (1762; London: H. Frowde, 1911), 6–7, 11, 35–37, 45, 109.

2. George Ellis, *Specimens of Early English Metrical Romances*, 3 vols. (London, 1805), 1:263.

3. Sir Walter Scott, quoted in *Memoirs of the Life of Sir Walter Scott*, ed. John Lockhart, 9 vols. (Boston, 1881), 1:21–22.

4. Sir Walter Scott, *Ivanhoe* (Harmondsworth: Penguin, 1987), 317–18.

5. Edward Fitzgerald, quoted in Bernard Holland, *Memoir of Kenelm Henry Digby* (London: Longmans, Greene, 1919), 9.

6. Kenelm Henry Digby, *The Broadstone of Honour, or Rules for the Gentlemen of England* (London, 1823), 188.

7. Ironically, in 1821, George IV became the last monarch to be honored in this ceremony. When William IV came to the throne in 1830, he regarded it a wasteful extravagance. Because of its frugality, Victoria's ceremony was remembered as "The Penny Coronation." See W. J. Passingham, *A History of the Coronation* (London: Sampson, Low, Marston, n.d.), 41–54.

8. *London Times*, 16 April 1838, quoted in Sara Stevenson and Helen Bennett, *Van Dyck in Check Trousers: Fancy Dress in Art and Life, 1700–1900* (Edinburgh: Scottish National Portrait Gallery, 1978), 107.

9. *London Times*, 11 July 1839, 5, col. 2.

10. Charles Mackay, *Through the Long Day*, 2 vols. (London, 1887), 1:69.

11. Percy Bysshe Shelley, "Sonnet—England in 1819," in *The Complete Poetical Works of Percy Bysshe Shelley*, ed. G. E. Woodberry (Boston: Houghton Mifflin, 1901), 365.

12. Arthur Wellesley, duke of Wellington, quoted in Roger Fulford, *The Prince Consort* (London: Macmillan, 1949), 16.

13. Elizabeth Longford, *Queen Victoria: Born to Succeed* (New York: Harper and Row, 1964), 80.

14. William Maginn, quoted in Miriam M. H. Thrall, *Rebellious Fraser's* (New York: Columbia University Press, 1934), 155–56.

15. Lord John Manners, quoted in Joseph Ellis Baker, *The Novel and the Oxford Movement* (New York: Russell and Russell, 1965), 1.

16. Lord John Manners, "England's Trust," in *"England's Trust" and Other Poems* (London, 1841), sec. 3, 24.

17. Lord John Manners to the Marquis of Granby, 10 September 1842, quoted in Charles Whibley, *Lord John Manners and His Friends*, 2 vols. (Edinburgh: William Blackwood and Sons, 1925), 1:137.

18. "Third Report: Resolution," in *Reports from the Select Committee of the Fine Arts, Together with the Minutes of Evidences, Appendix and Index, in 12 Parts* (London, 1841–64), 9.

19. *Athenaeum*, 5 July 1845, 663; *Art-Union* 7 (August 1845): 257, and 7 (November 1845): 349; and [Charles Dickens], "The Spirit of Chivalry in Westminster Hall," *Douglas Jerrold's Shilling Magazine* 2 (July–December 1845): 124–25.

20. *Illustrated London News* 7 (1845): 93.

21. Fulford, *Prince Consort*, 3.

22. Albert, quoted in Kurt Jagow, *Letters of the Prince Consort, 1831–1861* (London: John Murray, 1938), 66.

23. Sir Theodore Martin, *The Life of H.R.H. the Prince Consort*, 5 vols. (London, 1875–80), 1:212.

24. William Dyce, quoted in James Stirling Dyce, "Life, Correspondence, and Writings of William Dyce, R.A. 1806–1864, Painter, Musician, and Scholar, by His Son," undated MS. bound in 4 vols., Aberdeen Art Gallery, 3:992

25. Ibid.

26. Dyce to Charles L. Eastlake, 20 July 1848, in ibid., 3: letter 49, n.p.

CHAPTER 3

"Ideal Manhood Closed in Real Man"

1. Hallam Tennyson, *Alfred, Lord Tennyson: A Memoir by His Son*, 2 vols. (New York, 1897), 1:59, 2:19

2. Aubrey De Vere, "Alfred Tennyson," in *Medieval Records and Sonnets* (London: Macmillan, 1893), 258.

3. Thomas Carlyle, "Sir Walter Scott," in *Critical and Miscellaneous Essays*, 5 vols. (London, 1842), 5:231–33.

4. H. Tennyson, *Memoir*, 2:128.

5. John Henry Newman, *Sermons and Discourses*, ed. C. F. Harrold, 2 vols. (London: Longmans, Green, 1949), 2:153, 155.

6. Thomas Carlyle, "The English," in *Past and Present* (London: J. M. Dent, 1919), 153.

7. Walter E. Houghton, *The Victorian Frame of Mind, 1830–1870* (New Haven: Yale University Press, 1985), 242.

8. John Ruskin, "Of Queen's Gardens," sec. 68, in *Sesame and Lilies*, vol. 18 of *Works*, ed. E. T. Cook and Alexander Wedderburn (London: George Allen, 1903–12), 22.

9. *Annales Cambriae*, quoted in Norris J. Lacy and Geoffrey Ashe, *The Arthurian Handbook* (New York: Garland, 1988), 22.

10. Charles Kingsley, *Letters and Memories of His Life*, ed. Fanny Kingsley, 2 vols. (London, 1877), 1:255.

11. Dyce submitted this work as a design for the queen's Robing Room, but it was rejected by the Fine Arts Commissioners owing to the tragic nature of its subject matter. See Debra N. Mancoff, *The Arthurian Revival in Victorian Art* (New York: Garland, 1990), 123–25.

12. Malory as quoted by Dyce to J. T. Coleridge, 17 April 1849, in James Stirling Dyce, "Life, Correspondence, and Writings of William Dyce, R.A. 1806–1864, Painter, Musician, and Scholar, by His Son," undated MS. bound in 4 vols., Aberdeen Art Gallery, 3: chap. 27, n.p.

13. Dyce to the Fine Arts Commissioners, 23 November 1848, in ibid.

14. *London Quarterly* 39 (January 1873): 402–3.

CHAPTER 4

Woman Worship

1. Coventry Patmore's long poem *The Angel in the House* was published in four parts: "The Betrothal" (1854), "The Espousals" (1856), "Faithful Forever" (1860), and "The Victories of Love" (1862). Celebrating the virtuous joys of married love, it also sets a standard for the ideal Victorian woman as dutiful daughter, devoted wife, and loving mother.

2. Walter E. Houghton, *The Victorian Frame of Mind* (New Haven: Yale University Press, 1985), 350–51.

3. For a full description of Victorian women's rights under the law, see Joan Perkin, *Women and Marriage in Nineteenth-Century England* (Chicago: Lyceum Books, 1989), 10–15.

4. Sarah Ellis, quoted in ibid., 260.

5. Cope intended *A Life Well Spent* as one painting of a pair set in one frame. *Time Ill Spent* has been lost, but contemporary art reviewers describe its subject as an idle mother more concerned with French novels and fashion than with her household duties and her children. See Susan P. Casteras, *Images of Victorian Womanhood in English Art* (Cranbury, N.J.: Associated University Press, 1987), 55.

6. Ibid., 59.

7. Elizabeth Missing Sewell, *Principles of Education, Drawn from Nature and Revelation, and Applied to Female Education in the Upper Classes* (London, 1865), 396. See also Casteras, *Images of Victorian Womanhood*, 35–49, "The Ideal of Victorian Girlhood."

8. Sarah Tyler, "Girls," *Mother's Companion* 1 (1887): 14.

9. *The Etiquette of Courtship and Marriage* (London, 1844), 13. See also Casteras, *Images of Victorian Womanhood*, 85–102, "Courtship and Marriage."

10. J. Baldwin Brown, *The Home Life: In the Light of Its Divine Idea* (New York, 1867), 23–25

11. Thomas Carlyle, *Memoirs of a Working Man*

(1845), quoted in Perkin, *Women and Marriage*, 260.

12. In some Welsh versions of the legend, Guinevere and Arthur have two sons, but the tradition of her infidelity has been so persistent in Wales that the name "Guinevere" was regarded as derogatory through the nineteenth century. See Beverly Kennedy, "Guenevere," in *The New Arthurian Encyclopedia*, ed. Norris J. Lacy (New York: Garland, 1991), 215.

13. William Acton, *The Functions and Disorders of the Reproductive Organs* (London, 1857), 102.

14. Casteras, *Images of Victorian Womanhood*, 53.

15. Mrs. Sarah Ellis, *The Wives of England, Their Relative Duties, Domestic Influence, and Social Obligations* (London, 1843), 99–100. This advice is in the section "Behaviour of Husbands." See also Houghton, *Victorian Frame of Mind*, 351.

16. Charlotte Yonge, *The Heir of Redclyffe* (London: Macmillan, 1902), 145.

17. Jonathan F. S. Post, in "Guenevere's Critical Performance: William Morris's 'The Defence of Guenevere,'" *Victorian Poetry* 17 (1979): 317, observes that the critics of Morris's poem in the literary world were as numerous and harsh as the queen's critics in the Arthurian world. See also Rebecca Cochran, "William Morris: Victorian Innovator," in *The Arthurian Revival: Essays on Form, Tradition, and Transformation*, ed. Debra N. Mancoff (New York: Garland, 1992), 75–96, and Florence S. Boos, "Justice and Vindication in William Morris's 'The Defence of Guenevere,'" in *King Arthur through the Ages*, ed. Valerie M. Lagorio and M. L. Day, 2 vols. (New York: Garland, 1990), 2:83–104.

18. Esther A. Wood, "A Consideration of the Work of Frederick Sandys," *Artist*, 18 November 1896, 24, and *Art Journal*, 1 June 1864, 161.

19. Sir Thomas Malory, *Le Morte Darthur*, 2 vols. (London: J. M. Dent and Sons, 1919), 1: bk. 4, chap. 1, 90.

CHAPTER 5

The "Bright Boy Knight"

1. James Anthony Froude, *The Nemesis of Faith* (London: Walter Scott, 1904), 116.

2. Charles Kingsley, *His Letters, and Memories of His Life*, 2 vols. (New York: J. F. Taylor, 1900), 2:138.

3. These figures are taken from Caroline Simon, *The Age of Innocence? Children in Art, 1830–1900* (Blackburn and Burnley: Lancashire County Council, 1989), 7.

4. For further discussion, see W. John Smith, "Children," in *Victorian Britain: An Encyclopedia*, ed. Sally Mitchell (New York: Garland, 1988), 142–43, and Susan P. Casteras, *Victorian Children* (New York: Harry N. Abrams, 1986), 4.

5. The Arthurian legend was a popular subject for domestic tapestries. The Merton Abbey tapestry works produced two additional sets from Burne-Jones's design for other clients. A decade earlier, in 1879, Herbert Bone produced designs for some of the most popular scenes from the legend—*The Arrival at Camelot of the Dead Elaine, The Parting of Arthur and Guinevere, The Passing of Arthur*—for the Royal Windsor Tapestry Manufactory. See "The Arras Tapestries of the San Graal at Stanmore Hall," *Studio* 15 (1899): 98–104, and Beryl Platts, "A Brave Victorian Venture: The Royal Windsor Tapestry Manufactory," *Country Life*, 29 November 1979, 2003–6.

6. See M. H. Noël-Paton, *Tales of a Grand-Daughter* (Elgin, Scot.: by the author, 1970), 14, and Malcolm Baker, "A Victorian Collector of Armour, Sir Joseph Noël Paton," *Country Life*, 25 January 1973, 234–36.

7. These early works are catalogued in Virginia Surtees, *The Paintings and Drawings of Dante Gabriel Rossetti (1828–1882): A Catalogue Raisonné*, 2 vols. (Oxford: Clarendon Press, 1971), 1:1; 2:229, 223.

8. The titles for these "novels" were "Sir Aubrey de Merford: A Romance of the Fourteenth Century," "Roderick and Rosalba," "A Tale of the Round Table," and "Raimond and Matilda: Retribution." Nothing remains of these works but the sketches. William Michael Rossetti recorded that some of his brother's early writings were strongly influenced by the stories published in *Tales of Chivalry*. See William Michael Rossetti, *Rossetti as Designer and Writer* (London, 1889), 175.

9. Charles Grey, *The Early Years of His Royal Highness the Prince Consort* (New York, 1867), 36–37, 40–41.

10. Albert, quoted in ibid., 48.

11. Arthur Mensdorff, quoted in ibid., 65–66.

12. J. M. Kemble, quoted in David Staines, *Tennyson's Camelot: The "Idylls of the King" and Its Medieval Sources* (Waterloo, Ont.: Wilfred Laurier University Press, 1983), 12, and Alfred Tennyson, quoted in Hallam Tennyson, *Alfred, Lord Tennyson: A Memoir by His Son*, 2 vols. (New York, 1897), 1:142. Agnes was the patron saint of chastity, martyred as a virgin in Rome c. A.D. 304–5.

13. *Blackwoods Magazine* 86 (November 1859): 610.

14. Edward Burne-Jones to Cormell Price, 1 May 1853, quoted in Georgiana Burne-Jones, *Memorials of Edward Burne-Jones*, 2 vols. (London: Macmillan, 1904), 1:76.

15. Tennyson to the Duke of Argyll, 3 October 1859, quoted in H. Tennyson, *Memoir*, 1:456–57. The duke had written to the poet, demanding, "The 'Grail' ought to be written forthwith" (1:459).

16. For a discussion of Hughes's novel in the context of the chivalric revival, see Mark Girouard, *The Return to Camelot: Chivalry and the English Gentleman* (New Haven: Yale University Press, 1981), 166–68.

17. For a full discussion of boys' clubs, see ibid., 251–58.

18. It has often been suggested that Watts used two models for this painting, Arthur Prinsep and Ellen Terry, which may explain the androgynous character of the figure. But Allen Staley has argued that the work was completed before the painter met Terry. He did, however, paint Terry in armor for his Joan of Arc subject *Watchman, What of the Night?* See Staley, *Victorian High Renaissance* (Minneapolis: Minneapolis Institute of Art, 1978), 68.

19. George Frederick Watts, quoted in Girouard, *Return to Camelot*, 176.

20. Letter to H. E. Luxmore, quoted in ibid.

13. George MacDonald, "Better Things," in *Poems* (London, 1857), 12.

14. The other versions are *La Morte D'Arthur* (1862); *The Sancgraeall, King Arthur Relieved of His Grievous Wound in the Island Valley of Avalon* (1863); *The Dying King Arthur in the Island of Avalon Has a Vision of the Holy Grail* (1880); and *Le Morte D'Arthur* (1897). All share the same compositional element, suggesting that Archer sought to refine the subject rather than reinterpret it.

15. Georgiana Burne-Jones, *Memorials of Edward Burne-Jones*, 2 vols. (London: Macmillan, 1906), 2:116.

16. Ibid., 340.

CHAPTER 6

To the Last Battle and Beyond

1. Alfred Tennyson, quoted in Hallam Tennyson, *Alfred, Lord Tennyson: A Memoir by His Son*, 2 vols. (New York, 1897), 2:127.

2. Walter Walsh, "Tennyson's Great Allegory," *Gentleman's Magazine* 50 (May 1893): 503–4.

3. Algernon Charles Swinburne, *Under the Microscope* (London, 1872), 35.

4. Ibid., 37–39.

5. Swinburne, "The Tale of Balen," in *The Poems of Algernon Charles Swinburne*, 6 vols. (London: Chatto and Windus, 1905), 4:165.

6. Elizabeth Barrett Browning, *Aurora Leigh* (New York, 1857), bk. 5, 169–71, ll. 151–52, 216–19.

7. W. H. Mallock, *Every Man His Own Poet, or The Inspired Singer's Recipe Book* (Chicago: privately printed, 1903), 16–18.

8. *Literary World*, n.s. 1, 7 December 1869, 97–98.

9. Anthony Trollope, *The Eustace Diamonds* (1873; New York: Dodd, Mead, 1919), chap. 19, 226–27.

10. Mary Neville, *Arthur, or A Knight of Our Own Day*, 2 vols. (London, 1876).

11. Alfred Tennyson, quoted in William Holman Hunt, *Pre-Raphaelitism and the Pre-Raphaelite Brotherhood*, 2 vols. (London: Chapman and Hall, 1913), 2:124–25.

12. Dante Gabriel Rossetti to William Allingham, 23 January 1855, in *The Letters of Dante Gabriel Rossetti to William Allingham* (London, 1897), 97.

Bibliography

The Arthurian Tradition

The Arthurian tradition in literature developed over centuries and is still growing today. This list is far from comprehensive, but it includes the landmark and representative works from the early Middle Ages through the Victorian era. The dates given for the medieval titles indicate the earliest known version of the text; for the modern titles the dates cite the first publication. Original languages other than English are noted; translations of these works are widely available.

Y Gododdin (c. 600; Welsh)

William of Malmesbury. *Gesta Regum Anglorum* (1125; Latin)

Geoffrey of Monmouth. *Historia Regum Britanniae* (1138; Latin)

Chrétien de Troyes. *Erec et Enide, Cligés, Le Chevalier de la charrete, Le Chevalier au lion, Le Conte del Graal* (1160–80; French)

Marie de France. *Lais* (1170; French)

Robert de Boron. *Le Roman de l'estoire dou Graal* (1200; French)

Wolfram von Eschenbach. *Parzival* (1210; German)

Gottfried von Strassburg. *Tristan und Isolde* (1210; German)

Vulgate Morte Artu (1215–35; French)

Sir Gawaine and the Greene Knight (1400)

Alliterative Morte Arthure (1400–1402)

Stanzaic Le Morte Arthur (1460–80)

Sir Thomas Malory. *Le Morte Darthur* (1469–70)

Edmund Spenser. *The Faerie Queene* (1589–98)

Thomas Campion. *Masque at Lord Hay's Marriage* (1606–7)

Ben Jonson. *The Speeches at Prince Henry's Barriers* (1610)

John Dryden and Henry Purcell. *King Arthur, or The British Worthy* (1685–88)

Henry Fielding. *The Tragedy of Tragedies, or The Life and Death of Tom Thumb the Great* (1731)

William Wordsworth. "The Egyptian Maid, or The Romance of the Water Lily" (1835)

Alfred Tennyson. "Morte d'Arthur," "The Lady of Shalott," "Sir Galahad," "The Palace of Art" (1842); *Idylls of the King* (1859–91); "Merlin and the Gleam" (1889)

Edward Bulwer-Lytton. *King Arthur* (1848)

Matthew Arnold. "Tristram and Iseult" (1852)

William Morris. "The Defence of Guenevere," "King Arthur's Tomb," "Sir Galahad, A Christmas Mystery," "The Chapel in Lyoness," "Near Avalon" (1858)

Algernon Charles Swinburne. "Tristram of Lyonesse" (1882); "The Tale of Balen" (1896)

Further Reading

Alcock, Leslie. *Arthur's Britain: History and Archaeology A.D. 367–634.* London: Penguin, 1971.

Altick, Richard D. *Paintings from Books: Art and Literature in Britain, 1760–1900.* Columbus: Ohio State University Press, 1985.

——. *Victorian People and Ideas.* New York: W. W. Norton, 1973.

Anstruther, Ian. *The Knight and the Umbrella: An Account of the Eglinton Tournament.* London: George Bles, 1963.

Arnold, Matthew. *Poems.* London: Macmillan, 1888.

Arnstein, Walter L. *Britain Yesterday and Today: 1830 to the Present.* Lexington, Ky.: D. C. Heath, 1988.

Ashe, Geoffrey. *The Landscape of King Arthur.* Exeter: Webb and Bower, 1987.

Auerbach, Nina. *Woman and the Demon: The Life of a Victorian Myth.* Cambridge: Harvard University Press, 1982.

Avery, Gillian. *Nineteenth-Century Children: A Study of Heroes and Heroines of Children's Fiction, 1770–1900.* London: Hodder and Stoughton, 1965.

Banham, Joanna, and Jennifer Harris, eds. *William Morris and the Middle Ages.* Manchester: Manchester University Press, 1984.

Barber, Richard. *The Arthurian Legends: An Illustrated Anthology.* Woodbridge, Suffolk: Boydell, 1979.

Baswell, Christopher, and William Sharpe, eds. *The Passing of Arthur: New Essays in the Arthurian Tradition.* New York: Garland, 1988.

Boase, T. S. R. *English Art, 1800–1870.* Oxford: Clarendon Press, 1959.

Bond, Maurice, ed. *Works of Art in the House of Lords.* London: Her Majesty's Stationery Office, 1980.

Boos, Florence S., ed. *History and Community: Essays in Victorian Medievalism.* New York: Garland, 1992.

Braswell, Mary Flowers, and John Bugge, eds. *The Arthurian Tradition: Essays in Convergence.* Tuscaloosa: University of Alabama Press, 1988.

Brighton Art Gallery. *"Gothick": 1720–1840.* Brighton: Royal Pavilion Art Gallery and Museums, 1975.

Brinkley, Roberta. *Arthurian Legend in the Seventeenth Century.* Baltimore: Johns Hopkins, 1932.

Burne-Jones, Georgiana. *Memorials of Edward Burne-Jones.*

2 vols. London: Macmillan, 1904–6.

Carlyle, Thomas. *Critical and Miscellaneous Essays*. 5 vols. London: Chapman and Hall, 1842.

——. *On Heroes and Hero Worship and the Heroic in History*. New York: Wiley and Halsted, 1859.

——. *Past and Present*. London: J. M. Dent, 1919.

Casteras, Susan P. *Images of Victorian Womanhood in English Art*. Cranbury, N.J.: Associated University Press, 1987.

——. *Victorian Children*. New York: Harry N. Abrams, 1986.

Chandler, Alice. *A Dream of Order: The Medieval Ideal in Nineteenth-Century English Literature*. Lincoln: University of Nebraska Press, 1970.

Christian, John. *The Last Romantics: The Romantic Tradition in British Art, Burne-Jones to Stanley Spencer*. London: Lund Humphries, 1993.

——. *The Oxford Union Murals*. Chicago: University of Chicago Press, 1981.

Clark, Kenneth. *The Gothic Revival: An Essay in the History of Taste*. 1928. New York: Charles Scribner's Sons, 1929.

Coghlan, Ronan. *The Illustrated Encyclopedia of Arthurian Legends*. Shaftesbury: Element Books, 1993.

Digby, Kenelm Henry. *The Broadstone of Honour, or Rules for the Gentlemen of England*. London: C. and J. Rivington, 1823.

Dodds, John W. *The Age of Paradox: A Biography of England, 1841–1851*. New York: Rinehart, 1952.

Eggers, J. Philip. *King Arthur's Laureate: Tennyson's "Idylls of the King."* New York: New York University Press, 1973.

Ellis, George. *Specimens of Early English Metrical Romances*. 3 vols. London: Longman, Hurst, Rees, Orme, and Brown, 1805.

Finster, Thelma, ed. *Arthurian Women: A Casebook*. New York: Garland, 1995.

Forbes, Christopher. *The Royal Academy Revisited, 1837–1901*. New York: Metropolitan Museum of Art, 1975.

Fulford, Roger. *The Prince Consort*. London: Macmillan, 1949.

Girouard, Mark. *The Return to Camelot: Chivalry and the English Gentleman*. New Haven: Yale University Press, 1981.

Goebel, Janet E., and Rebecca Cochran, eds. *Selected Papers on Medievalism*. Indiana, Pa.: Indiana University of Pennsylvania, 1988.

Goodman, Jennifer R. *The Legend of Arthur in British and American Literature*. Boston: Twayne, 1987.

Gorham, Deborah. *The Victorian Girl and the Feminine Ideal*. London: Croom Helm, 1982.

Grambert, Joan Tasker, ed. *Tristan and Isolde: A Casebook*. New York: Garland, 1995.

Gross, Arthur, ed. *Percival/Parzival: A Casebook*. New York: Garland, 1995.

Hadfield, John. *Every Picture Tells a Story*. London: Herbert Press, 1985.

Hamilton, Ruth E. *King Arthur in Word and Image*. Chicago: Newberry Library, 1988.

Himmelfarb, Gertrude. *Marriage and Morals among the Victorians and Other Essays*. New York: Vintage Books, 1987.

——. *Victorian Minds*. New York: Alfred A. Knopf, 1968.

Holland, Bernard. *Memoir of Kenelm Henry Digby*. London: Longmans, Greene, 1919.

Houghton, Walter E. *The Victorian Frame of Mind*. New Haven: Yale University Press, 1985.

Hughes, Linda K. *"The Many Fac'ed Glass": Tennyson's Dramatic Monologues*. Athens: Ohio University Press, 1987.

Hunt, John Dixon. *The Pre-Raphaelite Imagination, 1848–1900*. London: Routledge and Kegan Paul, 1968.

Hurd, Richard. *Letters on Chivalry and Romance*. 1762. London: H. Frowde, 1911.

Jenkins, Elizabeth. *The Mystery of King Arthur*. London: Michael Joseph, 1975.

Kennedy, Edward Donald, ed. *King Arthur: A Casebook*. New York: Garland, 1995.

Kestner, Joseph A. *Masculinities in Victorian Painting*. Leicester: Scolar / University of Leicester Press, 1995.

Lacy, Norris J., ed. *The New Arthurian Encyclopedia*. New York: Garland, 1991.

Lacy, Norris J., and Geoffrey Ashe. *The Arthurian Handbook*. New York: Garland, 1988.

Lagorio, Valerie M., and M. L. Day. *King Arthur through the Ages*. 2 vols. New York: Garland, 1990.

Landow, George, ed. *Ladies of Shalott: A Victorian Masterpiece and Its Contexts*. Providence, R.I.: Department of Art, Brown University, 1985.

Lockhart, John, ed. *Memoirs of the Life of Sir Walter Scott*. 9 vols. Boston, 1881.

Longford, Elizabeth. *Queen Victoria: Born to Succeed*. New York: Harper and Row, 1964.

——. *Victoria R.I.* New York: Harper and Row, 1973.

Loomis, Roger Sherman, and Laura Hibbard Loomis. *Arthurian Legends in Medieval Art*. London: Oxford University Press, 1938.

Lupack, Alan, ed. *Modern Arthurian Literature: An Anthology of English and American Arthuriana from the Renaissance to the Present*. New York: Garland, 1992.

Maas, Jeremy. *Victorian Painters*. London: Barrie and Rockliff, 1969.

Mallock, W. H. *Every Man His Own Poet, or The Inspired Singer's Recipe Book*. Chicago: privately printed, 1903.

Mancoff, Debra N. *The Arthurian Revival in Victorian Art*. New York: Garland, 1990.

———, ed. *The Arthurian Revival: Essays on Form, Tradition, and Transformation*. New York: Garland, 1992.

Marsh, Jan, and Pamela Gerrish Nunn. *Women Artists and the Pre-Raphaelite Movement*. London: Virago Press, 1989.

Martin, Robert Bernard. *Tennyson: The Unquiet Heart*. Oxford: Clarendon Press, 1980.

Martin, Sir Theodore. *The Life of H.R.H. the Prince Consort*. 5 vols. London: Smith, Elder, 1875–80.

Mason, Philip. *The English Gentleman: The Rise and Fall of an Ideal*. New York: William Morrow, 1982.

Merriman, James D. *The Flower of Kings: A Study of the Arthurian Legend in England between 1485 and 1835*. Wichita: University Press of Kansas, 1973.

Millar, Oliver. *The Victorian Pictures in the Collection of Her Majesty the Queen*. 2 vols. Cambridge: Cambridge University Press, 1992.

Mitchell, Sally, ed. *Victorian Britain: An Encyclopedia*. New York: Garland, 1988.

Morgan, Mary Louise. "Galahad in English Literature." Ph.D. diss., Catholic University of America, 1932.

Parris, Leslie, ed. *Pre-Raphaelite Papers*. London: Tate Gallery, 1984.

Parry, Linda. *William Morris Textiles*. New York: Viking Press, 1983.

Pearce, Lynne. *Woman/Image/Text: Readings in Pre-Raphaelite Art and Literature*. Toronto: University of Toronto Press, 1991.

Percy, Thomas. *Reliques of Ancient English Poetry*. 3 vols. London: J. Dodsley, 1765.

Perkin, Joan. *Women and Marriage in Nineteenth-Century England*. Chicago: Lyceum Books, 1989.

Port, M. H., ed. *The Houses of Parliament*. New Haven: Yale University Press, 1976.

Poulson, Christine. *William Morris*. London: Quintet Books, 1989.

The Pre-Raphaelites. London: Tate Gallery, 1984.

Redgrave, Richard, and Samuel Redgrave. *A Century of Painters of the English School*. Ithaca: Cornell University Press, 1981.

Reed, John R. *Perception and Design in Tennyson's "Idylls of the King."* New York: Columbia University Press, 1973.

———. *Victorian Conventions*. Athens: Ohio University Press, 1975.

Reid, Forrest. *Illustrators of the Sixties*. New York: Dover, 1975.

Renton, John D. *The Oxford Union Murals*. Oxford: Oxford Union, n.d.

Ricks, Christopher, ed. *The Poems of Tennyson*. London: Longman, 1987.

———. *Tennyson*. New York: Macmillan, 1972.

Roberts, David. *Paternalism in Early Victorian England*. New Brunswick, N.J.: Rutgers University Press, 1979.

Ruskin, John. *Works*. Edited by E. T. Cook and Alexander Wedderburn. 39 vols. London: George Allen, 1903–12.

Ryals, Clyde de L. *From the Great Deep: Essays on the "Idylls of the King."* Athens: Ohio University Press, 1967.

Scherer, Margaret R. *About the Round Table*. New York: Metropolitan Museum of Art, 1945.

Scott, Sir Walter. *Ivanhoe*. Harmondsworth: Penguin, 1987.

Shichtman, Martin B., and James P. Carley. *Culture and the King: The Social Implications of the Arthurian Legend*. Albany: State University of New York Press, 1994.

Simon, Caroline. *The Age of Innocence? Children in Art, 1830–1900*. Blackburn and Burnley: Lancashire County Council, 1989.

Simpson, Roger. *Camelot Regained: The Arthurian Revival and Tennyson, 1800–1849*. Cambridge: D. S. Brewer, 1990.

Spalding, Frances. *Magnificent Dreams: Burne-Jones and the Late Victorians*. New York: E. P. Dutton, 1978.

Staines, David. *Tennyson's Camelot: The "Idylls of the King" and Its Medieval Sources*. Waterloo, Ont.: Wilfred Laurier University Press, 1983.

Stange, Robert E. *The Poetical Works of Tennyson*. Boston: Houghton Mifflin, 1974.

Steegman, John. *Victorian Taste: A Study of the Arts and Architecture from 1830 to 1870*. Cambridge: M.I.T. Press, 1970.

Strachey, Lytton. *Queen Victoria*. New York: Harcourt, Brace, 1921.

Strong, Roy. *And When Did You Last See Your Father? The Victorian Painter and British History*. London: Thames and Hudson, 1978.

Surtees, Virginia. *The Paintings and Drawings of Dante Gabriel Rossetti (1828–1882): A Catalogue Raisonné*. 2 vols. Oxford: Clarendon Press, 1971.

Swinburne, Algernon Charles. *The Poems of Algernon Charles Swinburne*. 6 vols. London: Chatto and Windus, 1905.

Taylor, Beverly, and Elisabeth Brewer. *The Return of King Arthur: British and American Literature since 1800*. Totowa, N.J.: Barnes and Noble, 1983.

Tennyson, Hallam. *Alfred, Lord Tennyson: A Memoir by His*

Son. 2 vols. New York: Macmillan, 1897.

Thompson, Raymond H. *The Return from Avalon: A Study of the Arthurian Legend in Modern Fiction.* Westport, Conn.: Greenwood, 1985.

Treuherz, Julian. *Victorian Painting.* New York: Thames and Hudson, 1993.

Vicinus, Martha, ed. *Suffer and Be Still: Women in the Victorian Age.* Bloomington: Indiana University Press, 1973.

——, ed. *A Widening Sphere: The Changing Roles of Victorian Women.* Bloomington: Indiana University Press, 1977.

Victorian High Renaissance. Minneapolis: Minneapolis Institute of the Arts, 1978.

Walters, Lori, ed. *Lancelot and Guenevere: A Casebook.* New York: Garland, 1995.

Watkinson, Raymond. *Pre-Raphaelite Art and Design.* London: Studio Vista, 1970.

Weston, Jessie. *From Ritual to Romance.* Cambridge: Cambridge University Press, 1920.

Whitaker, Muriel. *The Legends of King Arthur in Art.* Cambridge: D. S. Brewer, 1990.

White, Gleeson. *English Illustration, "The Sixties": 1855–70.* Bath: Kingsmead Reprints, 1970.

Wilhelm, James J., ed. *The Romance of Arthur II.* New York: Garland, 1986.

Wilhelm, James J., and Laila Zamuelis Gross. *The Romance of Arthur.* New York: Garland, 1984.

Wood, Christopher. *The Dictionary of Victorian Painters.* London: Antique Collectors' Club, 1978.

——. *The Pre-Raphaelites.* New York: Viking Press, 1981.

——. *Victorian Panorama: Paintings of Victorian Life.* London: Faber and Faber, 1976.

Index

Italic page numbers refer to illustrations; asterisks indicate legendary or fictional characters and places.